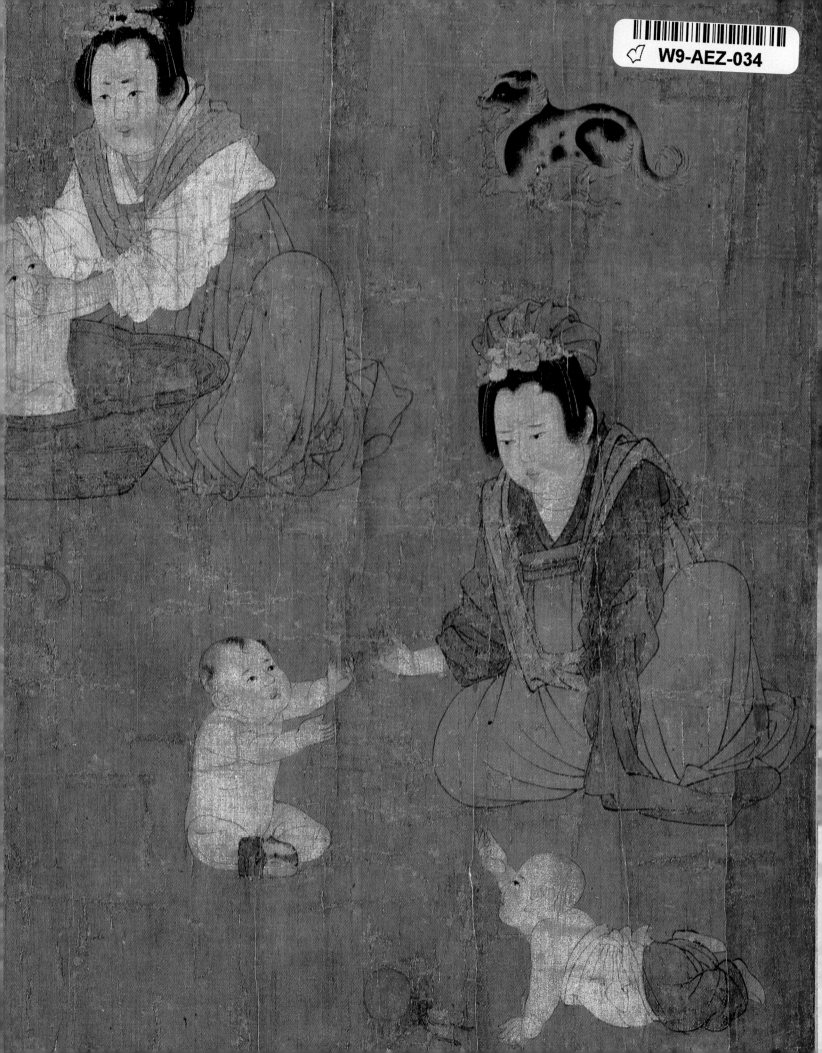

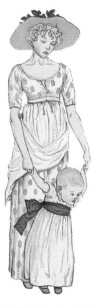

METROPOLITAN
CHILDREN

METROPOLITAN CHILDREN

Text by
BARBARA BURN

Design by
ALVIN GROSSMAN

THE METROPOLITAN MUSEUM OF ART, NEW YORK
HARRY N. ABRAMS, INC., PUBLISHERS, NEW YORK

Published by The Metropolitan Museum
of Art, New York
Bradford D. Kelleher, Publisher
John P. O'Neill, Editor in Chief
Barbara Burn, Project Supervisor
Alvin Grossman, Designer

Library of Congress Cataloging in Publi-
cation Data

Metropolitan Museum of Art (New York,
N.Y.) Metropolitan Children

1. Children in art. 2. Metropolitan Museum
of Art (New York, N.Y.) I. Burn, Barbara,
1940- II. Grossman, Alvin. III. Title.
N7642.B93 1984 704.9′425′07401471
84-9011
ISBN 0-87099-373-9 (MMA)
ISBN 0-8109-1321-6 (HNA)

The photographs for this volume were
taken by the Photograph Studio of The
Metropolitan Museum of Art, with the ex-
ception of those on pages 2, 5, 6, 10 (top),
14, 19, 27 (bottom), 28 (right), 29, 34
(left), 39, 41, 45, 49, 67 (left), 70, 71, 80,
81, 82 (top), 84, 85, 87, 91, 96, 102, 103,
which were taken by Malcolm Varon.

Composition by The Graphic Word Inc.,
New York
Printed and bound by Dai Nippon Printing
Co., Ltd., Tokyo, Japan

FRONT AND BACK ENDPAPERS. **Playing with Babies.** Handscroll, 17th century, in the style of Chou Fang (Chinese, ca. 730–ca. 800)

PAGE 1. Illustration from **A Day in a Child's Life,** 1881, by Kate Greenaway (British, 1846–1901)

FRONTISPIECE. **Ernesta (Child with Nurse).** The theme of a child's first steps was a popular, sentimental one at the turn of the century, but Cecilia Beaux (American, 1855–1942), a contemporary of John Singer Sargent, has transmuted this portrait of her two-year-old niece Ernesta Drinker into a wonderfully perceptive image of childhood. By cropping the figure of the nurse and creating empty space around Ernesta, Beaux suggests the vast adult world from the child's point of view as she ventures forth into it, holding tightly to her nurse's hand for support. This innovative, bold composition was widely admired when the painting was first exhibited; the contemporary sculptor Lorado Taft felt that the painting was wonderful, explaining that the "nurse had...lost her head, as young and pretty nurses often do...."

OPPOSITE. **Woman with a *Hydria* Leading Little Boy.** This 5th-century Greek *pelike* shows a woman carrying a *hydria*, or water jar, and leading a little boy, perhaps to the village fountain to fill the container and swap some gossip with her friends. This Greek genre scene captures perfectly the relationship between the woman and her young charge, who like all toddlers tends to drag his feet when his mother is hurrying to accomplish her household chores.

OVERLEAF. **The Fly.** This page from *Songs of Innocence and of Experience,* by William Blake (British, 1757–1827), is one of his most poignant views of childhood, accompanying as it does a poem about the ephemeral nature of life. This was his most popular illustrated book, combining the joyful *Songs of Innocence,* written at the time of the French Revolution, which he strongly supported, and his more somber *Songs of Experience,* written in 1794, when Britain and France were at war. While the first set of verses are happy lyrics, celebrating the unfettered pleasures of childhood, the later poems, including "The Fly," reveal the disappointment and sorrow of a mature man.

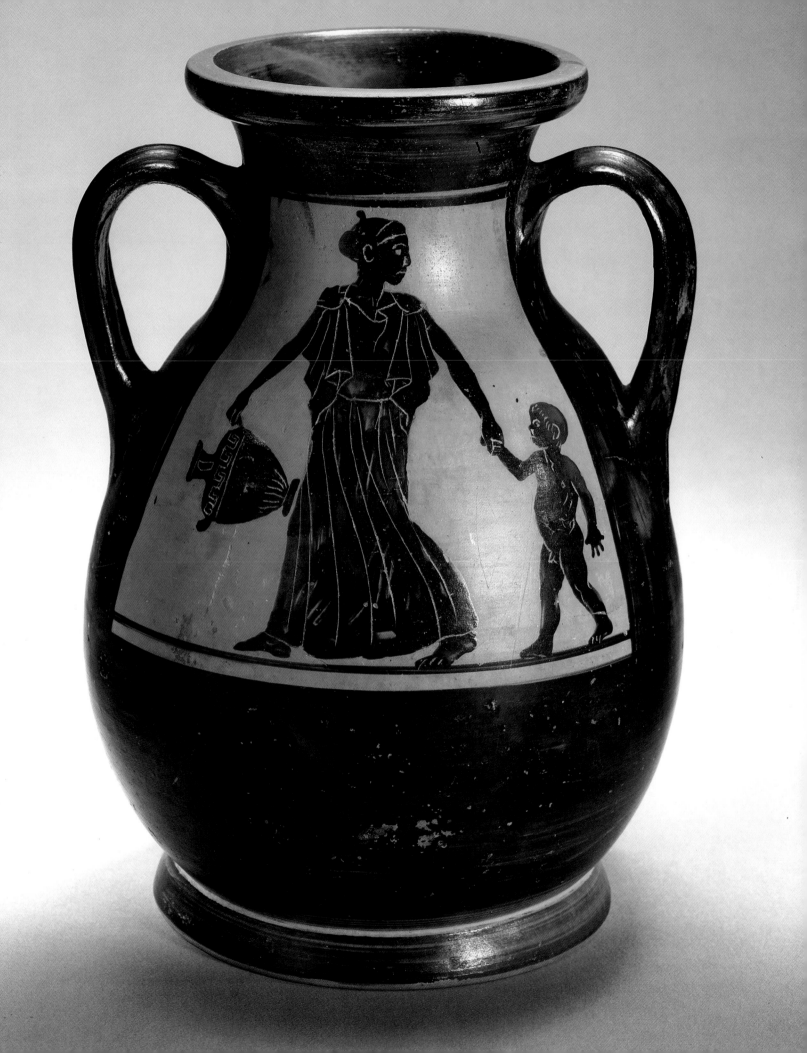

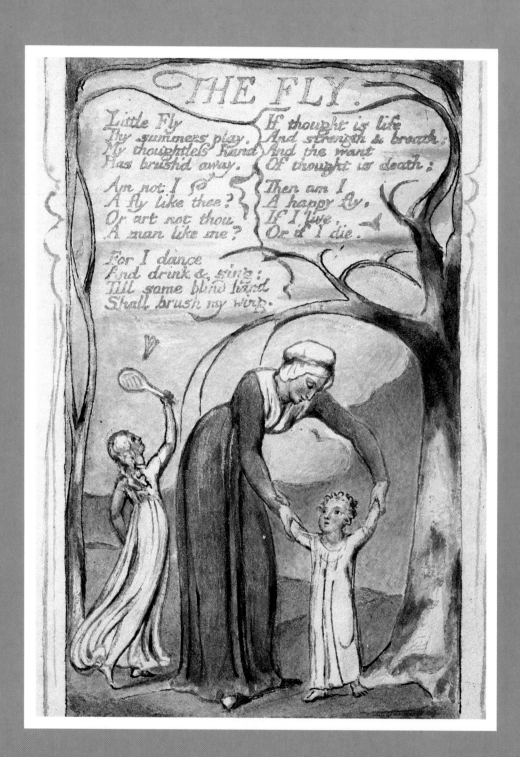

Introduction

Some of us remember our childhood with pleasure as a time of innocence and joy, while others recall only the difficult moments, the fears and frustrations. Some of us believe, as Victor Hugo did, that "the sublimest song to be heard on earth is the lisping of the human soul on the lips of children," while others would prefer that children be seen and not heard. All of us would agree, however, that childhood is a complex period and that children can be as willful and annoying as they are vulnerable and appealing. Or, as Mark Twain put it, "Babies are an inestimable blessing and a bother."

Visual artists, too, have taken varying attitudes toward children and childhood, and in this book of images from the collection of The Metropolitan Museum of Art, we can see how varied those views have been throughout the world and throughout history. Some artists, of course, produced no works in which children appear; Vermeer, the father of eleven, never painted a child, so far as we know. Others, including Mary Cassatt and Winslow Homer, had no children but depicted many. During the Middle Ages and the early Renaissance in Europe, "real" children appear very seldom, which has led some social historians to speculate that children were not given the same affectionate treatment by society that they receive today. But there are few children in works of 20th-century art, and one hopes that historians centuries from now will not draw the same conclusion about us. In fact, very few "real" people of any age appear in medieval and early Renaissance art, and babies surely served as models for the thousands of images of the Christ Child and the winged cherubim produced during that time. It would be unwise to assume that medieval mothers loved their children any less than the Victorian Englishwomen who were so frequently pictured with their offspring.

Because we have chosen to represent in this book only "real" children, we will see few examples from some periods and many from others; nevertheless, we can still make some interesting observations as we look at the paintings, sculptures, drawings, prints, and ceramics reproduced here. We will feel the strong bond between mother and child in ancient Egypt, classical Greece, 18th-century Japan, and 19th-century France. We can sympathize with very young children facing the adult world before reaching adolescence, dressed like their parents, performing difficult chores, gazing at the viewer with the melancholy wisdom of the no-longer-innocent.

Children at play have attracted the attention of many artists, and in their works, we find the universal pleasures of childhood—toys, games, pet animals, and mischievous behavior—from areas as culturally different as 12th-century China, 17th-century Persia, and 19th-century America. Some artists celebrate these childish joys for what they are; others draw allegorical or symbolic meaning from them, finding the transience of human life in the act of blowing soap bubbles or the imprisonment of the soul in a caged pet bird. A number of artists depicted children because their patrons demanded it in portraits or genre scenes; some even chose to represent their own children, whether out of affection or for the simple reason that they were handy models.

Yet for all the universal themes and truths, we can also see great variations in the children themselves: royal princes and princesses in their finery, prosperous middle-class children surrounded with their favorite possessions and their close-knit families, working-class youngsters presented both realistically and romantically. Some of the babies here are beautiful, but a few are not; obedient, attentive children abound but so do the brats. In short, this book is as full of life as the average kindergarten, and in the works of the artists represented here, we can see ourselves and our own children as clearly as in our private snapshot albums. To borrow yet another truism from Mark Twain: "We haven't all had the good fortune to be ladies, we haven't all been generals, or poets, or statesmen, but when the toast comes down to the babies, we all stand on common ground."

In putting this book together, I am grateful to a number of people: John O'Neill, for giving me the project; Joan Holt, Kathleen Howard, and Phyllis Freeman, for their helpful suggestions; Al Grossman, who gave birth to the idea; Stephen Sechrist, for chasing more children around the Museum than anyone in the Education Department ever has; and my son, Philip, for his inspiration. My gratitude toward members of the Museum's curatorial staff, past and present, is immeasurable; without their research, helpful advice, and cooperation all along the way, this book would never have made it into long pants.

Barbara Burn

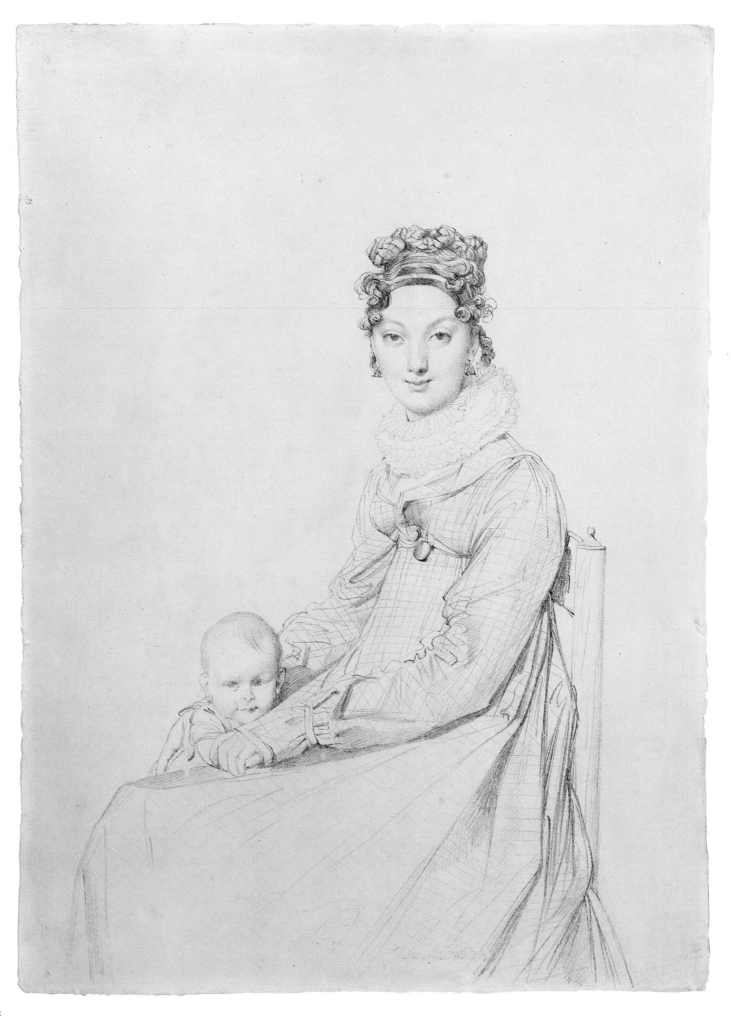

8

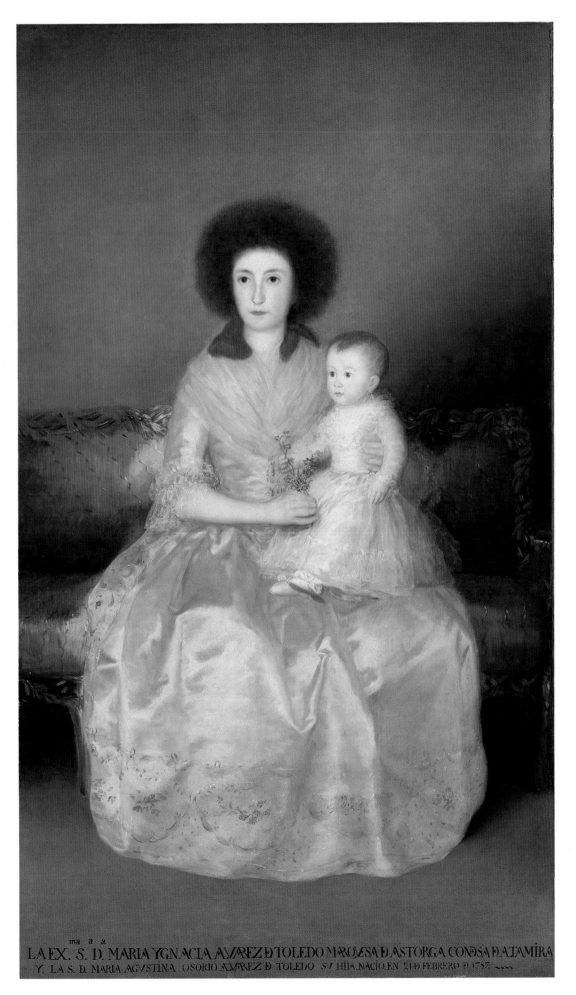

LA EX. S. D. MARIA YGNACIA AIVAREZ Ð TOLEDO MARQ/ESA Ð ASTORGA CONÐSA Ð ALTAMIRA
Y LA S. D. MARIA AGVSTINA OSORIO AIVAREZ Ð TOLEDO SV HIIA NACIO EN 21 Ð FEBRERO Ð 1787.

Madame Lethière and Her Daughter, Letizia. Jean-Auguste-Dominique Ingres (French, 1780–1867) was the dominant Neoclassical artist of the 19th century, and he made many portrait drawings of friends and officials in Italy, where he spent most of his life. One of his teachers, Guillaume Guillon Lethière, was the director of the French Academy in Rome, and Ingres portrayed several members of his family, including his daughter-in-law, Madame Alexandre Lethière, and her one-year-old daughter in this elegant drawing. As in his paintings, Ingres posed his subjects here with great care and formality, demonstrating extreme precision and purity of line. Nevertheless, the artist has treated the mother and child with warmth, sympathy, and softness, emphasizing the affectionate bond between them.

The Countess of Altamira and Her Daughter. This painting by Francisco Goya (Spanish, 1746–1828) is one of four portraits of the family of the thirteenth count of Altamira (Don Manuel, the second son, appears on page 67). The daughter appears to be about a year old, and since we know that she was born in February of 1787, the painting can be dated to 1788, the year before Goya was appointed painter to the King of Spain. The pose of mother and child is clearly inspired by images of the Madonna created by Goya's predecessors, although one can also see the influence of the contemporary British portraitists Joshua Reynolds and Thomas Gainsborough, whose work Goya admired. Goya's masterful brushwork, use of color, and intensity of expression, however, make this a unique masterpiece of characterization, revealing the strong, quiet personality of a woman whose husband was a powerful member of the Spanish aristocracy.

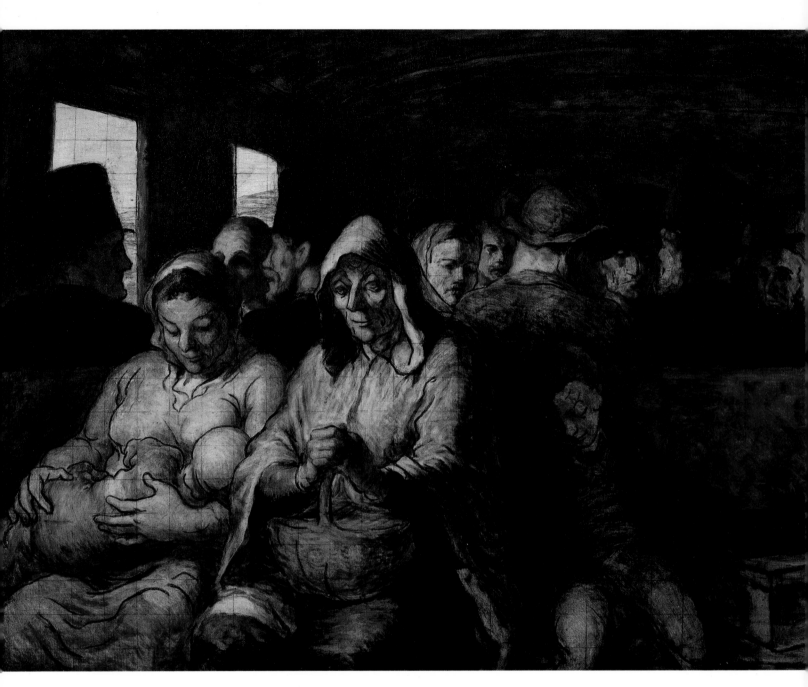

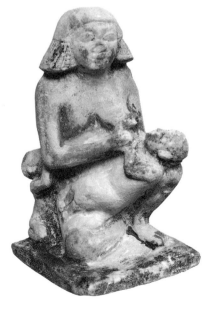

The Third-Class Carriage. Honoré Daumier (French, 1808–79), the great political satirist, brought a social conscience to his paintings, especially his studies of people in public conveyances, in which he recorded the great changes brought on by industrialization. This version of the theme, painted in the early 1860s, shows a far different world from that celebrated by Ingres and Goya, yet his poor old woman—flanked by a nursing mother and a sleeping boy, each lost in his or her own world—is treated with great sympathy. Psychologically isolated even in this crowded railway carriage, the group is visually unified and takes on a universal quality, as if representing the three ages of man.

Woman and Two Children. This small limestone statuette dates from the 6th Dynasty of the Old Kingdom in Egypt, making these children the oldest in the book. Nevertheless, the pleasures and problems of motherhood were the same then as they are now; the young mother seems to be doing her best to keep both infants amused and occupied.

Mother and Child. Camille Corot (French, 1796–1875) was a contemporary of Daumier, yet many of his paintings recall traditional themes and compositions. Corot treated the subject of a nursing mother several times during the last two decades of his life, but unlike Daumier, he made no social comment and no effort to present a slice of everyday life. His mother and child resemble images of the Madonna and Christ Child that appear in the works of the Old Masters whom he admired—Leonardo, Raphael, Rembrandt, and the Venetians.

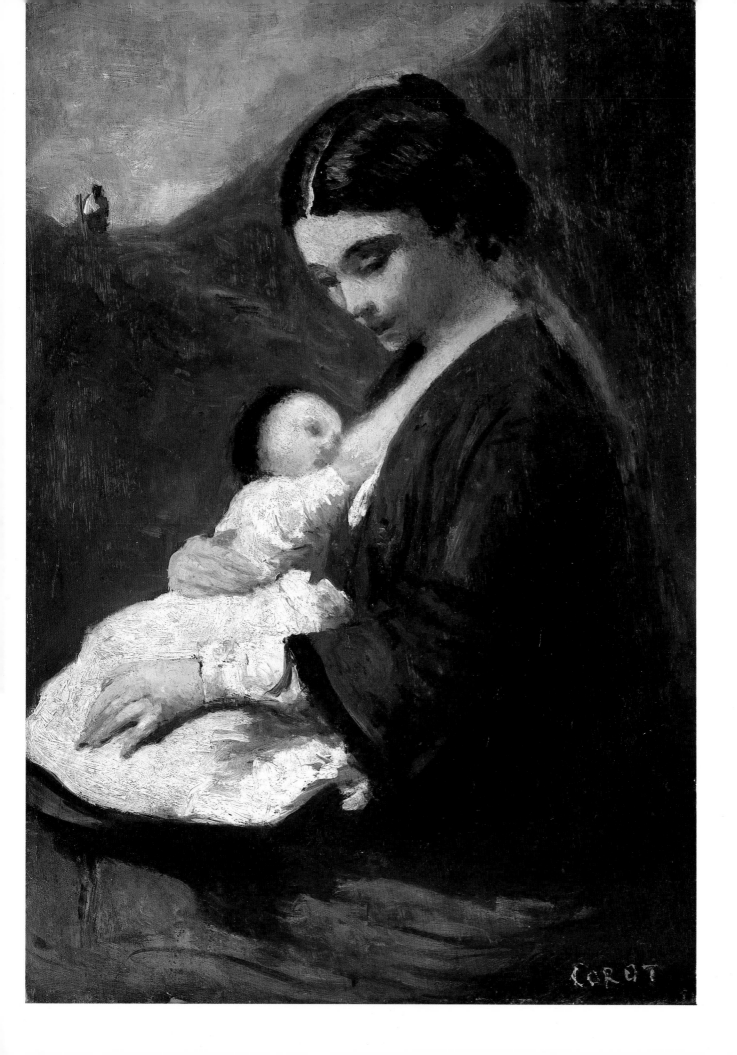

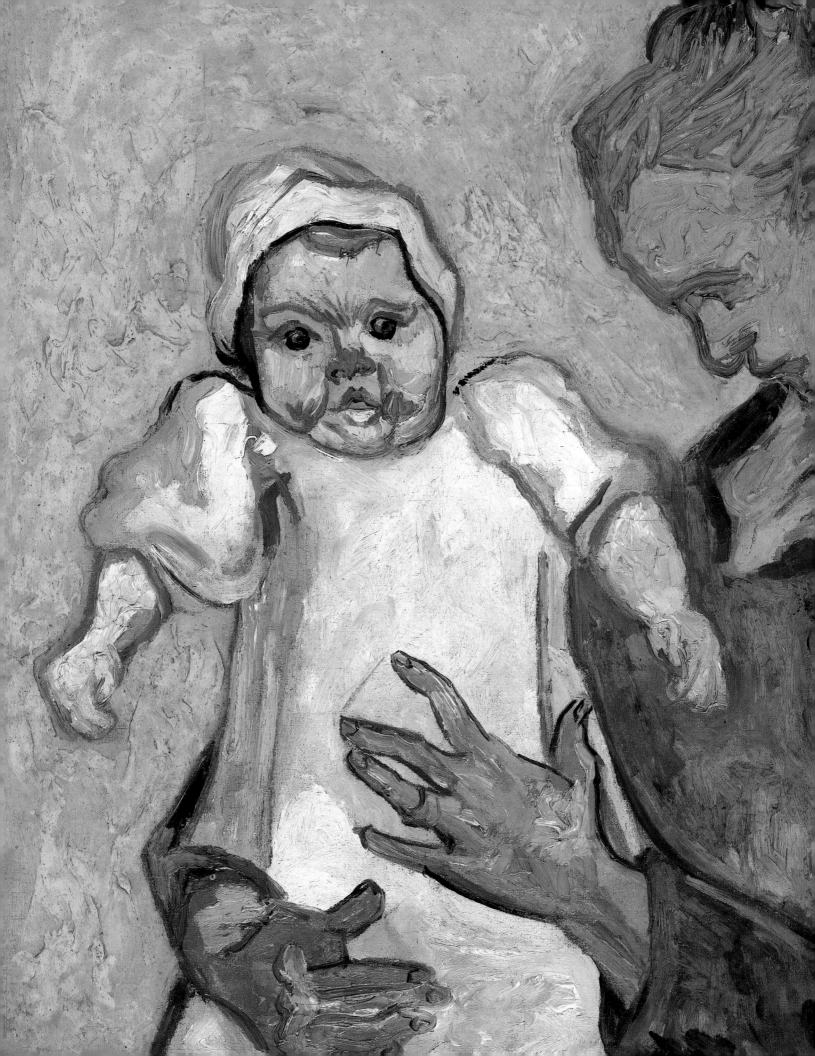

Madame Roulin and Her Baby. Vincent van Gogh (Dutch, 1853–90) painted members of the Roulin family of Arles several times during the fall of 1888, a very troubled time for the artist. His intensity can be seen in the modeling of the mother's hand and in the baby's expression, although it is also likely that Vincent rather frightened both models, since the baby, Marcelle, was only three months old when the portrait was painted. Madame Roulin was the subject of van Gogh's famous painting *La Berceuse* (Woman Rocking the Cradle) and her husband, a postal clerk, also sat frequently for him.

Mother and Child. As recently as 1925 it was discovered that Eskimos in the Cape Dorset region of Canada had made small carvings in ivory, wood, and bone from about the 7th century B.C. to the 12th century A.D. With the encouragement of the Canadian government, Cape Dorset is once again the center of considerable artistic activity, where sculptors, such as Oshaweektuk-A, who made this small stone carving in 1956, are creating impressive depictions of everyday life. The work is contemporary in form although the infant appears to be wrapped in swaddling clothes, a practice that was virtually abandoned in the early 19th century throughout the Western world.

Woman Holding Child. This tiny figurine is one of a group of limestone pieces from the 12th Dynasty of the Egyptian Middle Kingdom. Scholars have called them dolls, but it is unlikely that they were playthings for children. The woman holds the swaddled baby against her left side in a fashion that seems nearly universal; this position frees the mother to use her right hand to perform her household chores without putting her baby down.

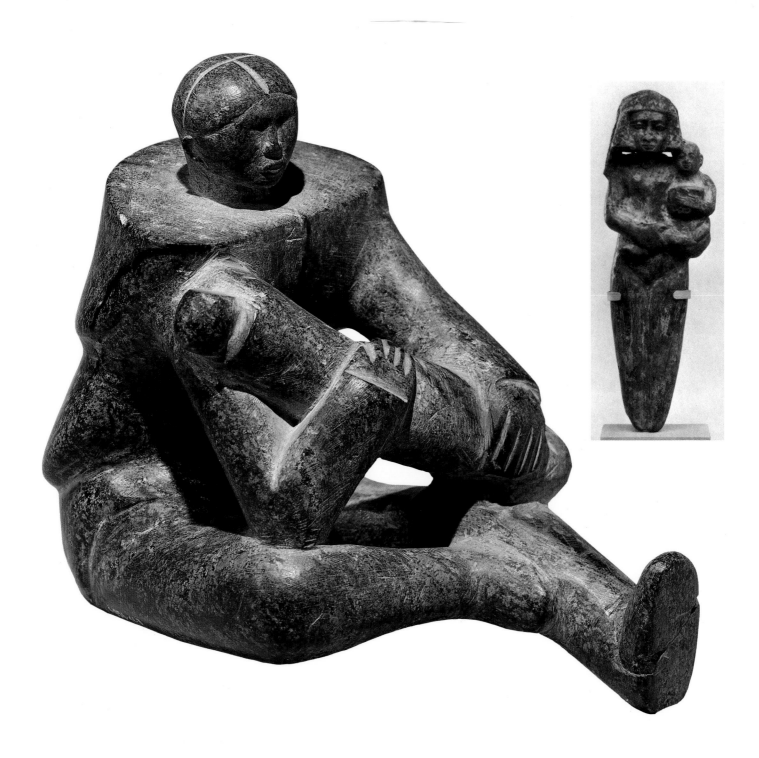

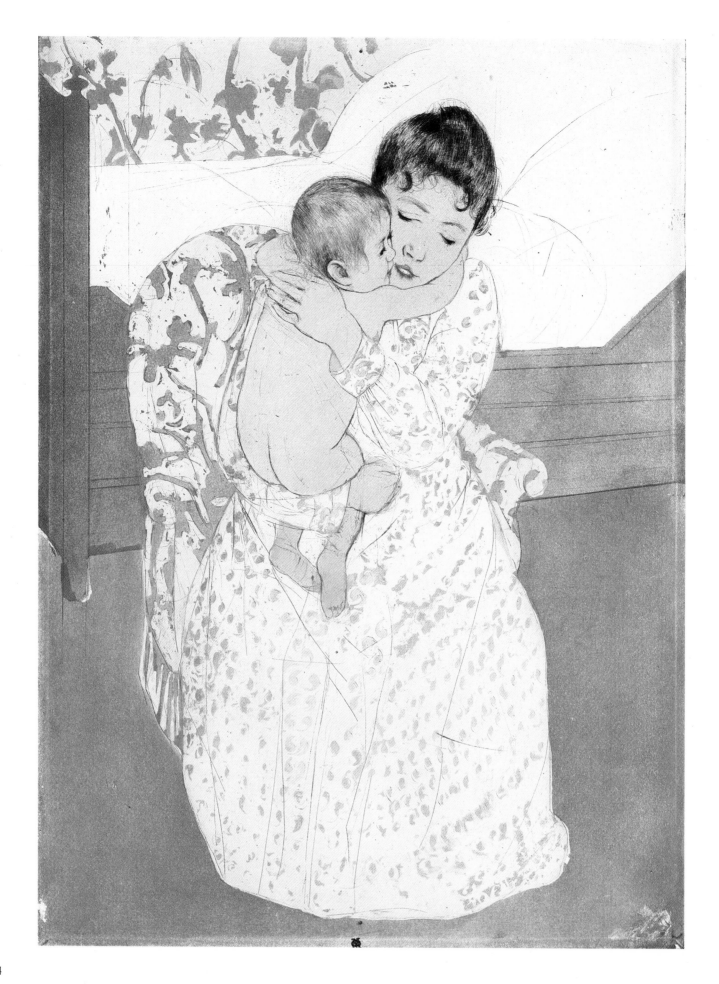

14

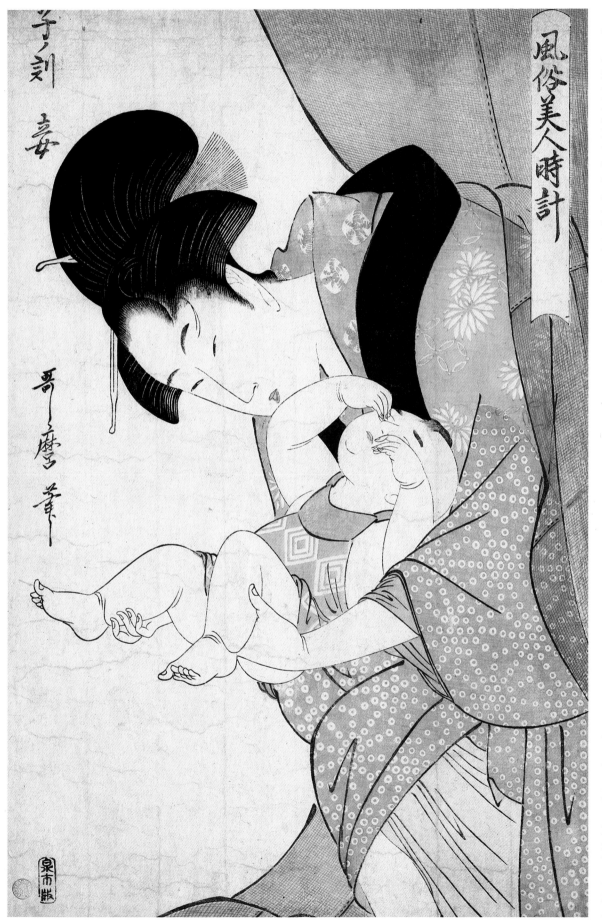

Maternal Caress. Mary Cassatt (American, 1845–1926) was born in Pennsylvania but went to Europe in 1866 and remained there, studying the Old Masters, joining the circle of Impressionists through her close friend and mentor Edgar Degas, and eventually becoming one of the most highly regarded of American artists. Her graphic work was especially fine, and she found inspiration in the work of Japanese printmakers, as did many of her contemporaries. Cassatt concentrated on domestic scenes and was especially drawn to the work of Utamaro, who also captured successfully the intimacy of the relationship between mother and child. Japanese influence can be seen in this colored drypoint etching and aquatint, one of a series of ten made in 1891; the entwining forms of the two figures, the patterns of the fabrics, and the flat background can be found in both works illustrated on these pages.

Midnight, the Hour of the Rat: Mother and Sleepy Child. This woodblock print by Kitagawa Utamaro (Japanese, 1753–1806) was one of a series of twelve depicting the customs of women in the twelve hours of the day. (The Japanese day was divided into two-hour segments; the hour of the rat was between 11:00 P.M. and 1:00 A.M.) The scene illustrated here is that of a concubine who leans out of her mosquito netting to help her sleepy child relieve himself. While the artist's viewpoint is certainly down-to-earth, the image is very affecting in its warmth and charm.

15

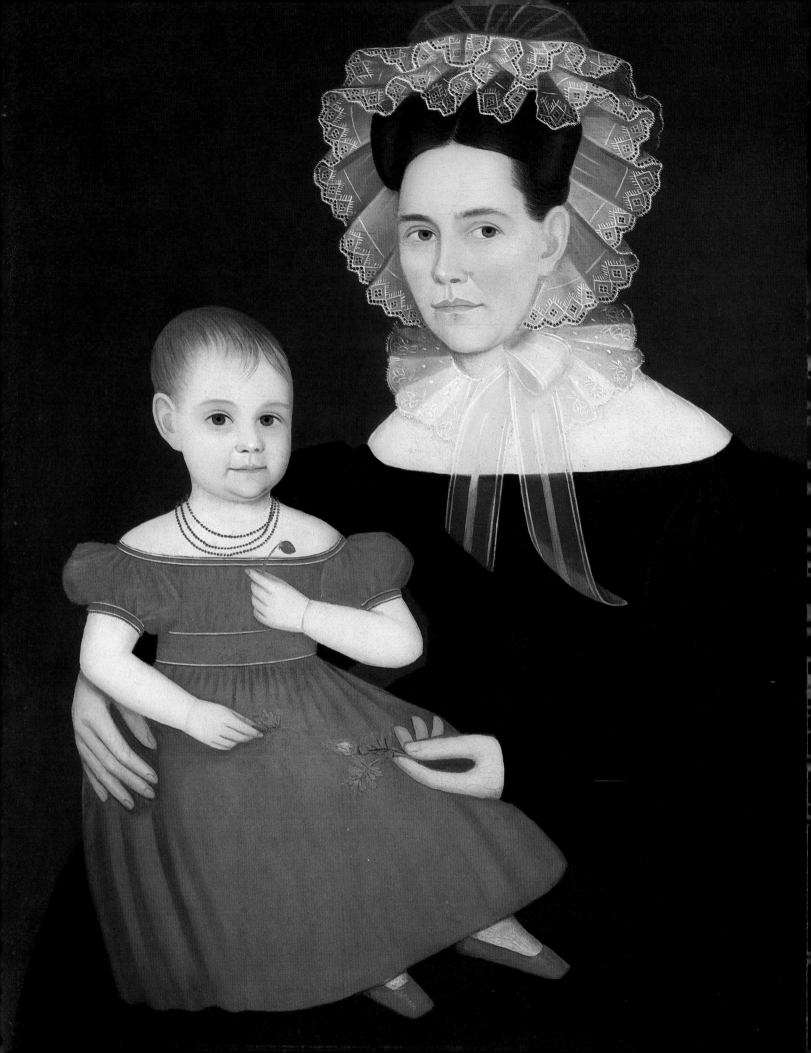

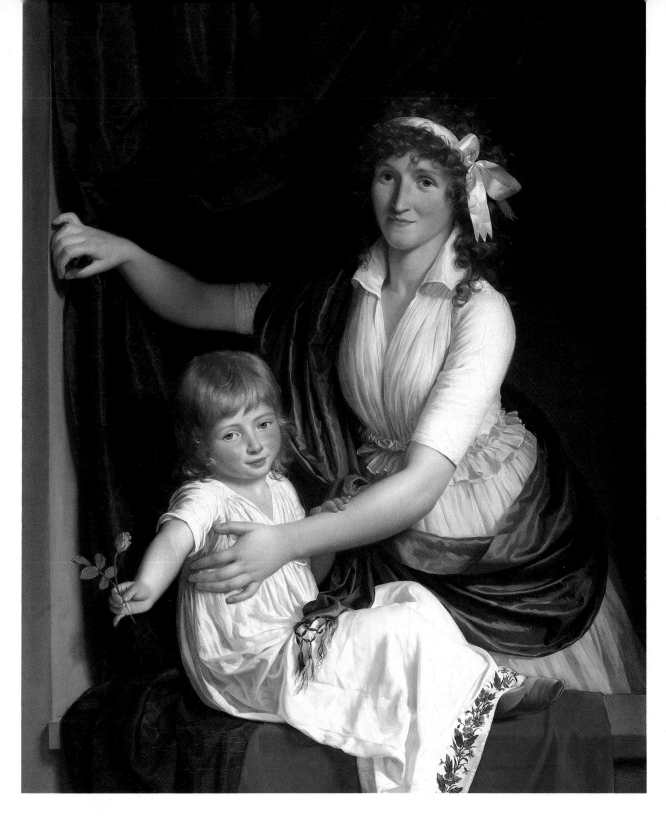

Mrs. Mayer and Daughter. Ammi Phillips (American, 1788–1865) was one of the most prolific and talented folk artists of the 19th century. He was a self-taught painter and tended to gloss over anatomical details, but his images were strong, for he concentrated on his subjects' faces and their costumes, setting them off against flat, plain backgrounds. He himself had four children by his second wife, whom he married about 1830, and he obviously appreciated the mother-child relationship, as seen in this portrait painted during the 1830s. Phillips was unquestionably aware of European portraiture, yet the traditional device of placing a flower in the child's hand may have been this mother's way of keeping her occupied during the sitting.

Portrait of a Woman and Child. We do not know the name of the pair depicted in this lively portrait by François-André Vincent (French, 1746–1816), but we can see that the artist, a highly regarded contemporary of Jacques-Louis David, took special care to show their affectionate rapport. The pose is unusual, but the style is Neoclassical, typical of the period following the French Revolution. It was at this time that mothers were encouraged to develop close ties with their children rather than turn them over to servants. One curious aspect of this new regard for children involved the fashion of dressing ladies in exceptionally youthful clothing, a rather silly reversal of the age-old custom of dressing children like adults.

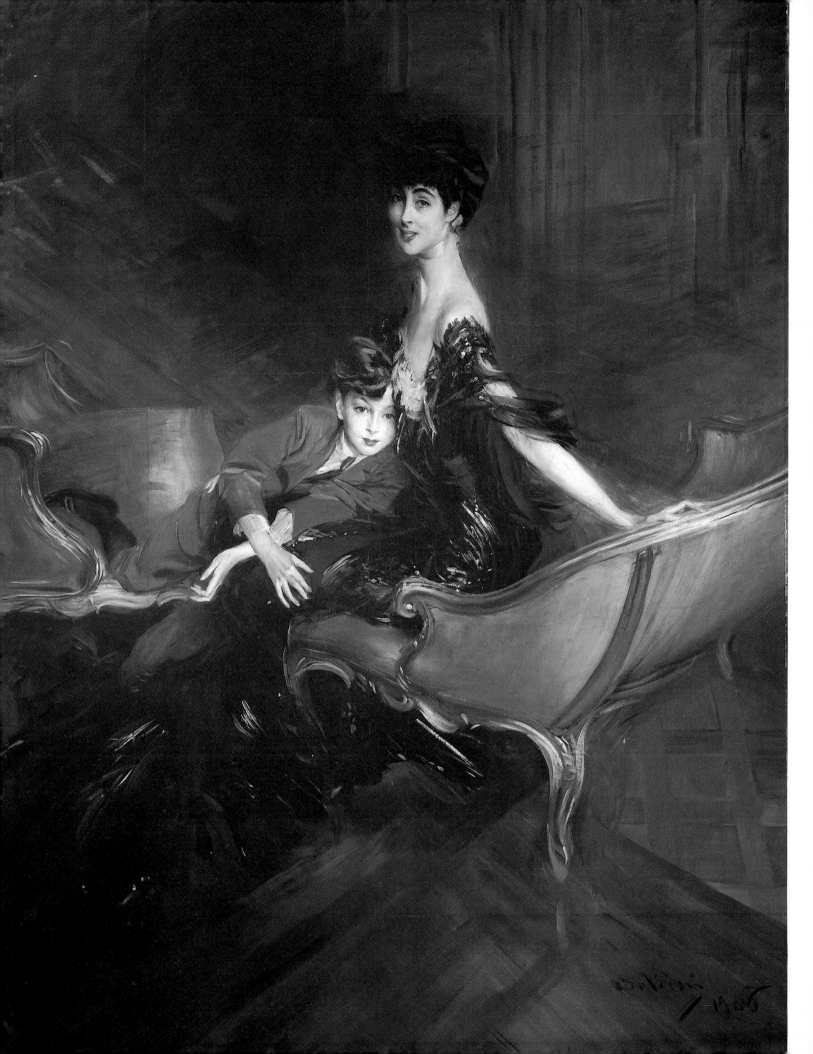

Consuelo, Duchess of Marlborough, and Her Son, Lord Ivor Spencer-Churchill. This is one of the most brilliant portraits painted by Giovanni Boldini (Italian, 1845–1931), whose subjects included the fashionable world of society at the turn of the century. The beautiful daughter of William K. Vanderbilt, Consuelo married the ninth duke of Marlborough at the age of nineteen and their son, Ivor Spencer-Churchill, was born in 1898. Boldini expressed the wish to paint her and, as she recounts in her autobiography, *The Glitter and the Gold*, "such a compliment could not be easily refused, and I agreed to sit for him provided his behaviour remained exemplary, for he had a salacious reputation with women.... As the portrait was a good likeness we decided to acquire it and to have the canvas enlarged to include my younger son so that it might hang in a space allotted for it in the dining room at Sunderland House."

Woman Holding a Child. Although this fragment is all that remains of a 5th-century-B.C. Greek bell krater, the painted image of the woman and child is a lovely expression of the emotional bond between them. We do not know whether the woman is the child's mother or nurse, for nurses were common in classical Greece, often remaining as beloved members of the household long after their charges were grown. The artist has taken special care in rendering the woman's finely pleated garment and her necklace; the child is wearing amulets across the chest, much like those worn by the Greek boy illustrated on page 60.

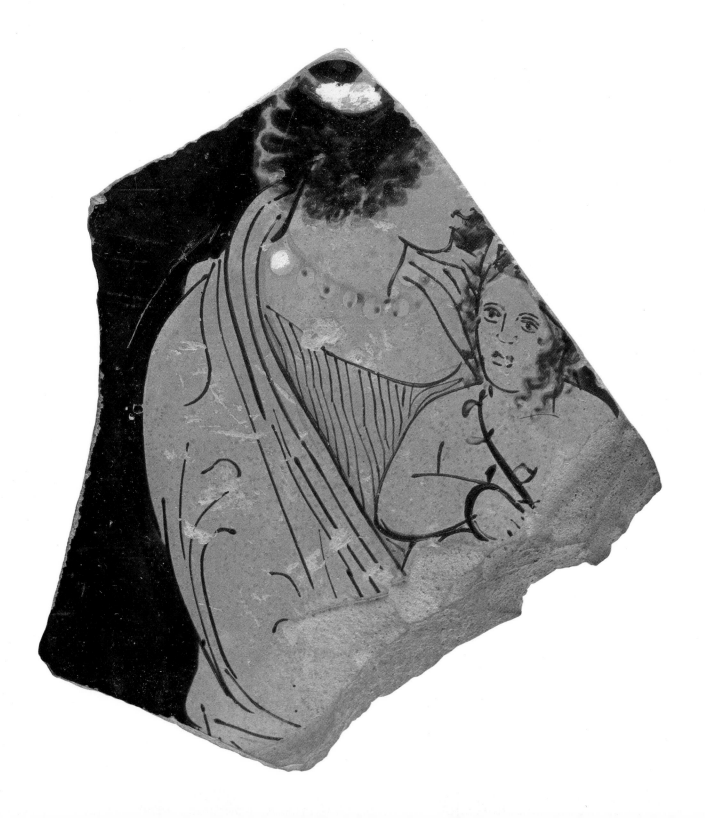

First Steps. In November of 1889, Theo van Gogh sent his brother Vincent (Dutch, 1853–90), at the asylum at St. Rémy, a package containing canvases, paints, and several reproductions of works by Vincent's favorite painter, J.-F. Millet. Among them was a picture that caused Vincent to exclaim in a letter to Theo: "How beautiful that Millet is, 'A Child's First Steps!'" He made a copy of the painting in January of 1890, shortly before Theo's wife gave birth to a baby boy whom his parents called Vincent. Clearly, the impending arrival of a nephew had a powerful effect on Vincent, who had written earlier to Theo: "I think the emotion which must move the future father of a family, the emotion which our good father so liked to talk about, must be with you, as with him, strong and fine.... After all, it is something to get back one's interest in life, as when I think that I am about to become uncle to this boy your wife plans for; I find it very droll that she feels so sure it is a boy."

21

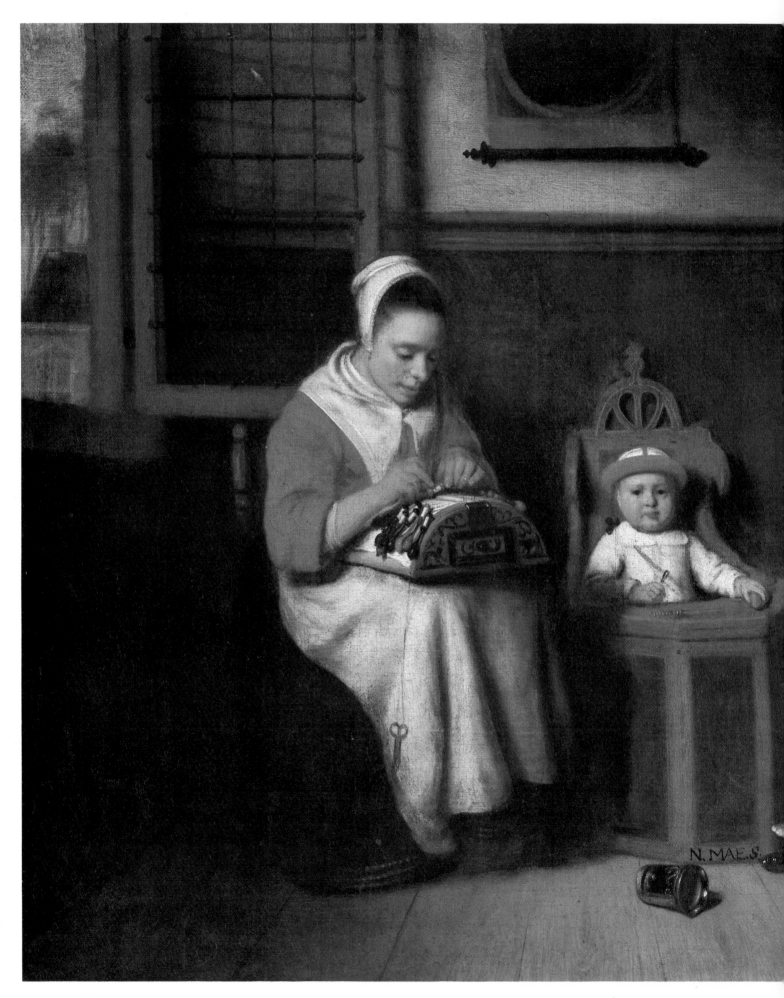

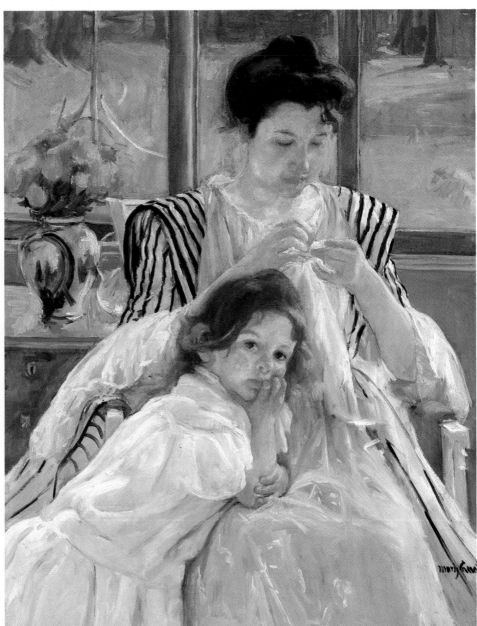

Young Mother Sewing. The young woman in this colorful painting by Mary Cassatt (American, 1845–1926) is contentedly sewing, seemingly oblivious to the activity of the artist, whom her daughter contemplates with that straightforward gaze so characteristic of young children. She leans on her mother almost possessively, as if to keep the intrusive artist from interrupting their peaceful domain. The mother here is Reine Lefebvre, who often posed for Cassatt in the early 1900s, when this painting was made, as did the girl, Margot Lux, who can also be seen in the Cassatt painting on page 28. The picture is carefully composed, yet the pair appears relaxed and natural; the immediate nature of the painting as well as the vivid use of color show Cassatt's close ties to the Impressionists.

The Lacemaker. Nicolaes Maes (Dutch, 1634–93) was one of Rembrandt's most gifted pupils, and his genre scenes showing domestic life in 17th-century Holland were very popular during his lifetime. This painting is typical of Maes's work from this period—solid and sincere enough to avoid sentimentality yet extremely appealing in subject matter. The child, who could be either a boy or a girl, since both sexes were dressed alike until the age of five or six, is confined to a contemporary equivalent of a high chair, obviously the only way the mother could concentrate on her fine lacemaking. The youngster, however, is definitely not satisfied with this arrangement; the overturned objects in front of the chair indicate that he or she has flung them to the floor in frustration, as any self-respecting toddler would do under the circumstances.

The Coiffure. Beginning in 1905, Pablo Picasso (Spanish, 1881–1973) frequently used as his models the saltimbanques, or itinerant circus people, whose world appeared in nearly every aspect of his work, including drawings, engravings, paintings, and sculpture. In painting, his palette shifted from blue to rose, though the works were not entirely happy; Apollinaire found them ambiguous, saying that "the charm and indisputable talent…appear at the service of an imagination that successfully unites the delightful with the horrible, the base with the delicate." This painting of a mother having her hair dressed while her son plays at her feet was made in 1906, toward the end of the Rose period, when Picasso developed a more classical, sculptural approach to depicting figures. The ambiguity of his circus pictures is still present, however, for the three figures seem unrelated to each other, formally united by the composition but psychologically isolated.

Yamauba Combing Her Hair and Kintoki. This hairdressing scene is one of a series of woodblock prints designed by Kitagawa Utamaro (Japanese, 1753–1806) about 1801, illustrating episodes in the childhood of Kintoki, or Kintaro, a legendary character who became known for his exceptional strength. Utamaro depicted many scenes of children with their mothers, who in Japan have always doted on their offspring, even to the point of spoiling them. In Kintoki, the artist clearly found a vehicle to characterize a toddler in that well-known stage the "terrible twos." Here Kintoki amuses himself by attempting to distract his mother from her toilette, but still the bond between them is very close, unlike the relationship described by Picasso, whose sensitivity to the uprootedness of family life among wandering circus players is clearly reflected in his study of a similar scene.

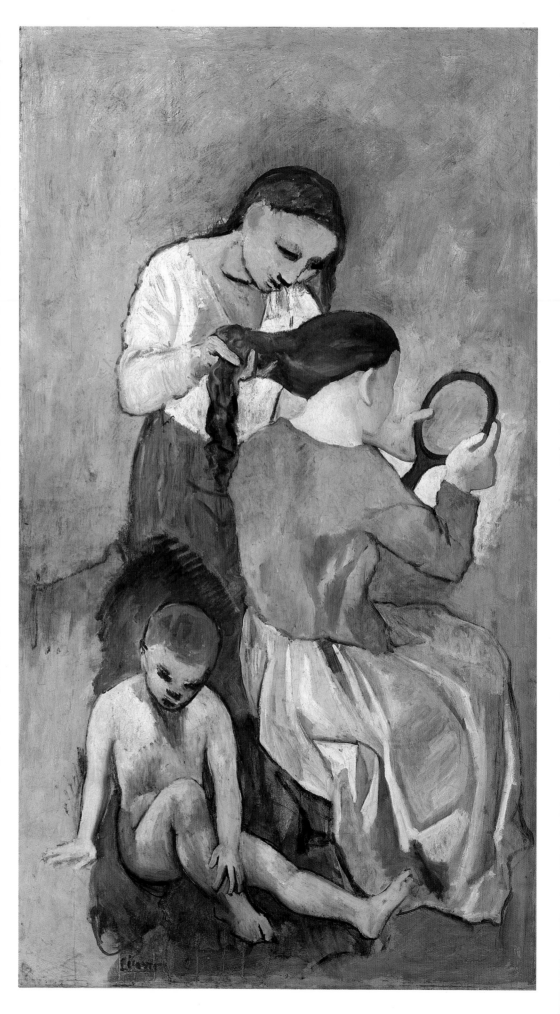

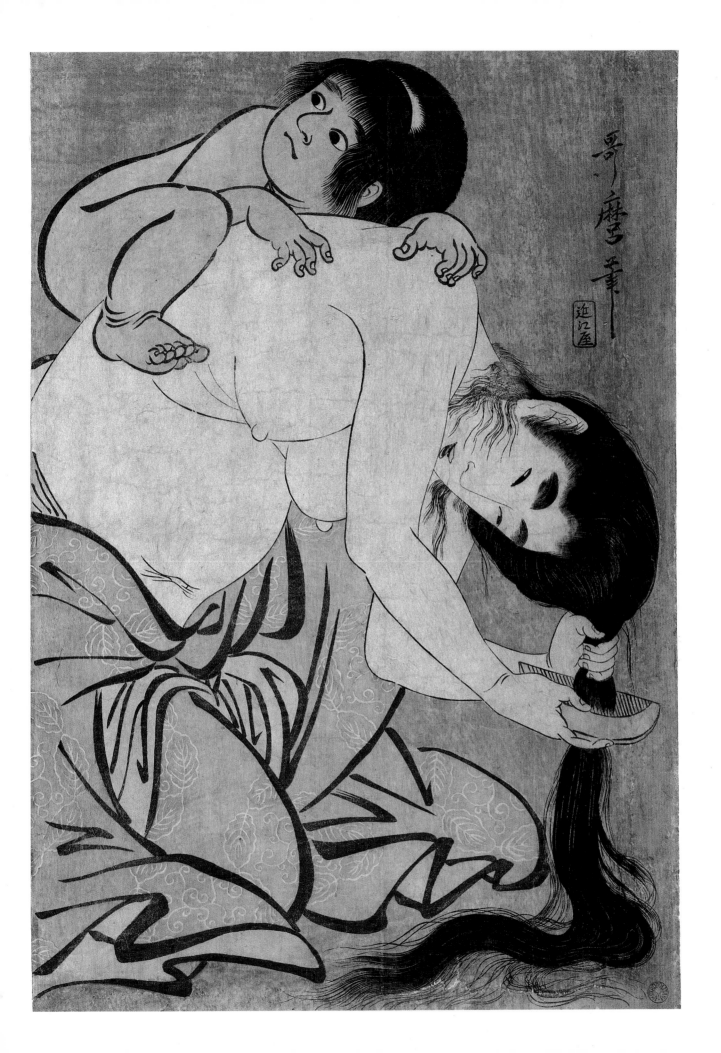

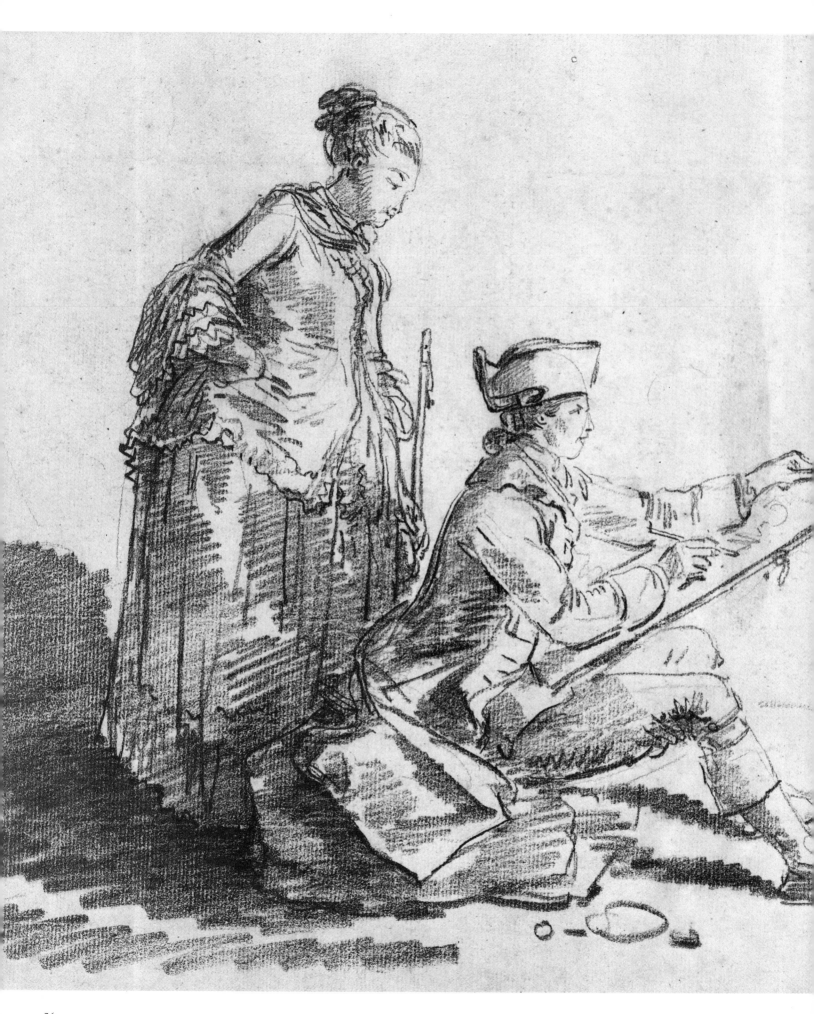

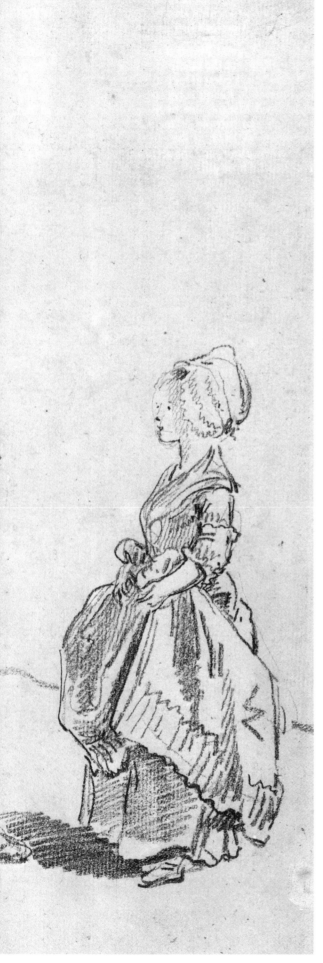

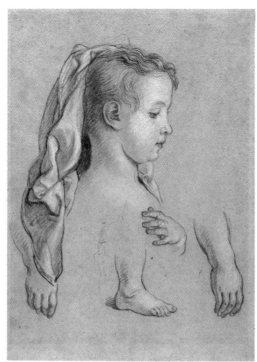

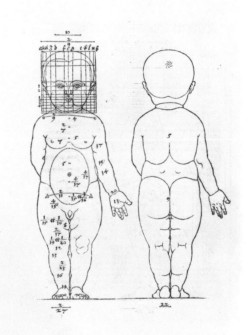

The Artist Sketching a Young Girl. Hubert Robert (French, 1733–1808) was a landscape painter and architect best known for his picturesque scenes of architectural ruins. He did, however, make a number of genre paintings, including one, now lost, on the subject of an artist drawing a young girl. This red-chalk study, made in 1773, may depict Robert's eldest daughter, Gabrielle-Charlotte (born in 1768), standing patiently at attention while a woman, possibly Robert's wife, Anne-Gabrielle Soos, looks over the artist's shoulder, perhaps to reassure the child that all is going well and that she should stand quietly just a few moments longer.

Head of a Young Girl. We do not know the identity of the modest but self-assured young girl in this drawing by Charles de La Fosse (French, 1636–1716), but eventually she would become the Virgin Mary in La Fosse's altarpiece *Presentation of the Virgin in the Temple*, painted in 1682 for the Carmelite order in Toulouse. At the time of the Presentation, the Virgin was only three years old, but this young model looks somewhat older, perhaps five or six.

The Proportions of an Infant. Over some thirty years, Albrecht Dürer (German, 1471–1528) measured hundreds of men, women, and children and tabulated the averages to arrive at ideal proportions. Unlike Leonardo, Dürer had little interest in the structure or function of human anatomy, and clearly he used no living model, for who has ever seen a toddler stand so straight?

Portrait of a Child. The name of the little girl in the portrait below right is unknown, but it is a delightful work by the Dutch architect Paulus Moreelse (1571–1638). Moreelse did a number of traditional portraits, and his dexterity shows in the fine details of the child's costume and the sweet expression on her face.

Spring: Margot Standing in a Garden. Although painted at about the same time as *Young Mother Sewing* (on page 23), the portrait of young Margot Lux below left shows a much different side of the little girl, who seems almost seductive in her coy pose and flushed complexion. Obviously the artist, Mary Cassatt, was well acquainted with the moods of her subjects. She once said that a "woman's vocation in life

is to bear children," and though she never married, she produced hundreds of them—on canvas—with a rare honesty and discipline that gained her reputation as America's first great woman painter.

Margot Bérard. Pierre-Auguste Renoir (French, 1841–1919) painted many portraits of members of the family of Ambassador Paul Bérard, who often had the artist as a guest at his country house on the coast of Normandy, but apparently Renoir considered this portrait of young Marguerite, nicknamed Margot, one of his best. According to the model's nephew, the seven-year-old girl met Renoir on the stairs of the château in the summer of 1879, as she ran in tears from a difficult lesson with her German tutor, and the artist tried to console her by painting her as a cheerful little girl.

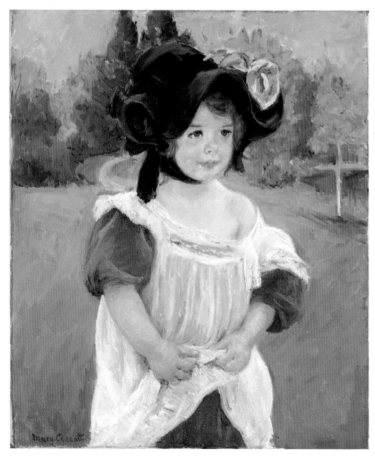

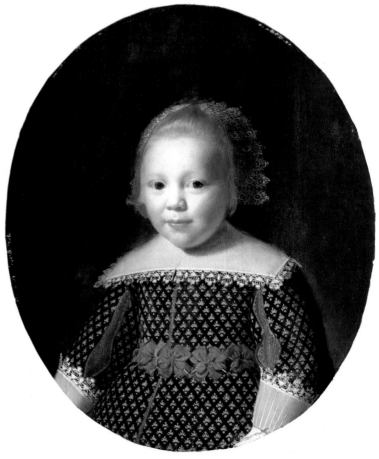

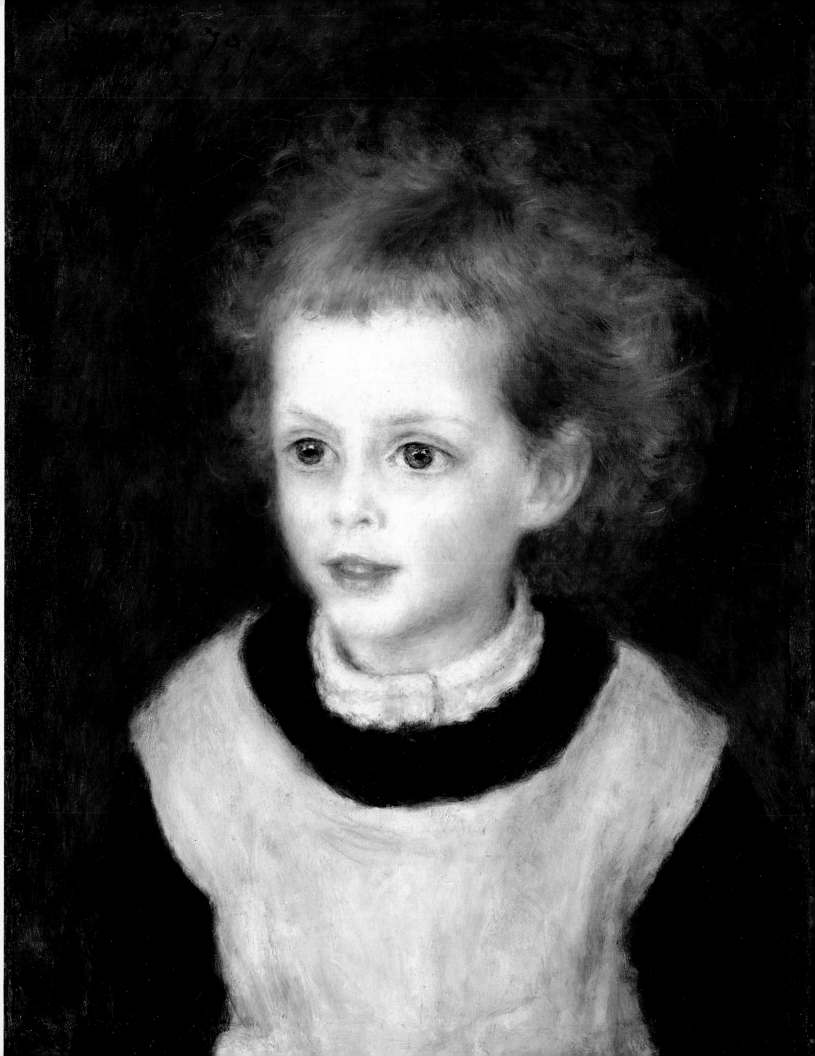

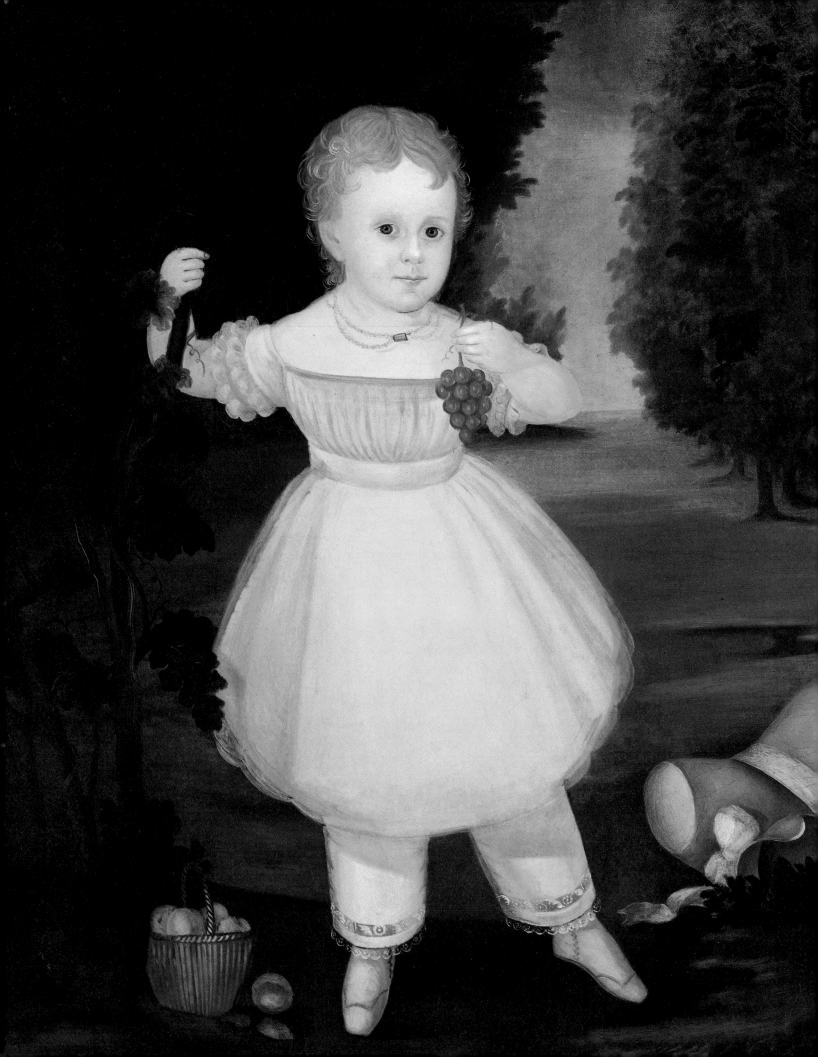

Little Girl Holding Grapes.
Painted in about 1835 by an unknown American artist, this lovely portrait reveals a familiarity with traditional portraiture. Children holding grapes can be seen in ancient Greek works of art, often conveying some symbolic message, and the device of placing a richly dressed child in the foreground surrounded by the objects of her world is an age-old means of displaying her parents' established position in society.

Her World. Philip Evergood (American, 1901–73) was politically active during the Great Depression, and his paintings of the 1930s reflect social concerns, though he rarely preached a specific moral lesson. European Surrealism influenced his work and can be seen here in this affecting dreamlike image of a young black girl painted in the 1940s. This is not a portrait in the technical sense, since it represents no particular girl, but Evergood has attempted a loftier theme—that of social isolation and prejudice—by placing the girl behind a fence and giving her a wistful expression.

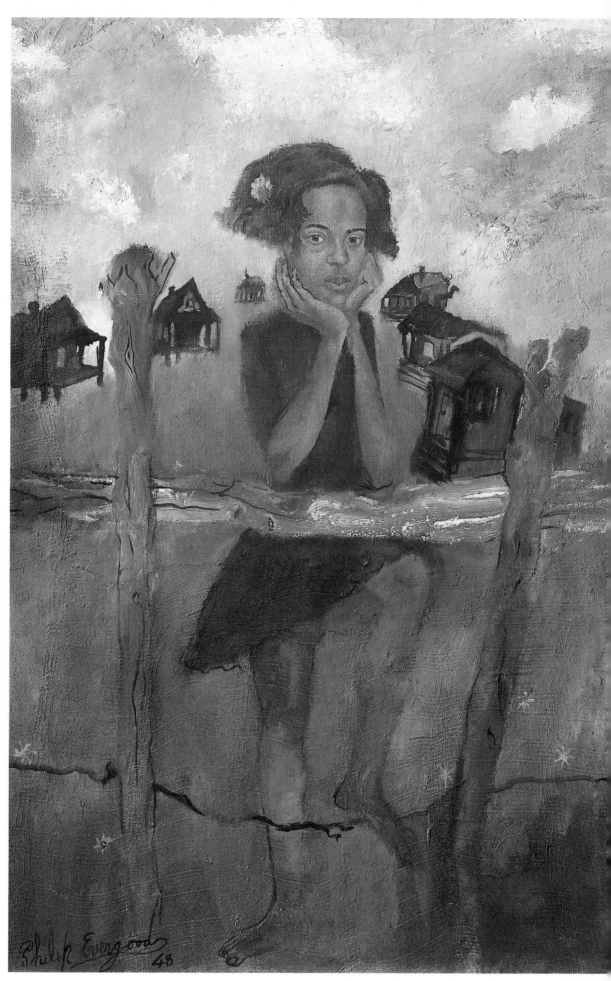

Florence Leyland. James McNeill Whistler (American, 1834–1903) spent much of his life in England. He was one of the principal exponents of Aestheticism, and though more concerned with form and style than with content, he did produce some of the most impressive portraits of his time. This young girl, Florence, was one of the three daughters of the Liverpool shipping magnate Frederick Leyland, Whistler's most generous patron in the 1860s and 1870s. It was Leyland who suggested the word "nocturne" for Whistler's night scenes; and it was for his house in London that Whistler designed and painted the famous Peacock Room, perhaps the most celebrated monument of the Aesthetic movement. This drypoint, one of a series that Whistler produced of the Leyland family, was made in 1873. His delicate line work stresses the shadows and not the contours of this active and vivacious girl.

Marion Lenbach, Daughter of the Artist. Franz von Lenbach (German, 1836–1904) was a society portraitist who often lapsed into a facile, routine technique. But his self-portraits and the portraits of his daughter, whom he painted many times, reveal an intense, Expressionist tendency. According to photographs, Marion was a normal-looking child, but here—at the age of eight—she appears to be much older, a veritable Lolita. Her pose, the disheveled hair covering one eye, and her facial expression seem adolescent, provocative, and even slightly deranged.

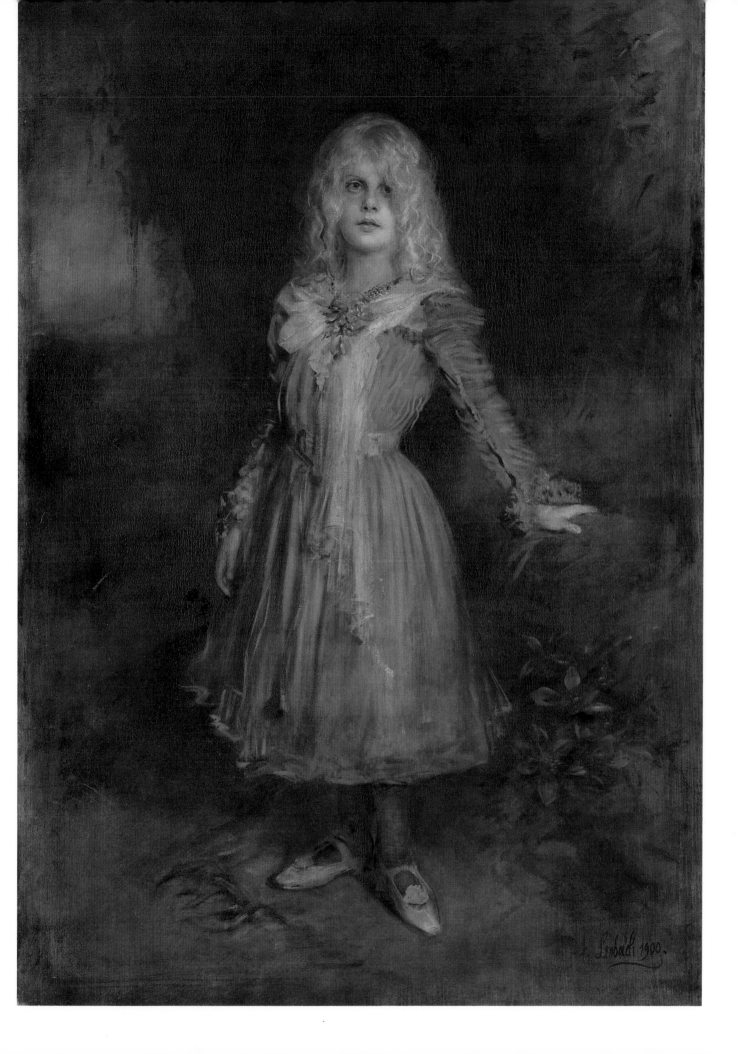

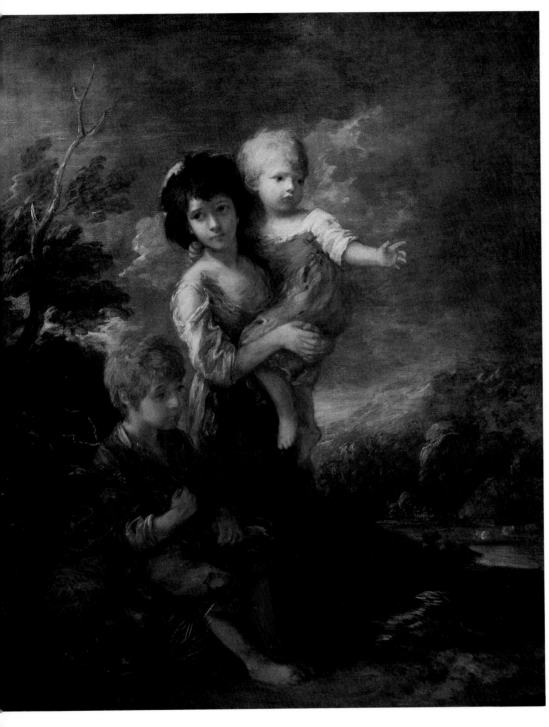

The Wood Gatherers. Thomas Gainsborough (British, 1727–88) is well known for his pastoral scenes and portraits, and toward the end of his life, he specialized in "fancy pictures," in which he placed figures, often children, in rustic landscapes. The romantic, sentimental theme of poor children dressed in ragged clothes to perform their chores indicates Gainsborough's awareness of the injustices suffered by common people, but the mood is poetic and his virtuoso technique is derived from the Rococo style of the period. The painting was made in about 1787 and the boy on the left has been identified as Jack Hill, the son of a woodsman.

The Calmady Children. This enchanting portrait of Emily and Laura Anne, the daughters of Charles Biggs Calmady, is, in the words of the artist, Sir Thomas Lawrence (British, 1769–1830), "my best picture...one of the few I should wish hereafter to be known by." When Lawrence first saw the girls, he thought they were so pretty he offered to paint them for much less than his usual fee. His brilliant style perfectly captures the spontaneous, lively nature of his two appealing subjects.

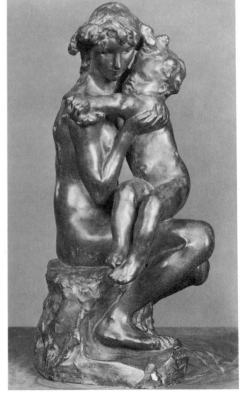

Brother and Sister. Best known for his monumental sculptures, notably *The Gates of Hell* and *The Burghers of Calais*, Auguste Rodin (French, 1840–1917) earned his living early in his career by modeling on a more intimate scale, and he continued to make smaller compositions as late as the 1890s, when this family group was done. This bronze cast, commissioned by the Metropolitan Museum in 1908, was the first Rodin to enter the collection.

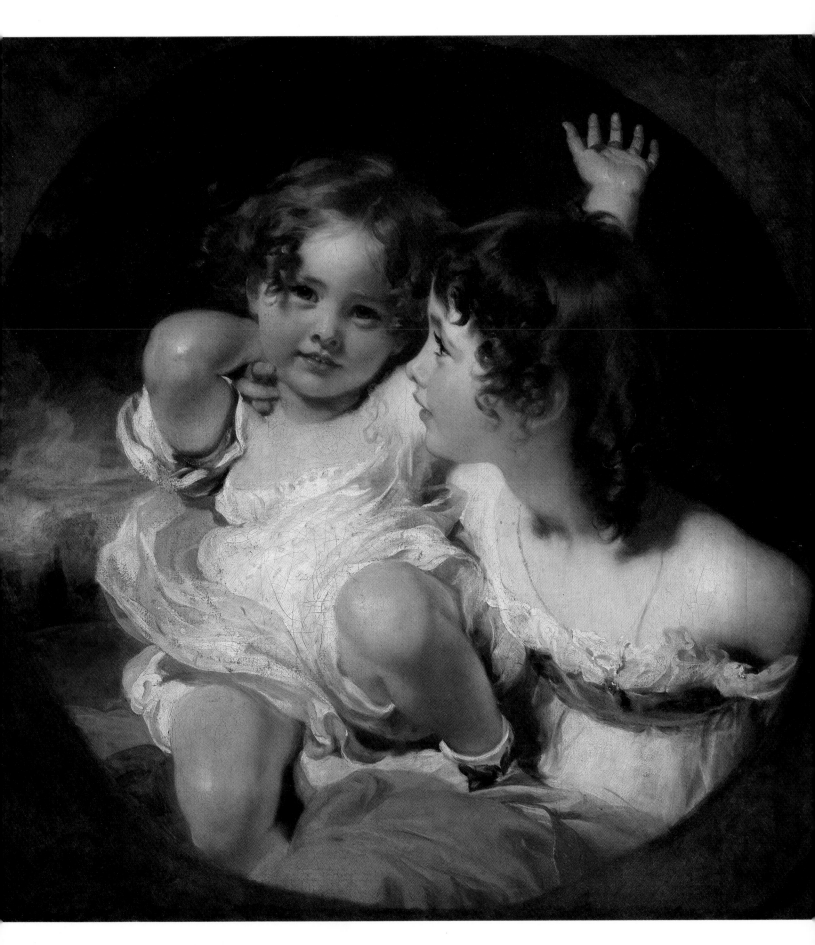

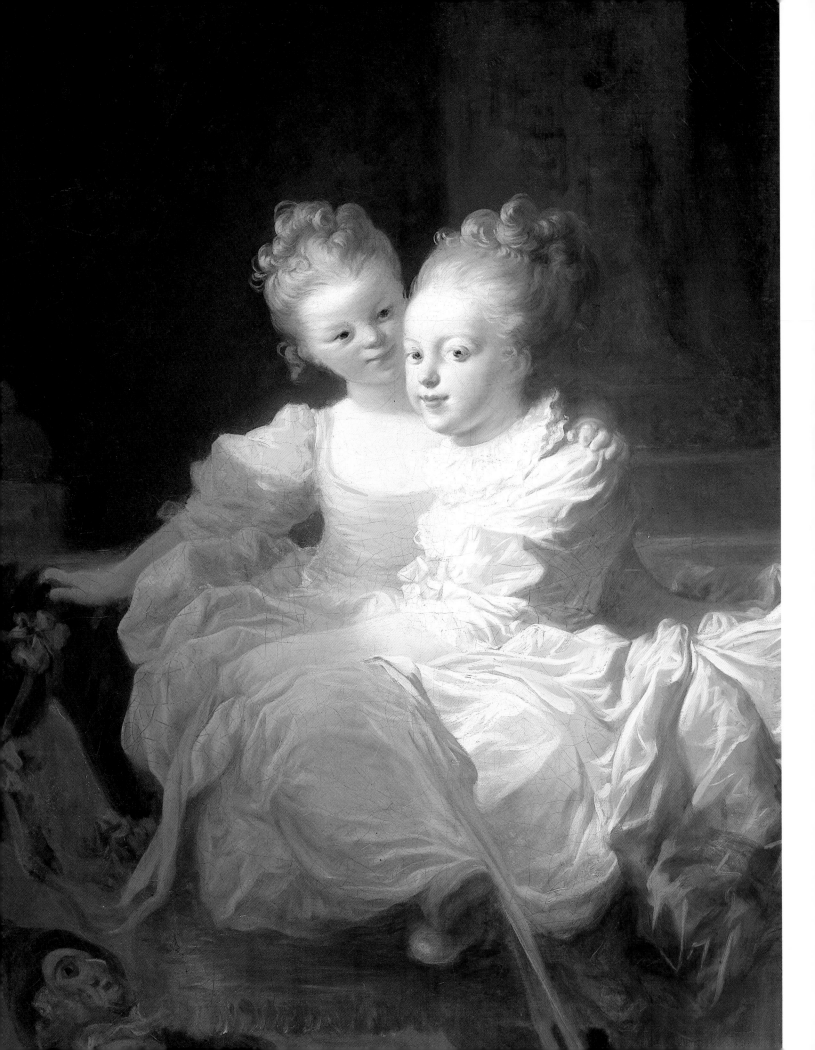

The Two Sisters. The Rococo paintings of Jean-Honoré Fragonard (French, 1732–1806) typify the era when painting functioned above all as a "delight to the eye." This graceful portrait (left) of two unidentified girls displays the brilliant draftsmanship and spirited technique that bring his subjects to life. The pastel below, by Fragonard's patron, the amateur artist Jean-Claude Richard (French, 1727–91), known as the Abbé de Saint-Non, was a copy that he made as a kind of homage to his protégé. Although far less spontaneous, it reveals the complete composition of Fragonard's original, which was cut down by nearly ten inches at the bottom and side. Now we can see clearly that the older child is supporting the younger one on a hobbyhorse and that their doll, a punchinello, or clown figure—perhaps the same held by Fragonard's son on page 100—is resting below.

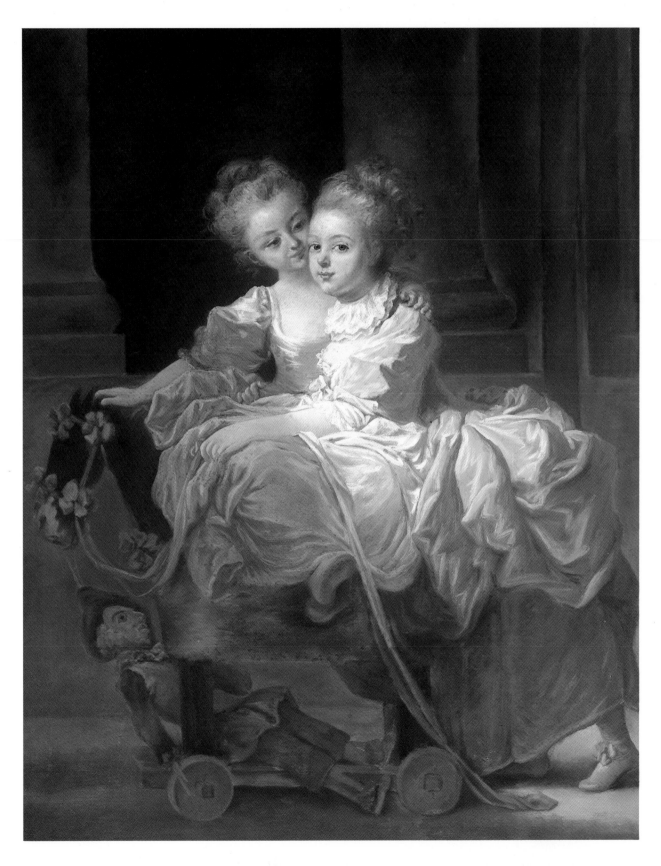

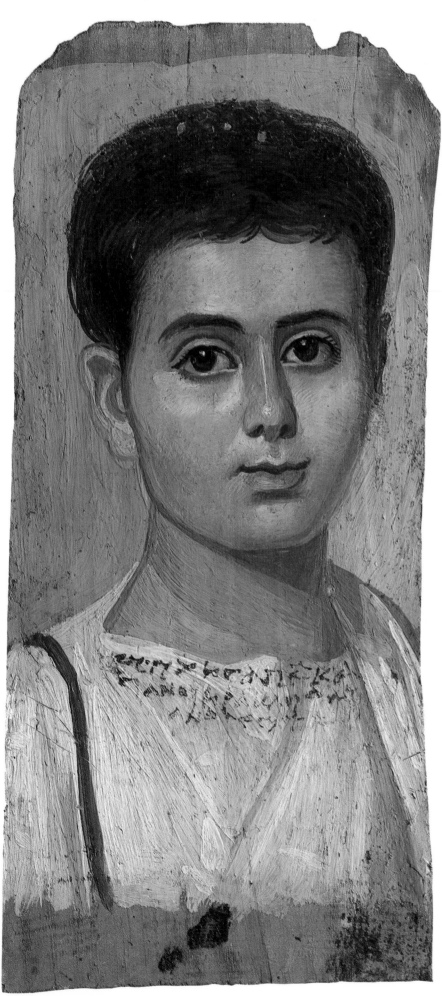

Portrait of a Boy. This remarkably lifelike depiction from an Egyptian mummy dates from the 2nd century A.D. and bears an inscription that identifies the boy as "Eutyches, son of Kasianos," reflecting the presence of a large Greek community in Egypt during the Roman period, as well as the flourishing Hellenistic tradition of portraiture. This painting is clearly a direct portrait, for the boy seems as bright and attractive now as he must have been during his lifetime.

Joseph Barra. Although this boy, too, died before reaching maturity, he is pictured in an extraordinarily lively and appealing fashion in this colored engraving by Pierre-Michel Alix (French, 1762–1817). According to the inscription, the brave boy was assassinated by rebels at the age of thirteen in 1793, during the chaotic epoch that followed the French Revolution, and he died crying "Vive la République!" He is dressed in an *hussard*, indicating that he was a member of the cavalry, and the band on his hat reads "Liberté ou la Mort."

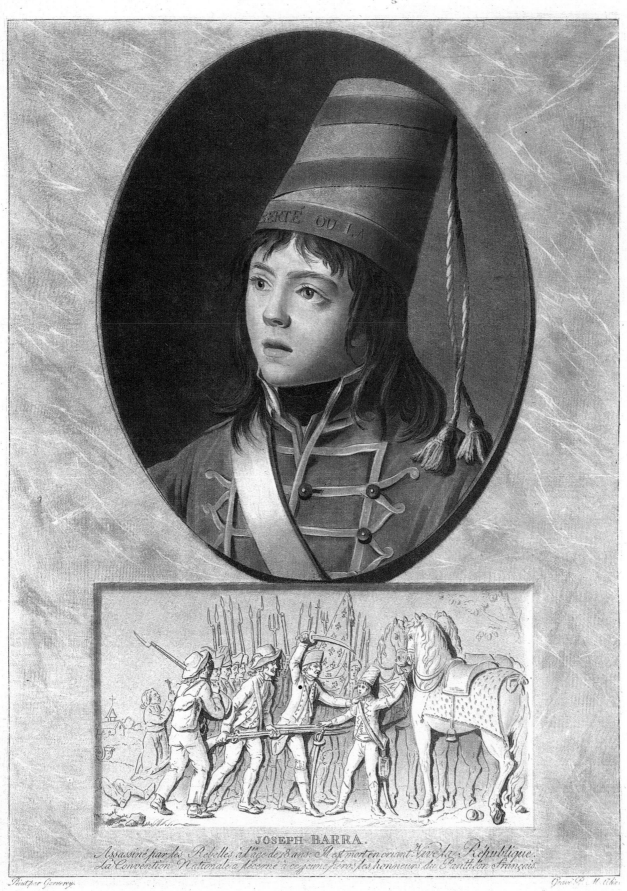

JOSEPH BARRA.

Assassiné par les Rebelles a l'âge de 13 ans, Il est mort en criant Vive la République.
La Convention Nationale a décerné a ce jeune héros les honneurs du Panthéon Français.

Peint par Garnerey. Gravé P. M. Alix

A Paris chez Marie François Drouhin, Éditeur et Imprimeur Libraire Rue Christine N° 2.

39

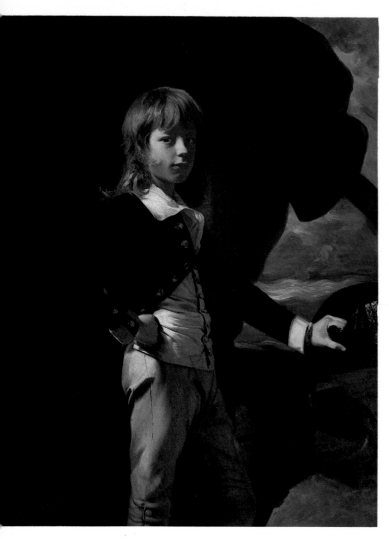

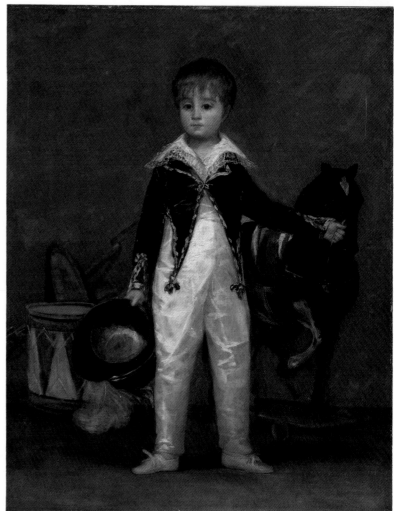

Midshipman Augustus Brine. Like Joseph Barra, this youngster joined the military while still a child, initially serving in the English Royal Navy at the age of thirteen under his father, Admiral James Brine. As for many children of the 18th century, childhood ended for Augustus at the age of six or seven, and the adult world intruded even before adolescence set in. Painted by John Singleton Copley (American, 1738–1815), the brilliant portraitist who moved to London in 1775, the boy appears to have cast off his youth with a certain self-confidence and pride, emphasized by Copley's dramatic composition and bold, fluent brushwork.

José Costa y Bonells, Called Pepito. This endearing boy of four or five is surrounded with toys typical of the age—a hobbyhorse, a drum, and a toy rifle—which, like his costume and Napoleonic haircut, are obviously military in nature. Dating from about 1810, the painting, by Francisco Goya (Spanish, 1746–1828), was made just after Napoleon had marched across Spain and subjected the Spanish people to the horrors of occupation, so it is not surprising that young Pepito's expression is one of melancholy, as if he were aware of the cruelty of the adult world, of which he is not yet a part. We do not know much about the boy himself, except that his grandfather and father were court physicians. Goya's colors are darker and more subdued than in his earlier works (see the portrait of Don Manuel Osorio on page 67), but his affection for children is obvious.

Portrait of a Child. For many years, the model for this appealing portrait by Camille Corot (French, 1796–1875) was thought to be a girl, a specific girl, in fact—Rosa Bonheur, who is best known for having painted *The Horse Fair* and for having worn men's clothing. Corot's portraits were generally restricted to friends and family, and it is known that he was a friend of the Bonheurs; young Rosa apparently called him "Little Father Corot." But the child pictured here does not resemble Rosa as she was painted by her father and is definitely dressed in boy's clothing, a habit that Rosa did not acquire until later in her life.

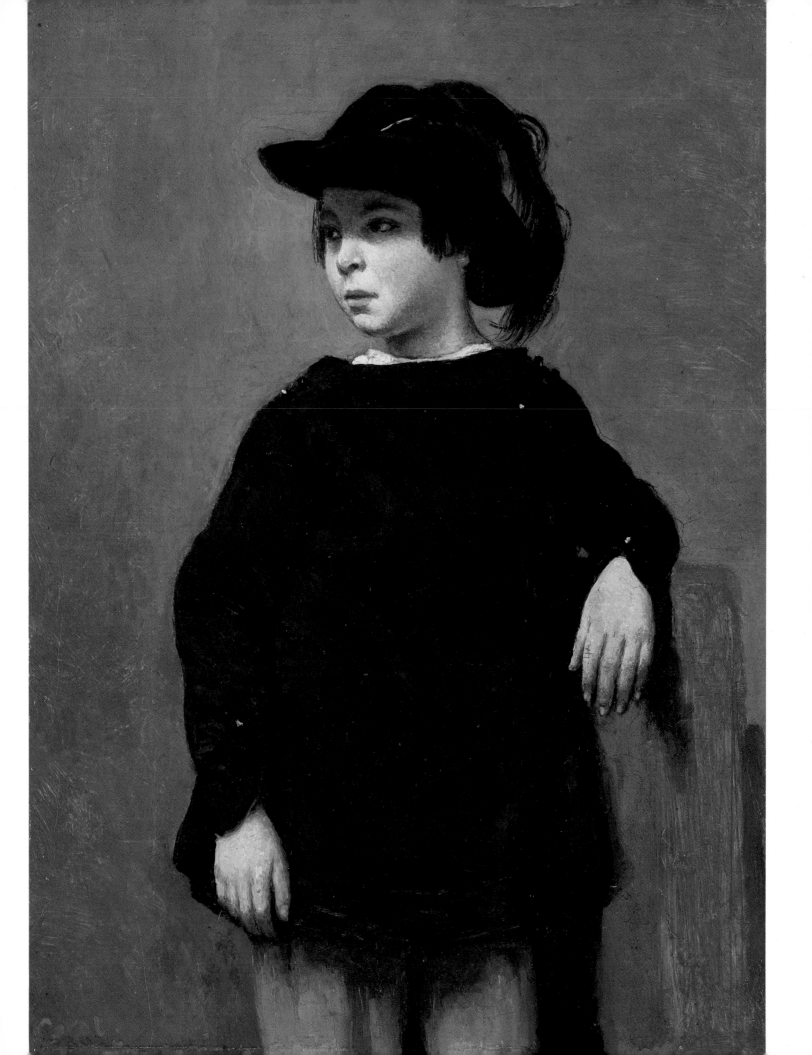

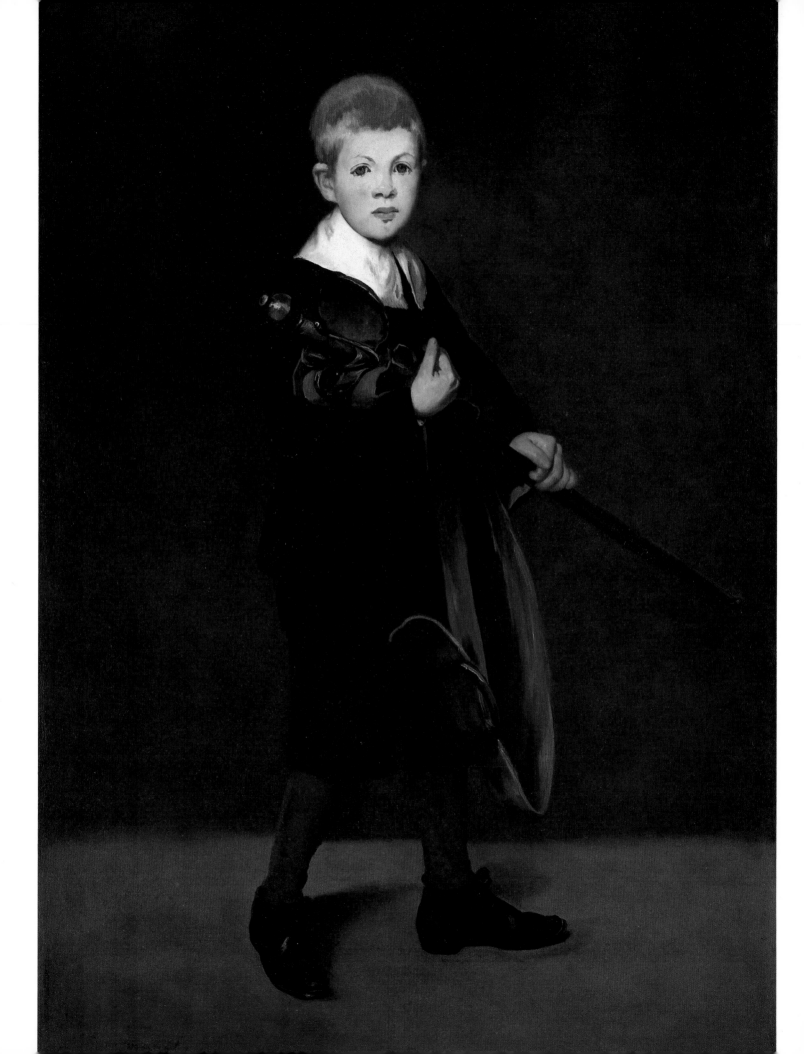

Boy with a Sword. The model for this famous painting by Edouard Manet (French, 1832–83) was Léon Koëlla-Leenhoff, who may have been Manet's own son; he was born to Manet's wife before their marriage and appears in more of Manet's pictures than any other member of the family. The painting was made in 1861, when Léon was nine, and Emile Zola wrote of it: ''The child's head is a marvel of modeling and controlled vigor. If the artist had always painted heads like this, he would have been the darling of the public, showered with money and praises...'' Both the boy's 17th-century Spanish costume and his pose betray Velázquez's strong influence, but there is also an affinity with Goya's portraits of children, especially the portrait of Pepito (see page 40), who also stares self-consciously at the viewer and seems unaware of the destructive potential of his military accessories.

Portrait Bust of Sabine Houdon. Jean-Antoine Houdon (French, 1741–1828) was a brilliantly gifted sculptor, famous for his portraits of statesmen and luminaries such as Benjamin Franklin and Voltaire. Yet some of his most delightful works were portrait busts of his three daughters, whom he evidently adored. Although Sabine is shown here at perhaps ten months of age, a distinct personality can already be seen emerging; she is serious and watchful, while her sisters appear very different in character. All of them are beautifully defined, childlike but never sentimentalized.

Portrait of Titus Van Ryn. Rembrandt van Rijn (Dutch, 1606–69) and his first wife, Saskia, had four children but only Titus, born in 1641, survived, and the artist was very fond of him, using him often as a model for figures of Christ, Tobias, Daniel, and the young Joseph. Rembrandt encountered severe financial difficulties during the 1650s but Titus and Hendrickje Stoffels, Rembrandt's common-law wife, became business partners in 1658, employing the artist, who turned over all of his paintings in return for support, thus averting bankruptcy. Titus gave Rembrandt a granddaughter but died in October 1669, during the last year of his father's life.

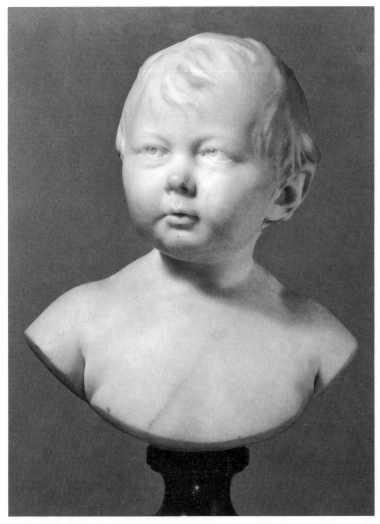

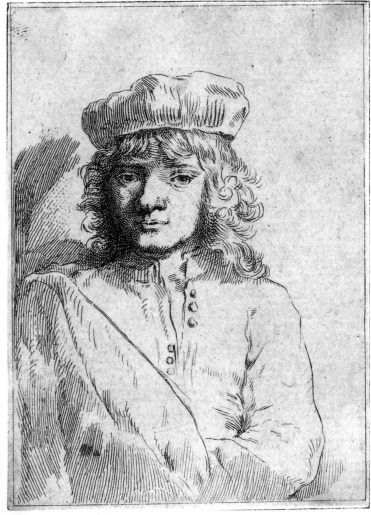

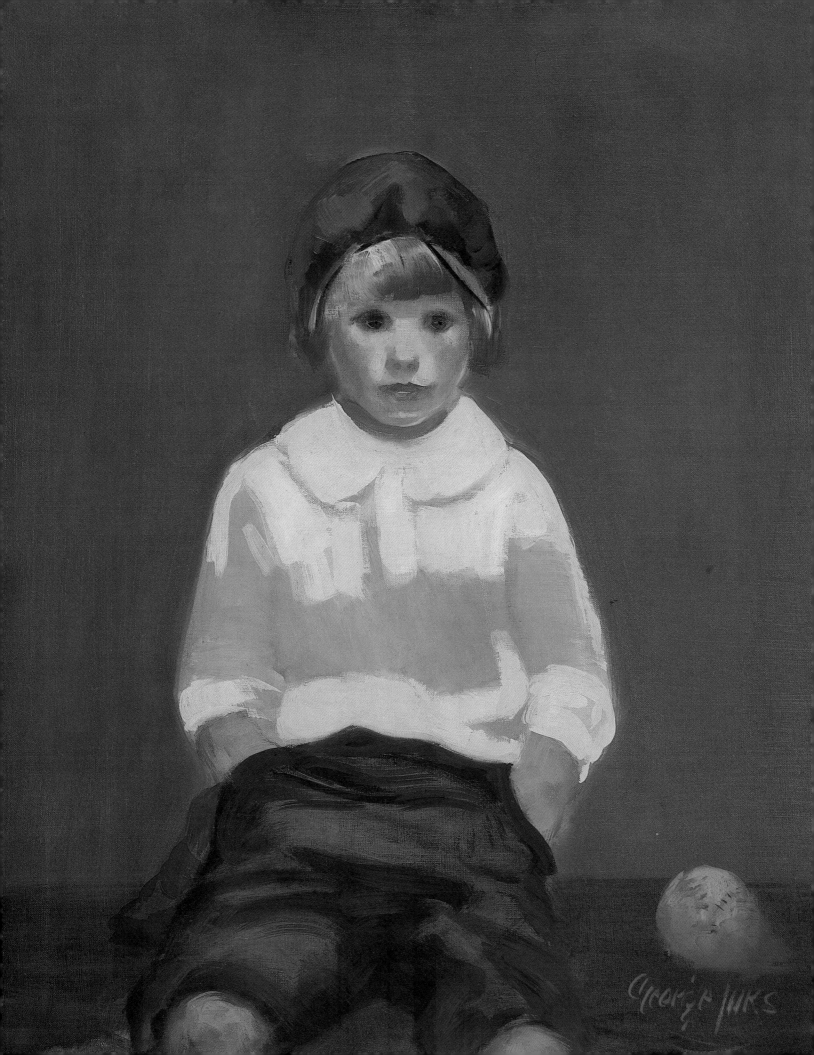

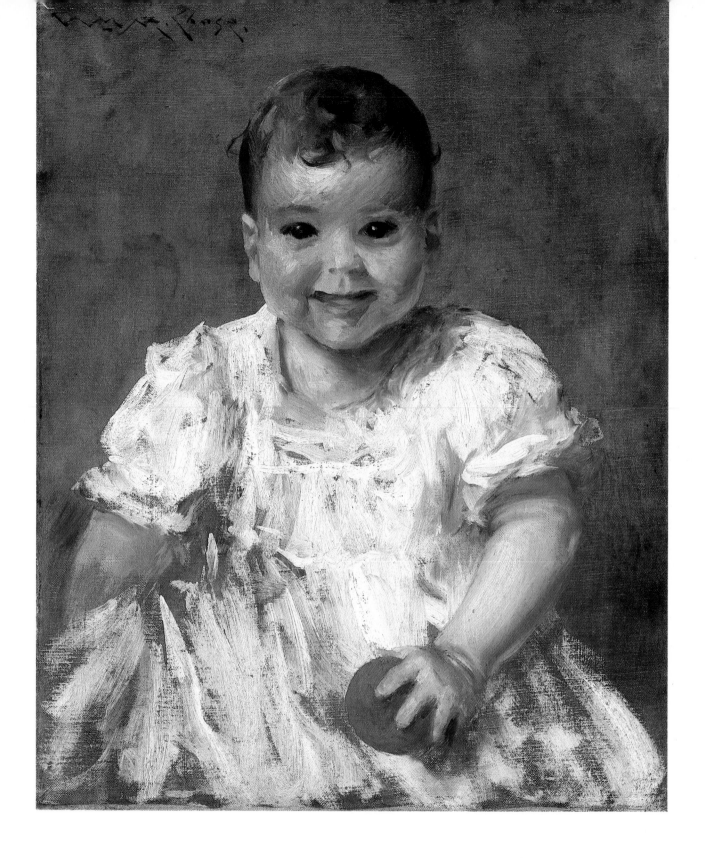

Boy with Baseball. The Ash Can school of American painting at the turn of the 20th century was perhaps the last to find a vitality in genre subjects. George Luks (American, 1867–1933) had a particular fondness for scenes featuring street urchins, whom he depicted with enormous charm and spontaneity. This appealing portrait reflects his knowledge of traditional European painting, for the boy is pictured in a formal pose with an attribute, a baseball, but the broad brushstrokes and deft handling of paint, to say nothing of the toy itself, place it firmly in 20th-century America.

Roland. The leading exponent of Impressionism in America and an influential teacher, William Merritt Chase (American, 1849–1916) painted a number of children—usually his own, for he had eight. This picture, painted about 1902, features his second son, Roland Dana. According to a biographer, Chase "never seemed to be disturbed by the presence of his children even in his studio, perhaps because they understood so well how to keep their freedom from becoming an intrusion."

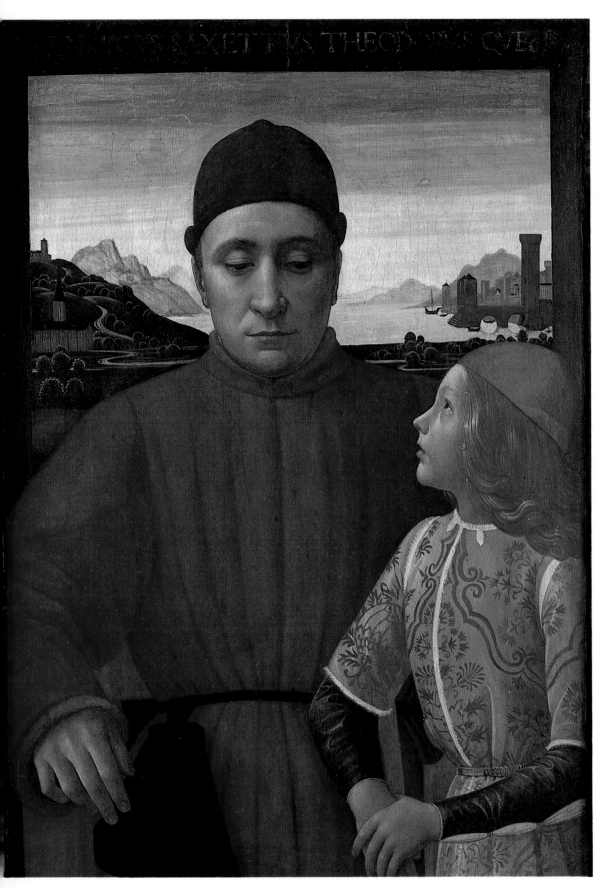

Francesco Sassetti and His Son Teodoro. Sassetti, a Florentine banker and business associate of Lorenzo de' Medici, had two sons named Teodoro: the first died in 1479 at nineteen; the second was born the same year and named for his deceased brother, as was the custom in Renaissance Italy. This fascinating portrait by Domenico Ghirlandaio (Italian, ca. 1448–94) was probably painted in the late 1480s, making this the second Teodoro.

The Emperor Shah Jahan and His Son Shuja. This Indian miniature, a splendid example of 17th-century Mughal painting, is taken from an album in the Museum's collection. Shah Jahan was a great patron of the arts, and he built the Taj Mahal as a tomb for his favorite wife, who died giving birth to his fourteenth child. Unfortunately, the elegant family life recorded here was not to last, as Shah Jahan's third son, Aurangzeb, would eventually imprison his father and defeat his brothers in his struggle for the throne.

Medal Commemorating the Baptism of the King of Rome. Napoleon Bonaparte was enormously proud when his empress, Marie-Louise, daughter of Francis I of Austria, gave birth to an heir in March of 1811. Following the baptismal ceremony in Notre-Dame, Napoleon seized the moment—and the child—to display his son to those assembled, an event commemorated in this bronze medal designed by Bertrand Andrieu (French, 1761–1822).

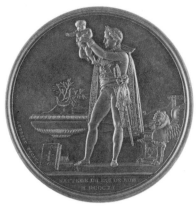

46

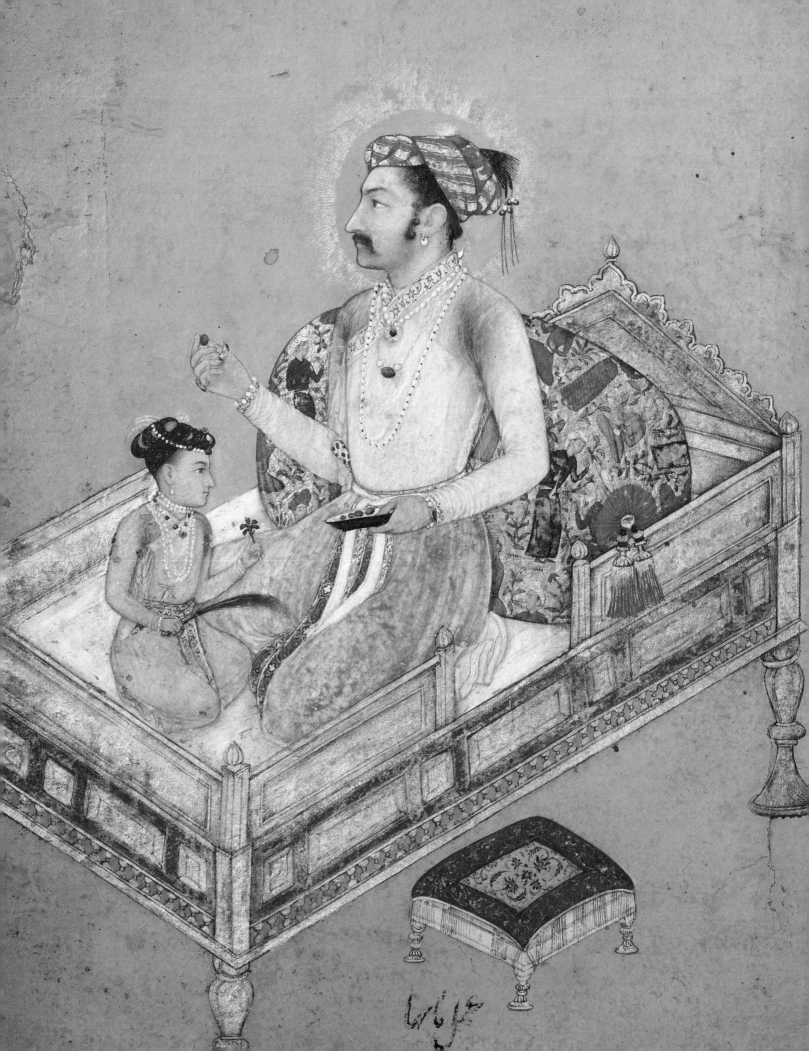

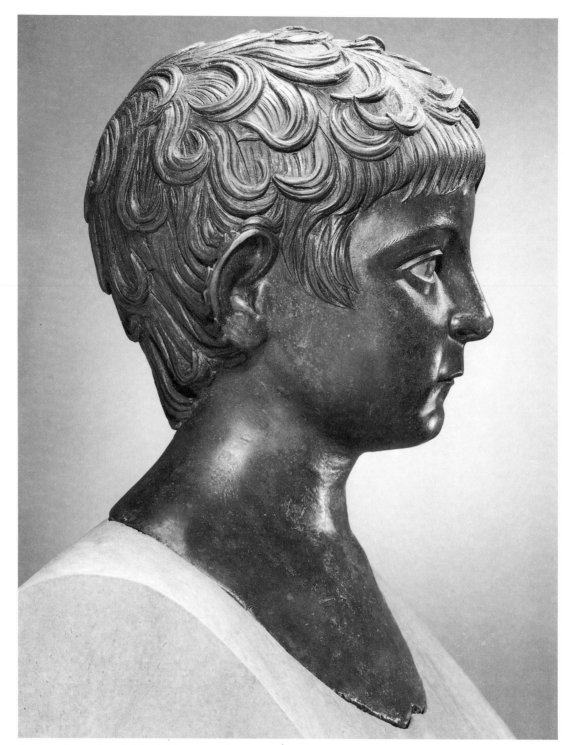

Portrait Bust of a Child. Children were frequently represented in Roman art, but a bronze bust signifies that the child was someone special. Because it resembles other portraits of Nero, scholars speculate that this one may show him at the age of six, though it certainly idealizes the personality of this future emperor, who even as a boy displayed the self-indulgence, brutality, and lustfulness that would eventually make him one of the world's most despised rulers. According to Suetonius, Nero's character was revealed at the moment of his birth on December 15, A.D. 37, when his own father announced "that any child born to himself and Agrippina was bound to have a detestable nature and become a public danger."

Federigo Gonzaga. This appealing young boy was also well born, the son of the marquis of Mantua and Isabella d'Este. Federigo, who would become the first duke of Mantua in 1530, was sent in 1510 at the age of ten to the papal court to act as a hostage for his father, who had been taken prisoner by the Venetians. His mother wanted to have a souvenir of her beloved son and commissioned Francesco Francia (Italian, ca. 1450–1517/18) to make this portrait, a task he completed in less than a week. Shortly afterward, she was forced to give it away and a year later asked Raphael to paint another. Small wonder that she is considered one of the first true art collectors, for it was under her reign that Mantua reached its peak of prestige and power, attracting such artists as Mantegna and Alberti.

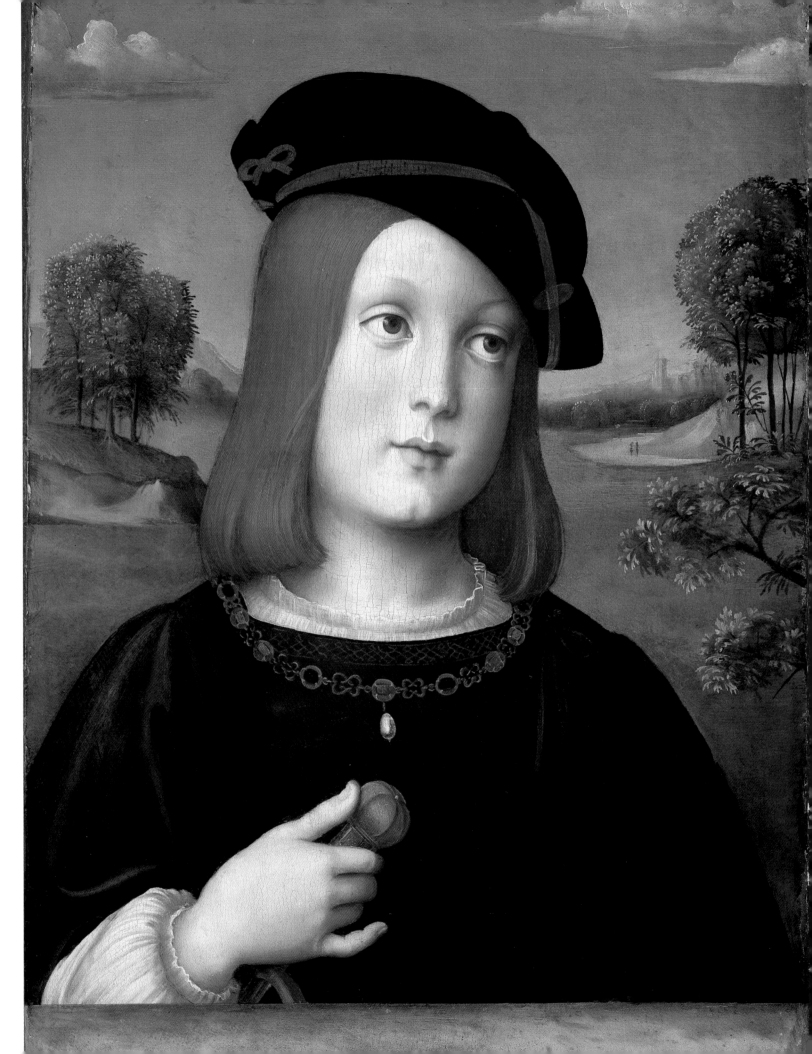

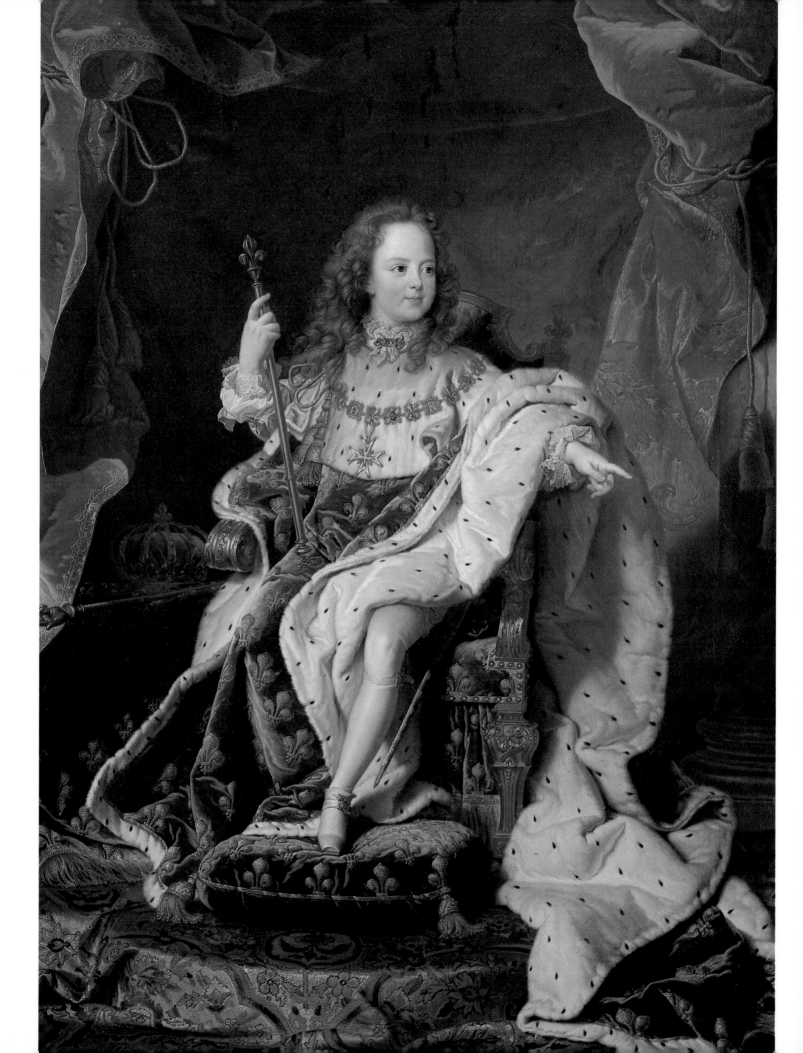

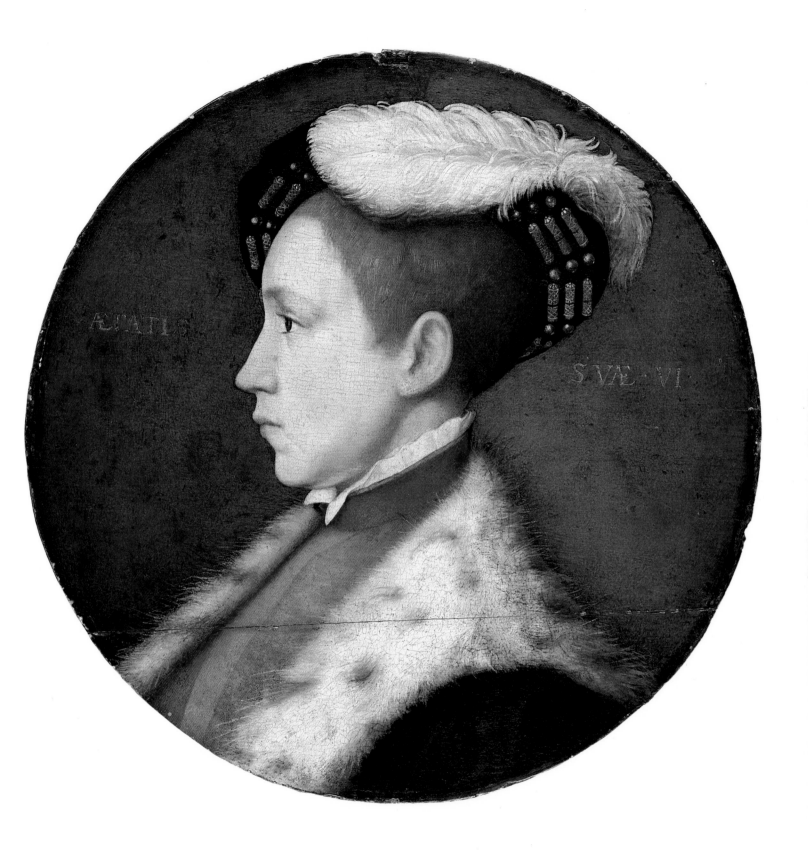

Louis XV as a Child. Unlike the royal subjects on the previous pages, this boy looks like the adult he was to become, perhaps because he was already the king of France at the age of five, in 1715, succeeding his great-grandfather, Louis XIV. Young Louis's formal coronation took place eight years later, to be followed shortly by his marriage in 1725 to Marie Leszczynski, daughter of the former king of Poland. This fine portrait was painted by Hyacinthe Rigaud (French, 1659–1743), who worked almost entirely at court and whose paintings epitomize the peak of Baroque state portraiture.

Edward VI, King of England, When Duke of Cornwall. Like Louis XV, this sensitive-looking boy entered the adult world very early in life. He was the son of Henry VIII and Jane Seymour, who died when Edward was less than two weeks old. He was only six when this portrait was made by the court painter, Hans Holbein the Younger (German, 1497/98–1543), and yet he was already betrothed to Mary, queen of Scots, herself only seven months of age. Four years later, he would succeed his father as king but at the age of sixteen he would succumb to tuberculosis.

51

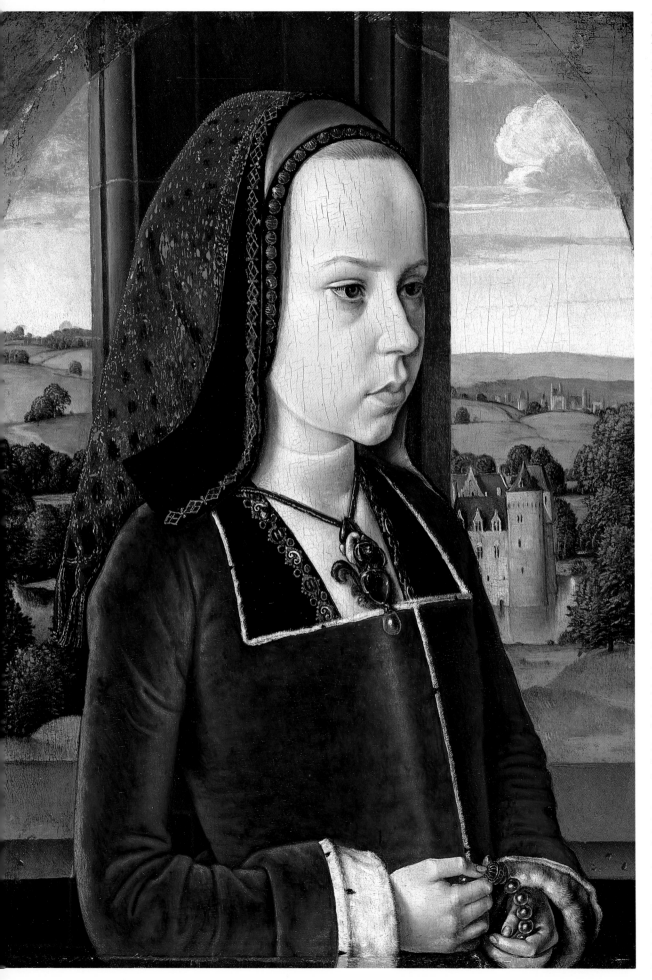

Portrait of a Young Princess. The painter of this beautifully composed panel is unknown and is referred to as the Master of Moulins after a triptych he painted for the cathedral at Moulins, but the subject is probably the daughter of the Austrian Emperor Maximilian I at the age of ten or eleven, portrayed at the time she was betrothed to Charles VIII, king of France, a marriage that was dissolved only a year or so later, in 1491. Whoever he may be, the artist has done justice to the child's social standing by giving her a crimson velvet robe and an elaborate jeweled headdress, which contrast sharply with her pale, sullen face, which poignantly expresses the loneliness and unhappiness of the life of this royal child.

Infanta María Teresa of Spain. Although the marriage of this ten-year-old girl to Louis XIV would not take place until she was over twenty, and it would last until her death, her life was not a happy one, as Diego Velázquez (Spanish, 1599–1660), the brilliant Spanish court painter, seems to foreshadow in this melancholy portrait. It is believed that Velázquez made the painting in order to "introduce" María Teresa to her future husband, who "thought that she possessed much beauty and that he would find it easy to fall in love with her." Velázquez, like Goya, lavished great affection on the children he portrayed, and even this serious princess is given lively treatment with his spontaneous brushwork, which highlights her jewels and her decorative hair ribbon.

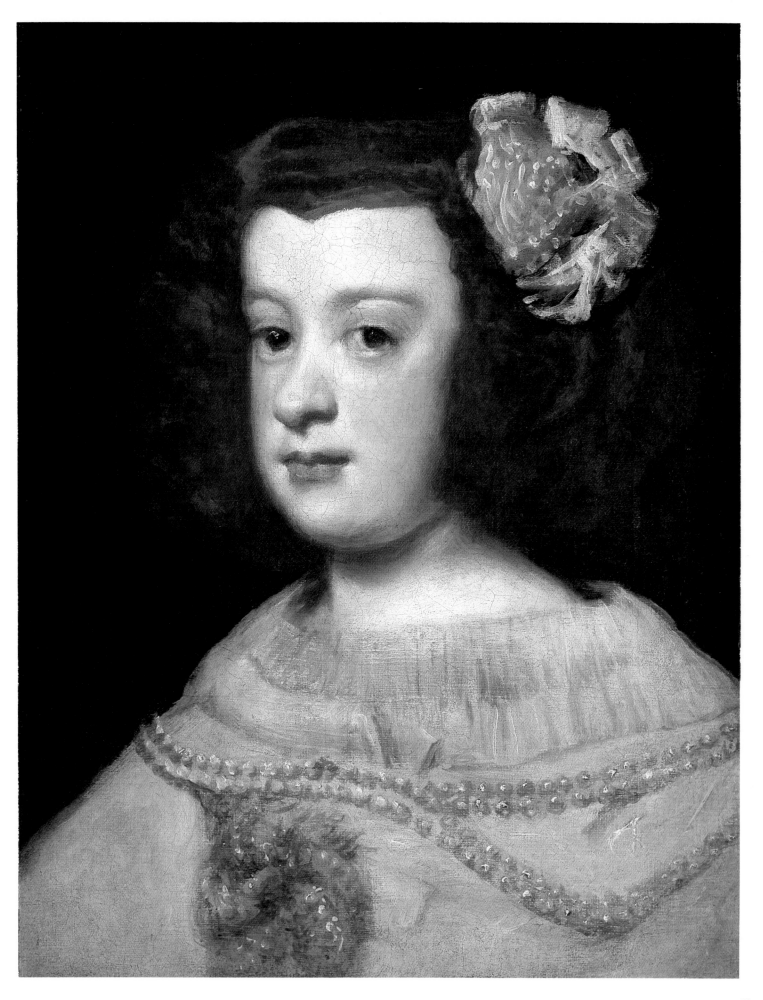

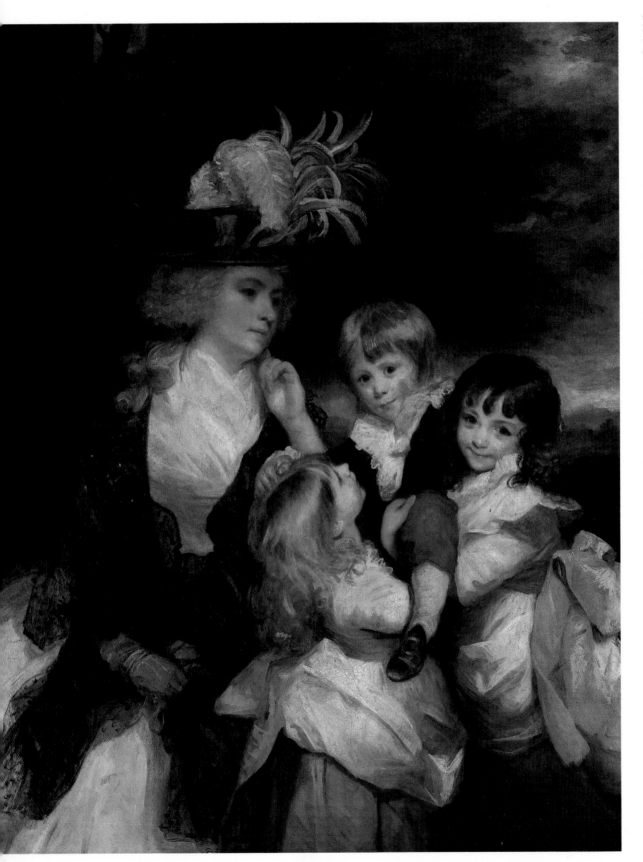

Lady Smith (Charlotte Delaval) and Her Children. Sir Joshua Reynolds (British, 1723–92) was the most fashionable and best-paid portraitist in London, as well as founder-president of the Royal Academy of Arts and a master of the "grand manner." Mrs. Smith, pictured here with her three children, was the wife of Sir Robert Smith, M.P. She is beautifully dressed and somewhat aloof, in contrast to her frolicking children. The two girls seem to have mischievously lifted their brother into a precarious position, perhaps to get the attention of their elegant mother.

The Sackville Children. John Hoppner (British, 1758–1810) was, like Reynolds, a society portrait painter, and about 1796 he visited the Sackville family at Knole, their country estate, to make a portrait of the three children, Mary (born 1792), George John Frederick (born 1793), and Elizabeth (born 1795). The children were brought up very strictly and were rarely allowed to speak in the presence of adults, even at mealtime. Nevertheless the portrait is full of charm, for though they are beautifully dressed in the typical children's clothes of the period—much looser than the adult clothing children were once forced to wear—there is a note of spontaneity in the fact that the the baby is wearing no shoes.

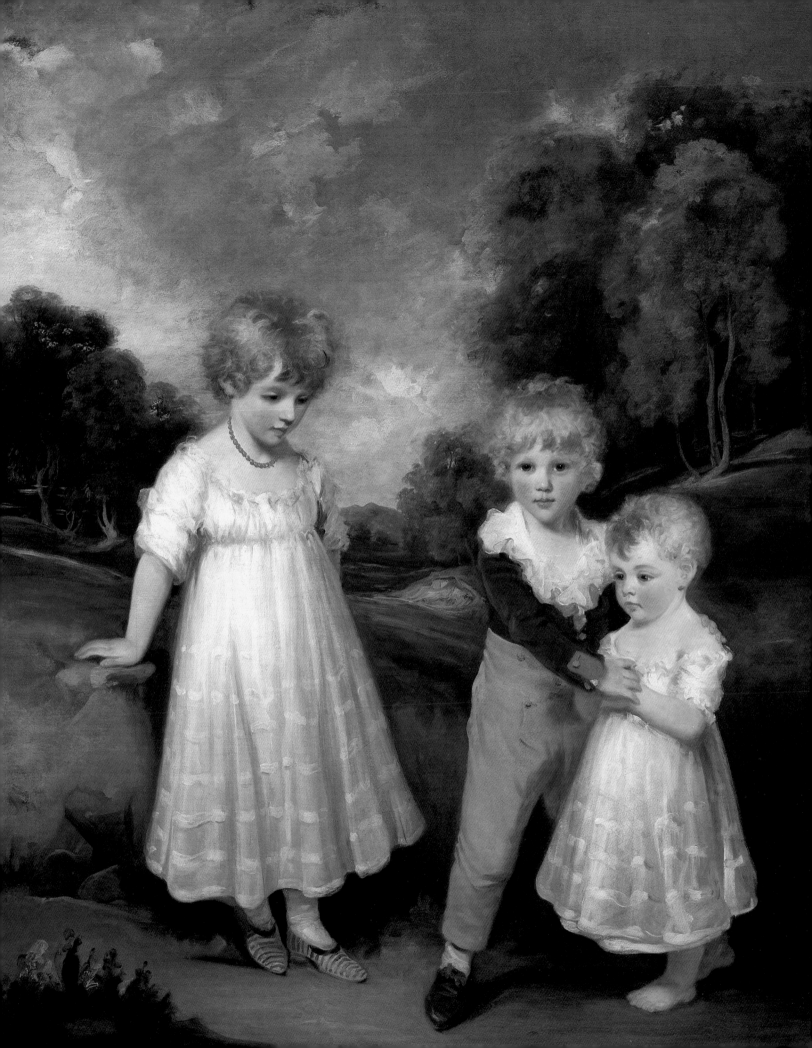

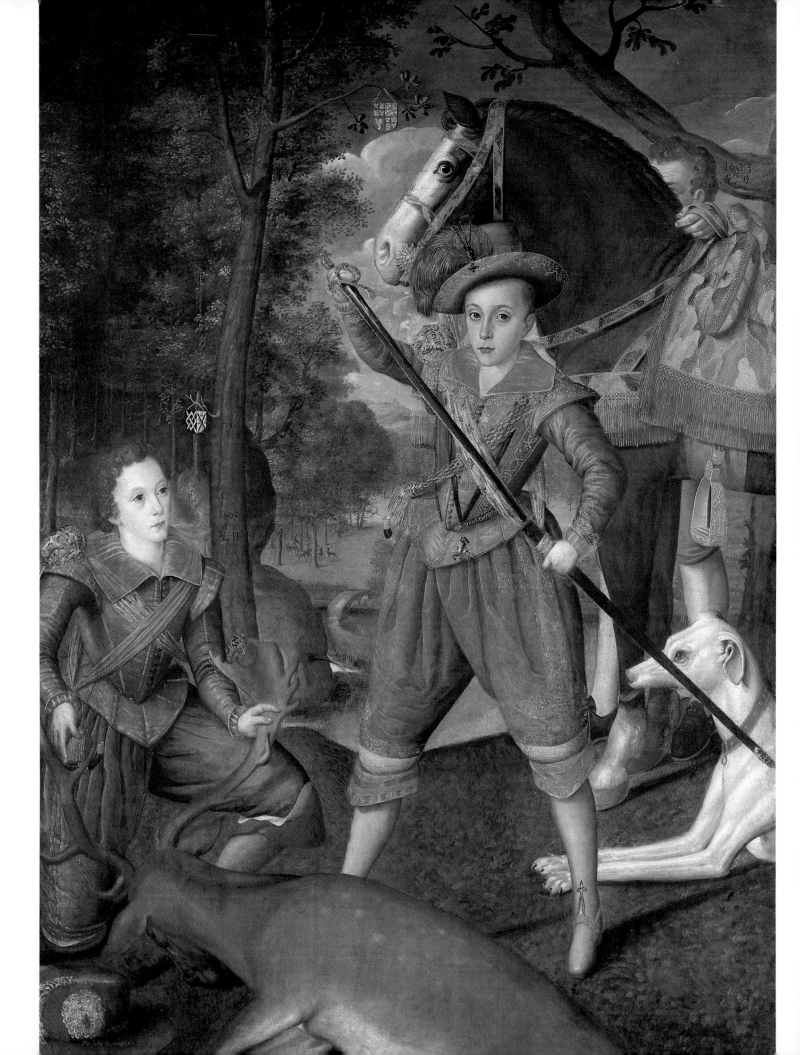

Henry Frederick, Prince of Wales, and Sir John Harington. This portrait by Robert Peake the Elder (British, active 1576–1626) was made just after young Henry's father became James I, king of England, in 1603. The boy, trained for kingship from an early age, was removed from his mother shortly after he was born to grow up with an assigned companion, John Harington, who was two years older. The boys are pictured here at the climax of a stag hunt, the noblest of kingly pastimes. The strong-willed, regal-looking boy was only nine at the time, and much to his father's distress died at eighteen, leaving the throne to his charming but foolish brother Charles, whose reign brought on the English Civil War.

Studies of a Seated Youth in Armor. As we have seen, children were often pictured in quasi-military garb to reflect the concerns of their parents; in this case a young assistant in the studio of Vittore Carpaccio (Italian, 1460/65–ca. 1526) has been put into a suit of armor and posed as if on horseback to serve as a model for the figure of Saint George in the act of slaying the dragon.

Child's Armor. Aristocratic European children were often trained for battle at an early age, but they rarely wore full suits of armor, since they were not expected to fight actual battles. Also, such an expensive "toy" would cost the present-day equivalent of $15,000 and very likely be outgrown in six months. This suit appears to have been designed for a boy of ten, probably the son of an earl or a duke who wished to display his wealth with an extravagant status symbol.

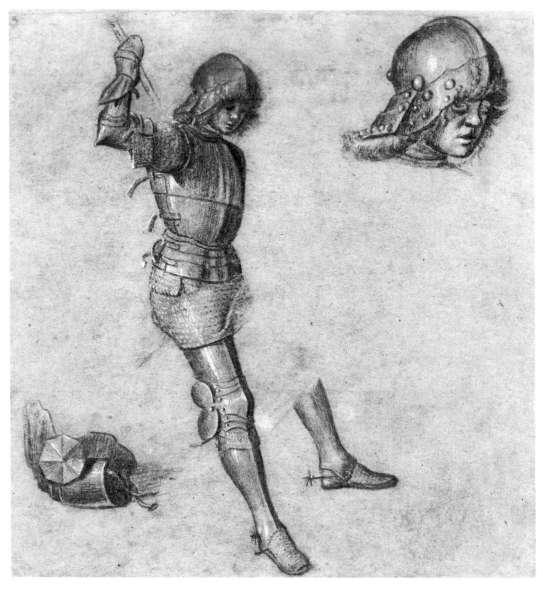

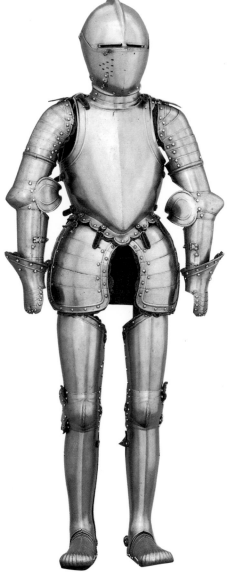

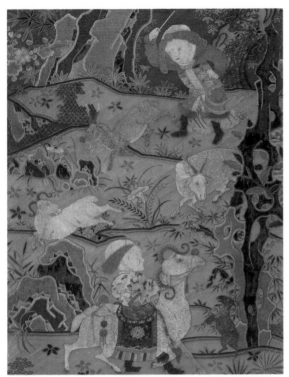

Welcoming the New Year (detail). This exquisite silk embroidery of the Yüan dynasty (late 13th–early 14th century) was undoubtedly designed to hang in a palace hall to celebrate the New Year. The young Mongol boys, here dressed in fur-trimmed winter clothes, represent the promise of new life, and the sheep and goats they are playing with are emblems of good fortune, auspicious symbols for a prosperous future.

The Drummond Children. Sir Henry Raeburn (British, 1756–1823), heavily influenced by Sir Joshua Reynolds, was a leading portrait painter in Scotland, where the Drummond family had a long, aristocratic history, boasting at least three queens since the eleventh century. Raeburn was commissioned to paint these three Drummonds in 1808. George, on the pony, was born in 1802; he is accompanied by his sister, Margaret, and his foster brother. In the Museum's galleries, this attractive trio hangs next to Raeburn's portrait of their father.

Starting for the Hunt. Traces of Persian influence can be seen in the exotic costumes worn by the two van Meerdervoort brothers, Michiel and Cornelis, who were members of a well-to-do Dutch family and are pictured here with their tutor and coachman. Aelbert Cuyp (Dutch, 1620–91) was a well-known landscape painter from the region of Dordrecht, and he was also renowned for his animal studies, as one can readily see in his masterful handling of the horses and dogs about to take off in pursuit of a hare.

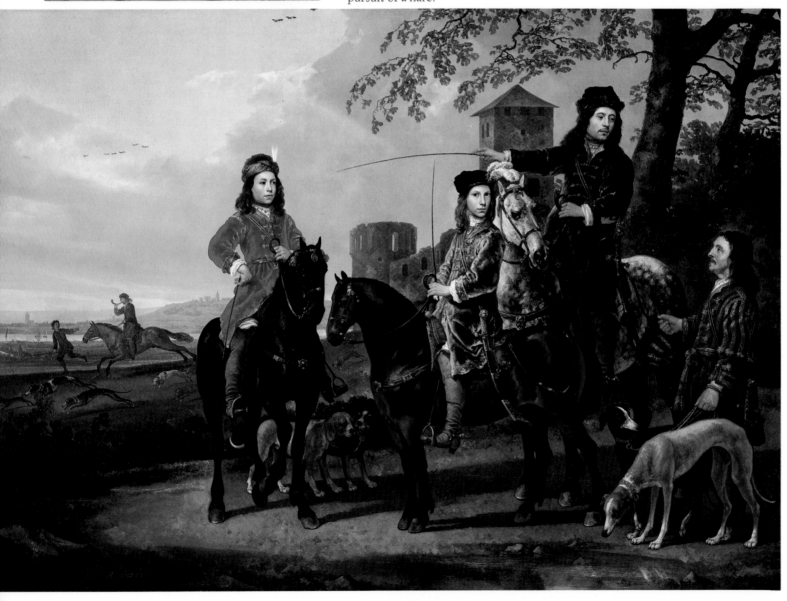

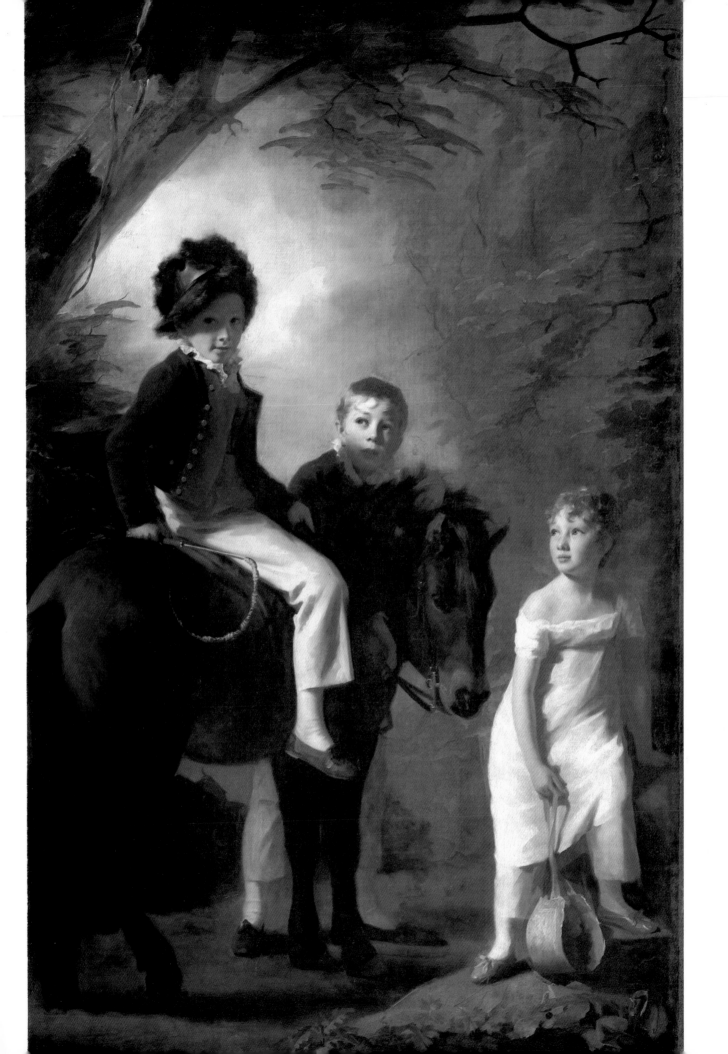

The Children of Jacob H. Schiff. Augustus Saint-Gaudens (American, 1848–1907) was America's finest and most influential sculptor of the late 19th century. He is best known for his public monuments, but two-thirds of his work consisted of relief portraits, such as this charming depiction of the children of banker-philanthropist Jacob Schiff, who commissioned a marble version especially for the Metropolitan in 1907, based on the original bronze of 1888. The children, Mortimer Leo and Frieda Fanny, are seen with the artist's dog, and while the piece bears a resemblance to gravestones, such as the Greek example pictured on page 64, it is most definitely a portrait of living children. Characteristic of Saint-Gaudens's style—unparalleled in the style of his followers—is his shift from the delicate, sketchy low relief of the dog to the fully rounded high relief of the boy.

Temple Boy. This piece of sculpture most likely represents a real Greek boy of the 5th century B.C. whose parents wished to seek protection for him from one of the deities concerned with child-rearing, such as Artemis or Apollo, in whose sanctuary the stone statuette would be placed. The amulets around the boy's neck probably have a protective function, but the hare in his lap is undoubtedly his own pet, with no particular symbolic meaning. Figures like this of both boys and girls were particularly common in Cyprus and were part of a long tradition that can be dated back to ancient Egypt.

Daniel Crommelin Verplanck. One of the earliest and most successful portraits by the great American painter John Singleton Copley (1738–1815) was entitled *Boy with a Squirrel,* and the artist has used the same device here in his painting of Daniel Verplanck, made in 1771 when Copley was at the height of his powers. The boy is only nine years old, but he seems extremely self-assured, dressed in adult clothing, as was the custom, and gazing directly at the viewer with the same bright, sharp eyes as those of the squirrel. Copley would have had no reason to idealize the period of childhood, for in his day children were often treated like adults after the age of six or seven, and he himself was already a professional artist at fifteen and helped to support his family.

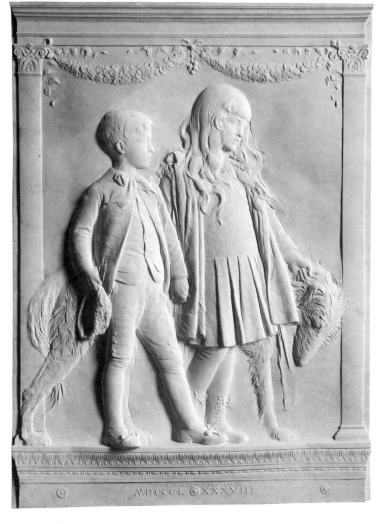

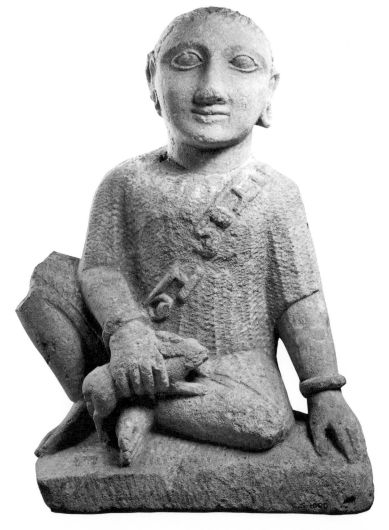

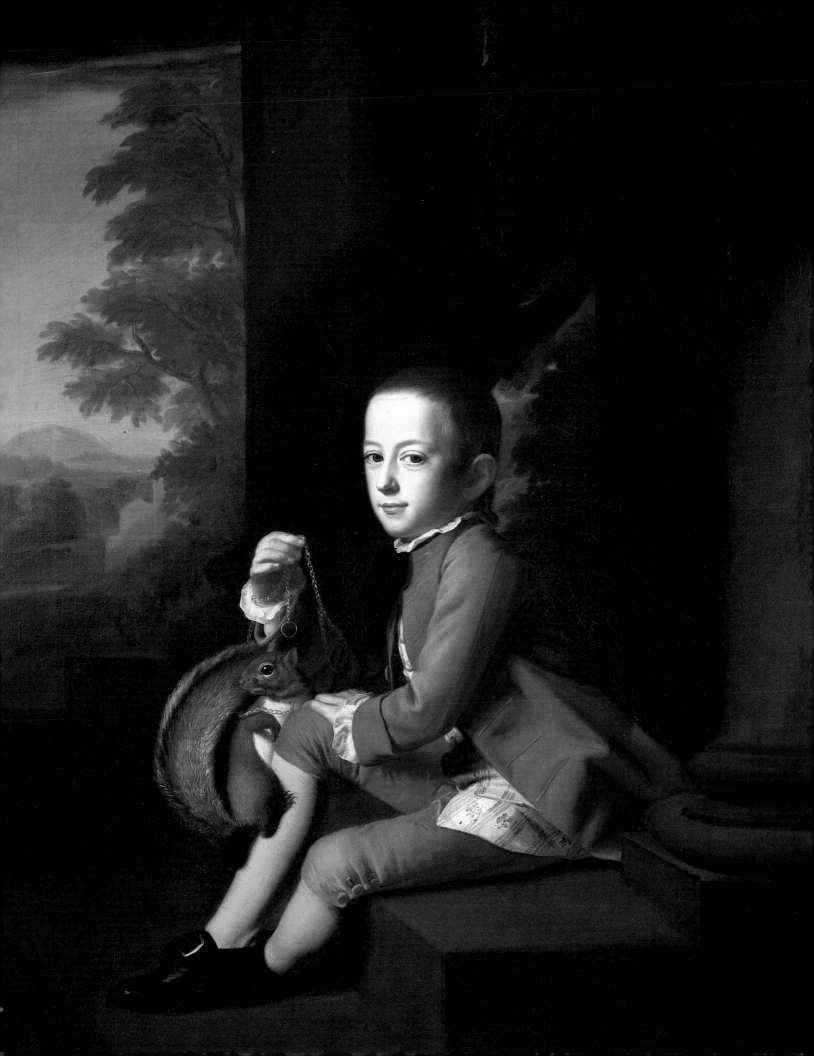

Boy on a Rooster. This beautiful red-figured Greek plate, dating from about 520–510 B.C., is unusual in that the subject it depicts is rarely seen in Greek art. A theme from a century earlier was that of a young man riding a rooster-horse, one of the more curious combination creatures in the Greek menagerie; perhaps this is a deliberate borrowing from an earlier style or perhaps the artist, Epiktetos, is playing a variation on the popular image of a child with a domestic animal. Chickens had been kept in Greece for only a short time before this plate was made and were called "Persian birds," much as we call various species of fowl by exotic names—turkeys and guinea hens, for example.

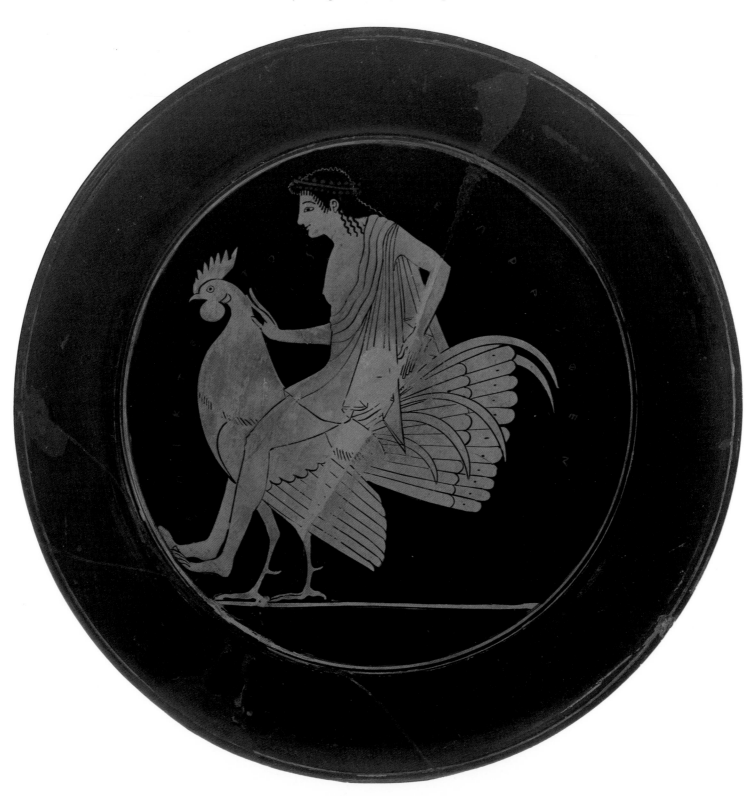

Children Playing with Birds. This lead garden sculpture was one of a pair produced around 1745–50 by François Ladatte (Italian, 1706–87) for the royal palace at Turin, where he was court artist. Although the group may have allegorical overtones as in the drawing by François Boucher on page 67, there is no deep symbolism here; artists have sometimes used the caged bird in Western art to symbolize the confined human soul, but it is more likely that Ladatte, who expressed the Rococo spirit of the period in sculpture as Boucher did in painting, was attracted mainly by the delightful interactions of the children involved with their lively pets.

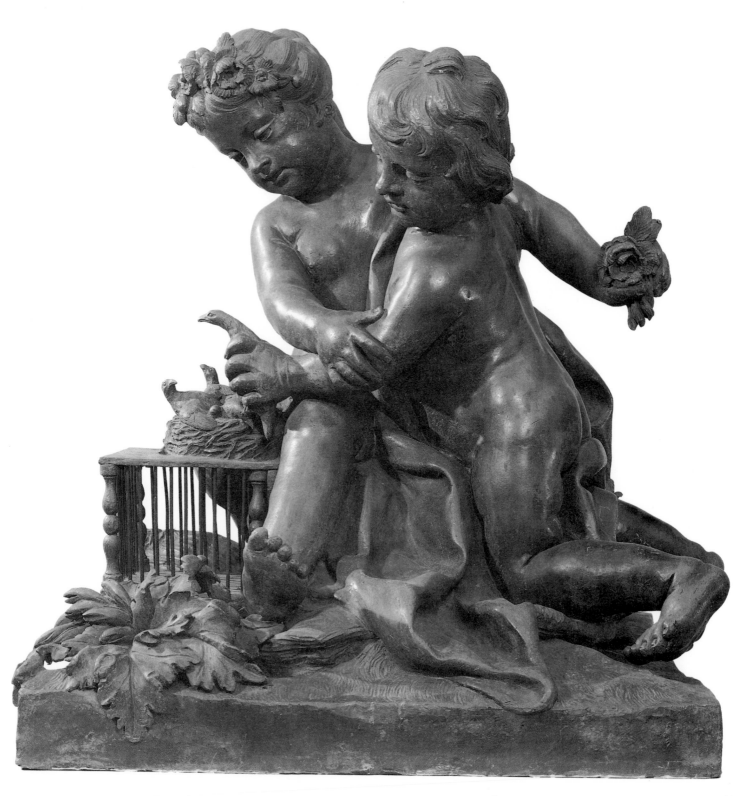

Boy and Duck. Frederick MacMonnies (American, 1863–1937) apprenticed to Saint-Gaudens, although his work reached a baroque phase of American Beaux-Arts sculpture, unlike his first teacher's. This charming bronze is a replica of a fountain group he designed for a pond in Prospect Park, Brooklyn, in 1898. The theme of a boy with a bird has classical origins, and it is a perfect fountain piece, since the water splashing from the duck's beak would add immeasurably to the fun.

Girl Holding Two Pigeons. The subject of this 5th-century B.C. Greek gravestone was clearly observed from life. The child carrying her pet pigeons has a large head and chubby arms, indicating that she is perhaps only four or five. Capturing a momentary act, the relief has a timeless quality and movingly expresses grief at the death of so young and appealing a child.

Frederick de Vries. Hendrik Goltzius (Dutch, 1558–1617) was an exceptional artist in spite of a childhood accident that cramped his hand. He copied many Old Masters to make their works available to the public, but he was also capable of great originality. This engraving of his ten-year-old apprentice owes something to tradition—the dove symbolizing peace and the dog faithfulness—but it is also a delightful view of a child with his pets, apparently made to be sent to Frederick's father in Italy to show him that all was well with his son.

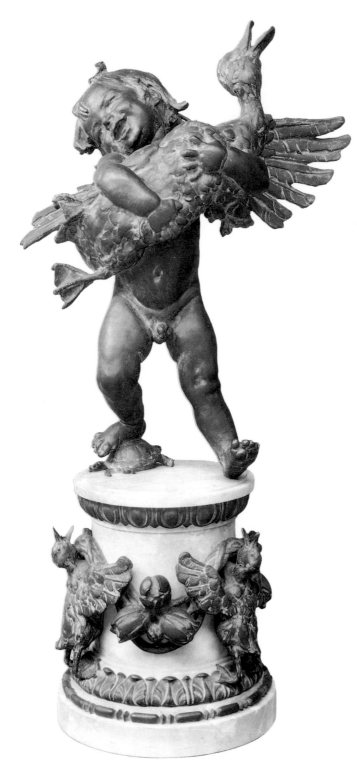

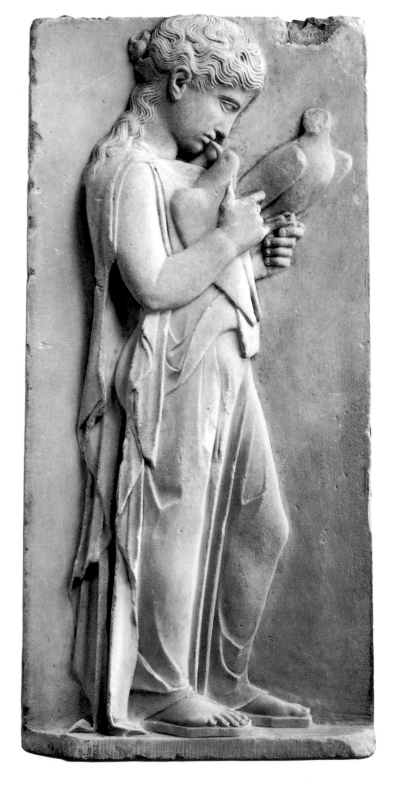

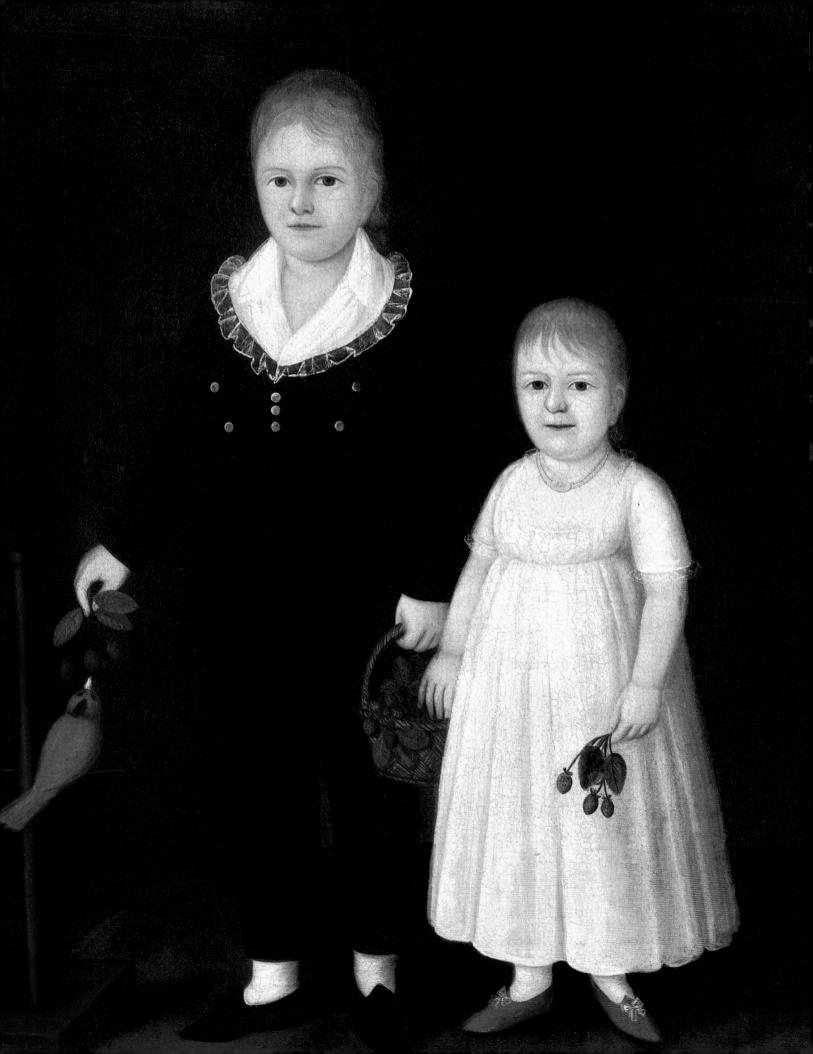

Edward and Sarah Rutter. The painter of this handsome portrait, Joshua Johnston (American, active 1796–1824), was the first notable black American artist, an important link between the primitive colonial portraitists and the full flowering of American folk art. It is likely, however, that he was aware of the European tradition of using birds in portraits, either as pets or for their symbolic value. His subjects are the children of Captain Joshua Rutter of Baltimore, who felt the painting of sufficient value to list it in his will. Johnston was known for his expressive linear design, and though he did not sign the painting, the strawberry basket appears often in his work and can be considered a good indication of his hand.

Allegory of Air. This chalk drawing by François Boucher (French, 1703–70), like the drawing of *Earth* on page 81, was apparently one of a series depicting the elements made for the artist's patron Mme de Pompadour. There are no known paintings or tapestries for which they might have been studies, nor are the subjects unique in their allegorical refer-ences. Nonetheless, the charm of the figures and the spontaneous Rococo style are typical of Boucher's work, and though the models are unknown, they are delightfully rendered and could be taken to represent playful children of any period.

Don Manuel Osorio Manrique de Zuñiga. Birds are a traditional childhood pet and a delightful device for painters, but Francisco Goya (Spanish, 1746–1828) takes a rather more somber view of the theme in this enchanting portrait of the young son of the count of Altamira. This four-year-old boy, brightly clothed and surrounded with pets, is one of Goya's most winning children, yet the artist has taken the opportunity to express his views on the nature of childhood by showing the bird on a string—perhaps to signify the inhibited spirit of the aristocratic youth—and carefully watched by predatory cats, perhaps an indication of the eventual loss of innocence that the pale, fragile Don Manuel must eventually experience when he confronts the adult world in a Europe about to be disrupted by the French Revolution.

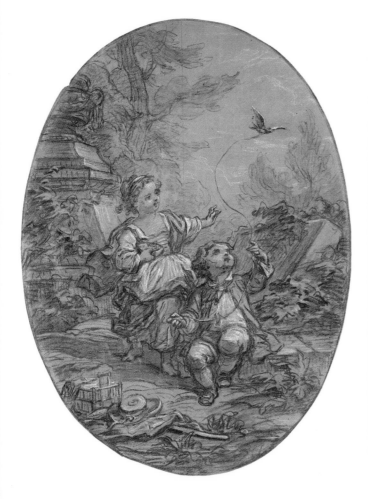

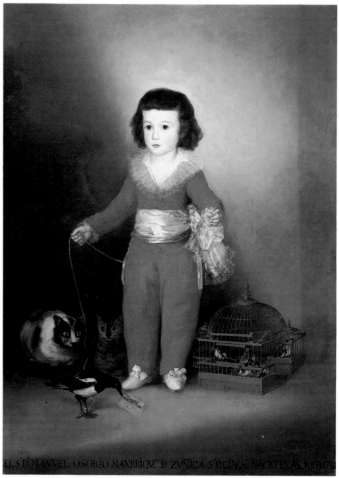

The Hatch Family. Eastman Johnson (American, 1824–1906), a contemporary of Eakins and Homer, was strongly attracted to the Old Masters, especially the Dutch genre painters, and their influence is clear in this handsome, well-composed family portrait. It epitomizes Victorian upper-class life, showing comfortable surroundings—in the Hatch house on Park Avenue in New York—and a closely knit family group, complete with grandparents. Johnson's interest in children is apparent in the attention he pays to their activities; the detail at the upper right shows young Horace and Jane Hatch happily occupied with some pictures.

The Holy Kinship. Throughout the Middle Ages and the early Renaissance, children rarely appeared in works of art except as holy figures. Some artists, however, including Lucas Cranach the Elder (German, 1472–1553), clearly demonstrated their love of children in their art. In this woodcut depicting the Virgin Mary, her mother, and the Christ Child, the holy group is virtually upstaged by what appears for all the world to be a typical nursery in the foreground. In a painting of the same subject, Cranach portrayed members of his own family, and it may be that his beloved son, Lucas Cranach the Younger, is one of the youngsters playing at the feet of his mother.

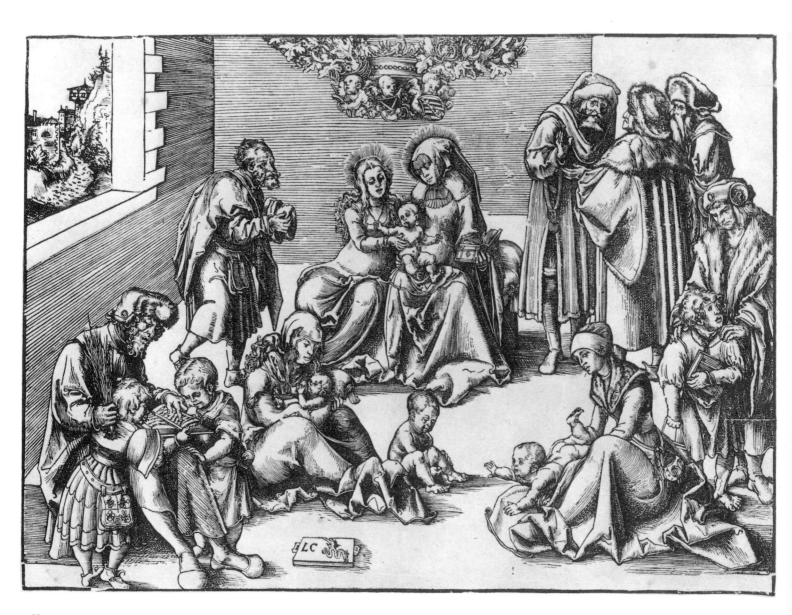

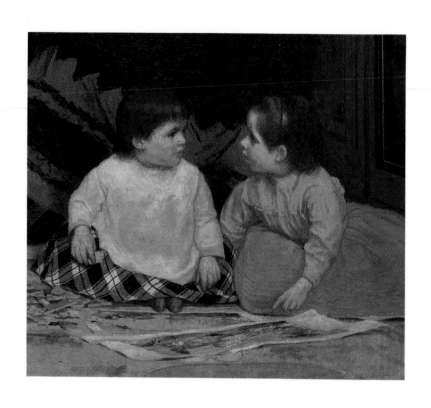

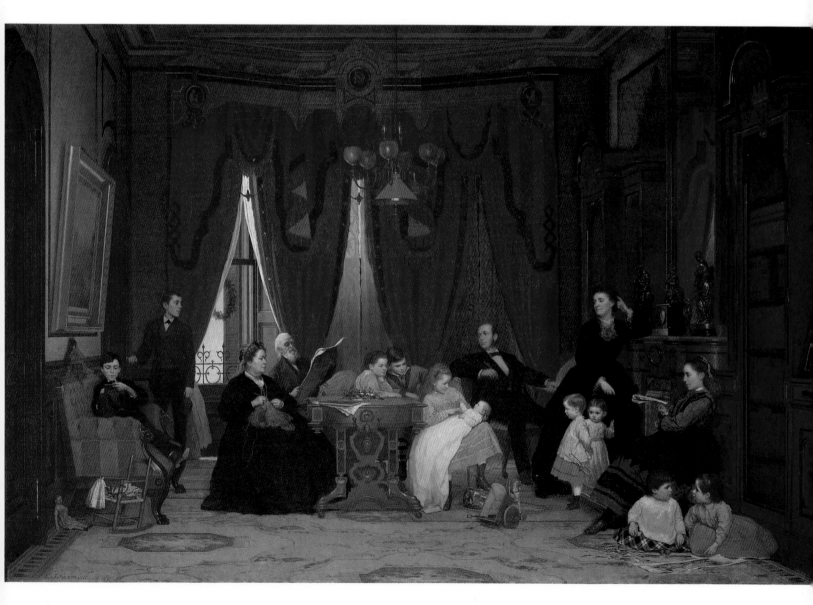

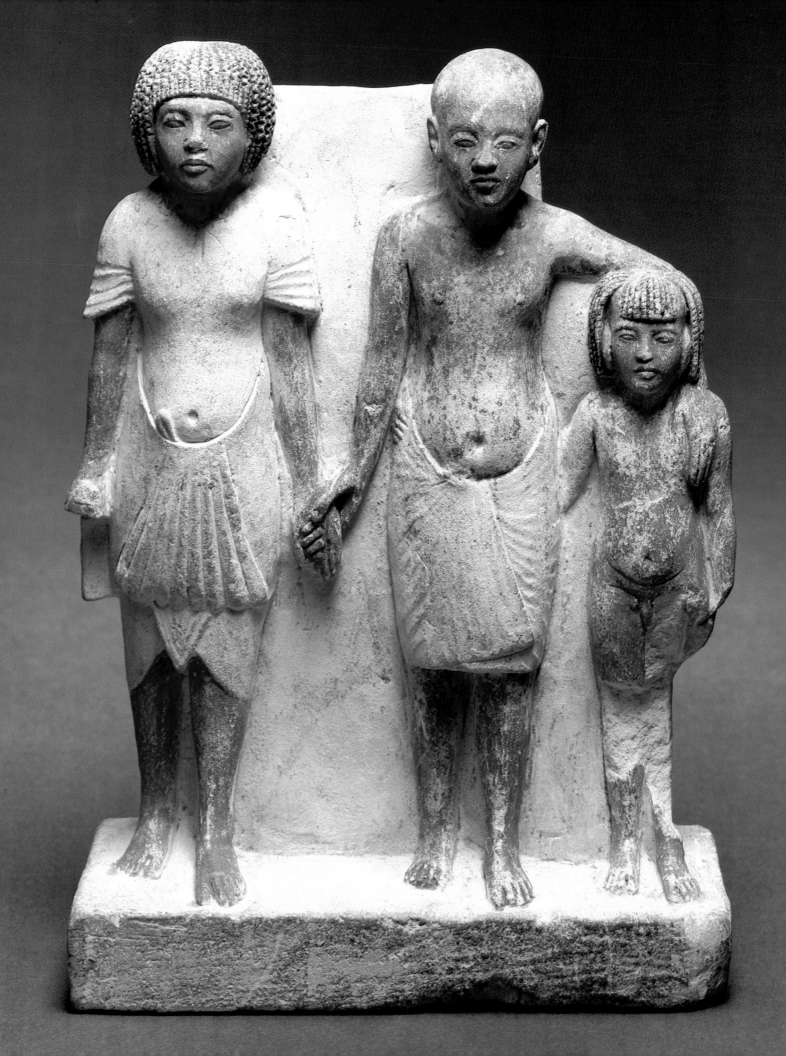

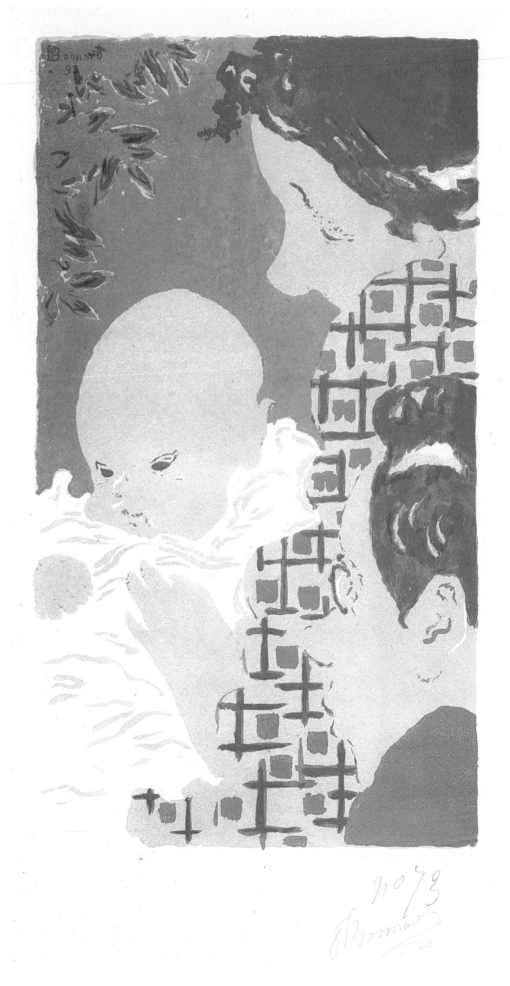

Priest Presenting Man and Boy. This impressive Egyptian group dates from the late 18th Dynasty (1379–50 B.C.), a period when families were often depicted in sculpture. Although we do not know exactly what, if any, religious significance can be attached to this particular work, it seems possible that the priest, who stands in the center affectionately clasping the man and boy, is related to them. This group is unusual in a number of respects: there is no inscription to identify the figures; all of them are striding rather than seated; and a child is present, perhaps indicating that he was a rather special individual in his own right.

Family Scene. This four-color lithograph by the great Post-Impressionist Pierre Bonnard (French, 1867–1947) is one of his earliest and most characteristic prints. Made in 1893, the lithograph depicts Bonnard's sister, Mme Claude Terrasse, her composer husband, and their infant son Jean, of whom they were clearly very proud. The influence of Japanese printmakers can be seen in the flat areas of color and the absence of modeling, as well as in the pattern of the mother's dress, which is emphasized by the light green background. The baby is delightfully drawn with an oversized head, and the pose of the doting parents draws our attention to him. Bonnard's use of the white of the paper at the bottom of the child's dress and of a tentative line to suggest spontaneous movement is both skillful and innovative.

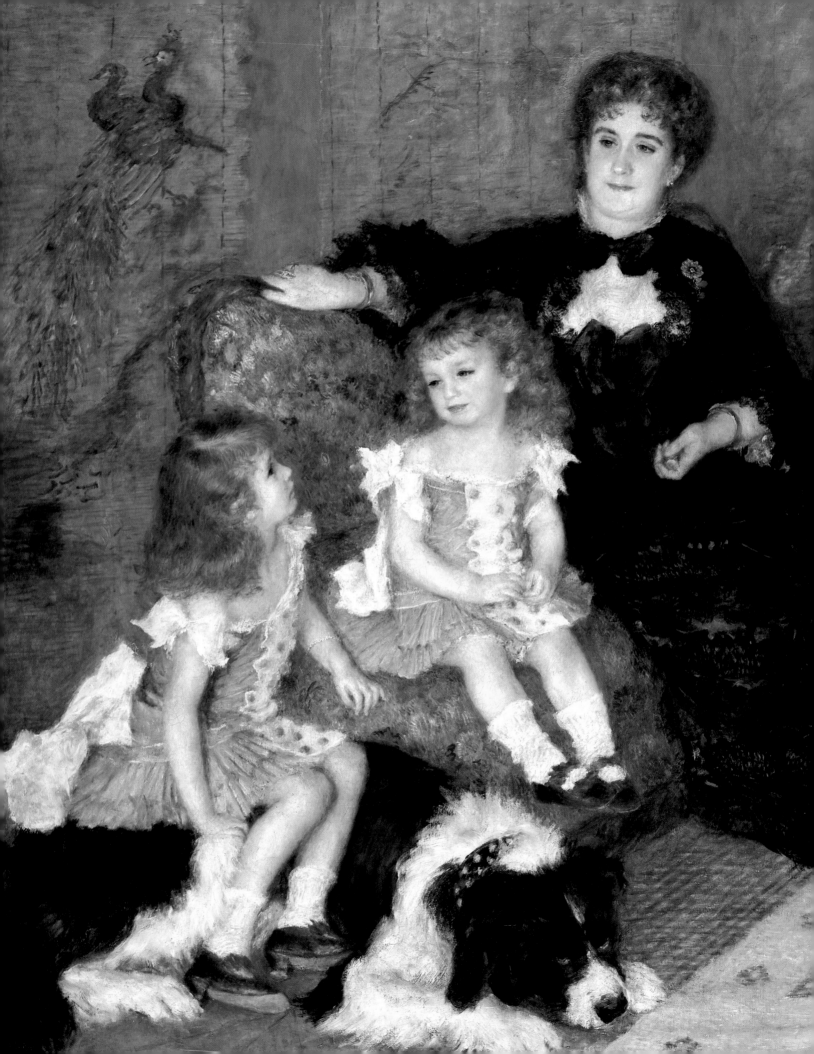

Madame Charpentier and Her Children. This charming family portrait marks an important turning point in the career of Pierre-Auguste Renoir (French, 1841–1919). Madame Georges Charpentier was married to the publisher of Zola, Flaubert, and Maupassant, and her drawing room served as a salon for influential writers, politicians, and artists. Because of their social and intellectual prominence, the Charpentiers were able to arrange for this painting to be hung at the official Salon of 1879 rather than at the Impressionist exhibition. Its success there promised new financial and critical acceptance for Renoir, who seems to have retreated somewhat from his innovative Impressionist techniques for this important portrait to adopt rather more traditional methods. The fashionable Japanese decor and Madame Charpentier's elegant Worth dress do not at all detract from the intimacy and affection of the scene, which Marcel Proust admired as characterizing the charm of domestic life in 19th-century France. Renoir's own warm feeling for the children is clearly expressed; the daughter is comfortably seated on the family dog, Porto, while the boy, Paul, dressed in girl's clothing because he is not yet five years old, virtually glows with the freshness and innocence of happy childhood.

The Monet Family in Their Garden. During the summer of 1874, Edouard Manet (French, 1832–83) visited his painter friend Claude Monet at Argenteuil and, delighted by the light and color in the garden, was inspired to paint this portrait of Monet's wife, Camille, and their son, Jean, seated under the trees. While he worked, Monet painted Manet at his easel, and shortly after they had begun, Renoir arrived on the scene. According to Monet, "He, too, was caught up in the spirit of the moment. He asked me for palette, brush, and canvas, and there he was, painting away alongside Manet. The latter was watching him out of the corner of his eye, and from time to time came over for a closer look at the canvas. Then he made a face, passed discreetly near me, and whispered in my ear about Renoir: 'He has no talent, that boy! Since you're his friend, tell him to give up painting!' Wasn't that amusing of Manet?" This delightful story and the three paintings that emerged from the sunny afternoon seem to epitomize the friendly and creative atmosphere in which Impressionism reached its peak.

Rubens, His Wife, Helena Fourment, and Their Son Peter Paul. Peter Paul Rubens (Flemish, 1577–1640) was a distinguished diplomat and court painter, yet he was also a devoted family man, the father of eight children, several of whom served as models for religious figures in his major paintings. He did not depict them as miniature adults, like so many of his contemporaries, but as real children, and it is believed that he was influenced by the drawing books based on Dürer's proportional studies (see page 27), which show that young children have distinctive physical characteristics. This magnificent portrait was painted to express the artist's love for his young, beautiful second wife, but it is clearly a celebration of her maternal role as well, given her intense involvement with the baby and the presence of a parrot, once connected with the Virgin Mary as a symbol of motherhood. Blue and pink were used to distinguish boys and girls long before Rubens's time, and since this baby is wearing a blue sash, as well as heavy shoes and a collar resembling the one worn by the painter himself, we can be reasonably certain that this little Rubens is a son rather than a daughter.

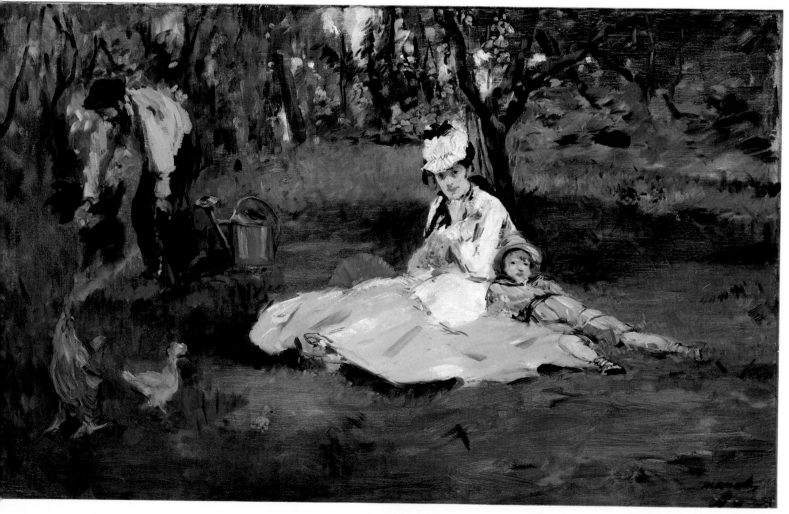

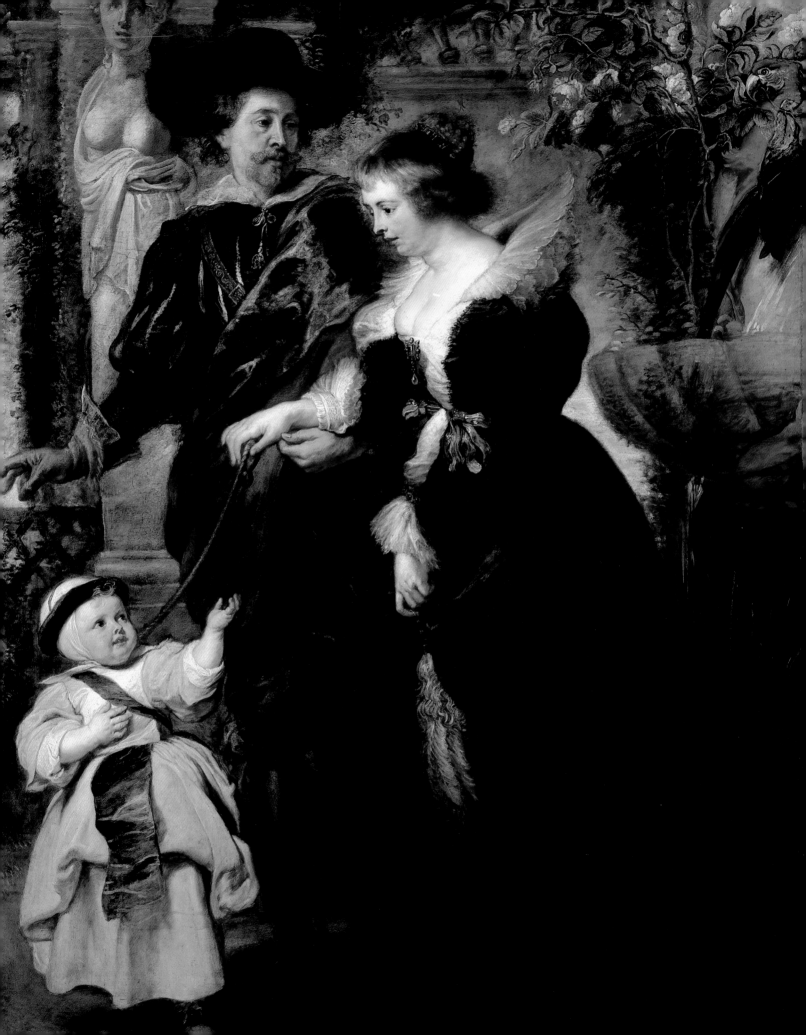

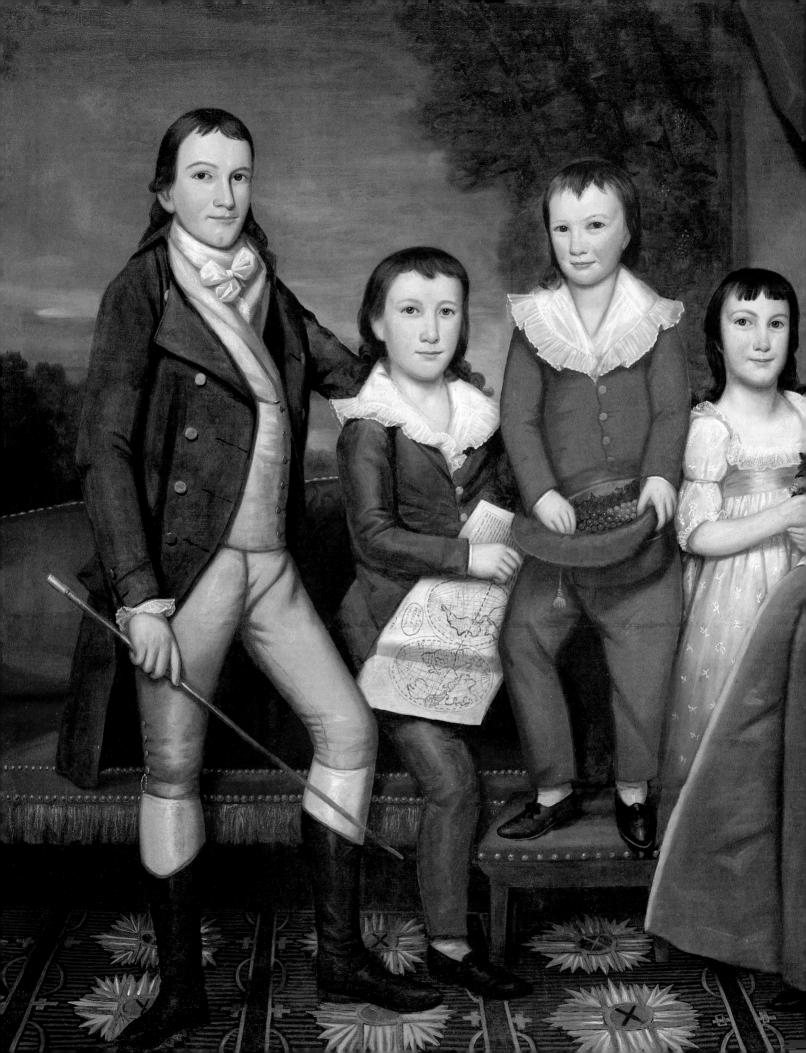

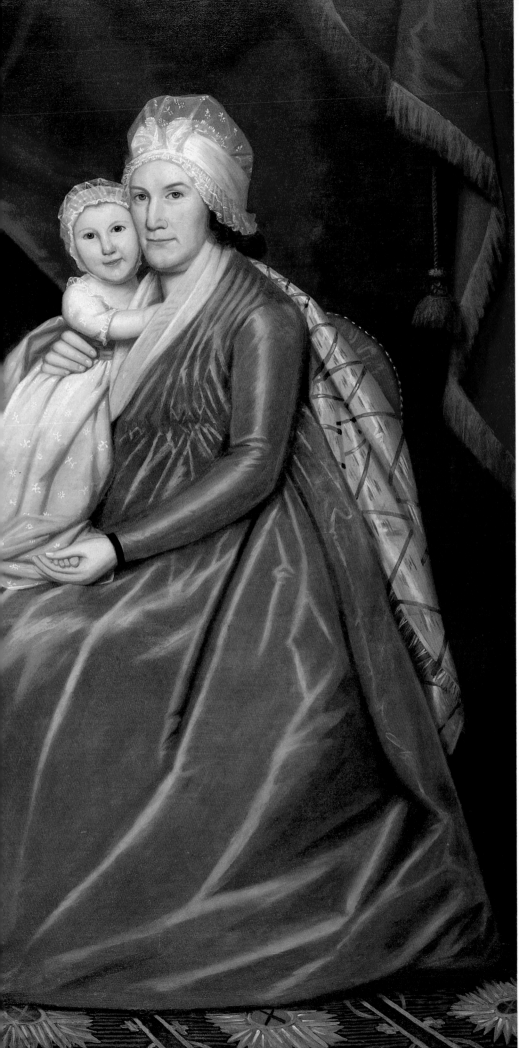

Mrs. Noah Smith and Her Children. Ralph Earl (American, 1751–1801) was one of the most important portraitists of the early Federal period, and although he was himself a terrible family man (he deserted at least one wife and family), he painted some marvelous family groups, of which this is a fine example. As a Tory, he fled to England during the Revolution and was impressed there by the work of Benjamin West and the great portraitists Joshua Reynolds and Thomas Gainsborough. When he returned to America in 1785, however, he regained his directness of vision and abandoned the stock backgrounds and traditional poses he had borrowed from the British. There is little of Reynolds's elegant line and brushwork in this straightforward portrait of the family of Noah Smith, the chief judge of the Vermont Supreme Court, but we may assume that this was an affluent family, given the rich fabrics of their clothing and furnishings. The composition is harmonious and strong, indicating that this is a peaceful, prosperous home. The children are well behaved and closely knit, yet each has a distinct personality, judging from their facial expressions and the objects they carry. Unfortunately, this happy home life was not to continue, for the father died several years later, after a term in debtors' prison.

Thanksgiving Turkey. All farm children must perform daily chores, but in America the onerous nature of these tasks disappears in the annual turkey chase that precedes the Thanksgiving feast. Anna Mary Robertson Moses (Grandma Moses; American, 1860–1961) has captured all of the colorful excitement of the event in this delightful painting, one of several she devoted to the theme. Children play an important role in her work; not only were they popular with her enthusiastic audience, but they were also an inescapable part of her life, since she was one of ten brothers and sisters and herself bore ten children. This remarkable artist began painting in her seventies, recalling scenes from her own childhood in upstate New York and borrowing images from Currier & Ives and magazines, which she would clip and adapt to her own compositions. Her works are invariably busy and spacious, and the rhythmic patterns in the figures and their gestures have the same vitality and charm as a merry folk dance.

The Vintage. Since children rarely appear in medieval art, it may be that these naked boys working in a vineyard busily harvesting grapes have a symbolic role to play. They look very classical, even Bacchic, which is not surprising since the Early Christian artist who carved them lived in the 3rd or 4th century, shortly after the fall of the Roman Empire. Nevertheless, the artist was clearly familiar with the antics of real children and took the occasion of this commission to record his personal observations.

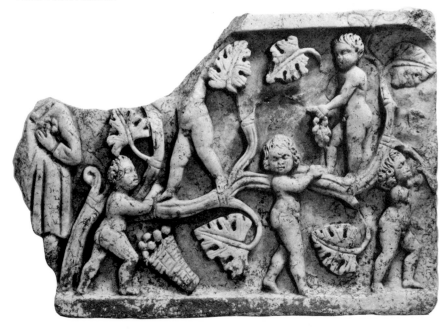

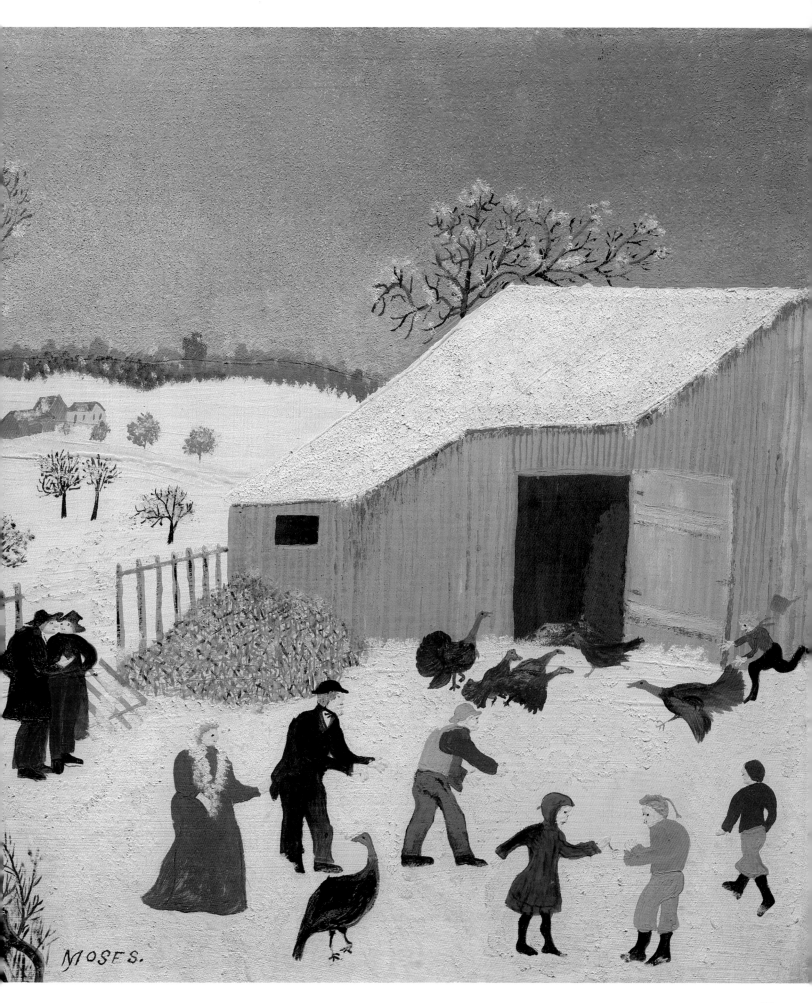

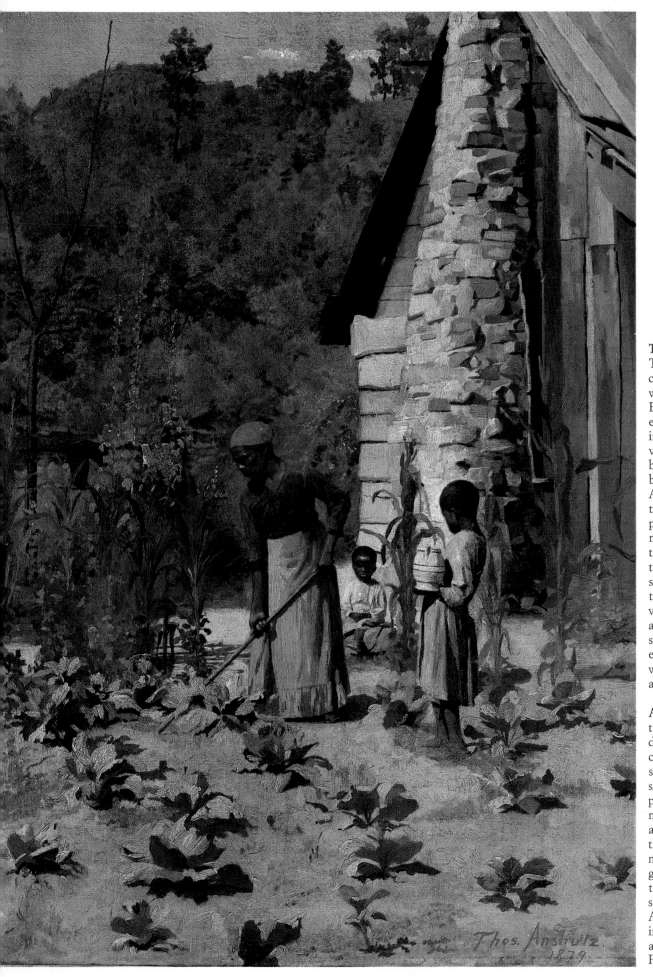

Thos. Anshutz
1879

The Way They Live.
Thomas Anshutz (American, 1851–1912), along with his teacher Thomas Eakins and Winslow Homer, made a number of paintings after the Civil War devoted to the activities of black people. In spite of the bright, pastoral setting, Anshutz displays a sensitive understanding of the predicaments of a black mother and her children as they tend the cabbages in their small garden. The stiffness of the figures and their tired expressions convey a sense of frustration and despair. The children seem to share their mother's heavy burdens of overwork, financial insecurity, and social oppression.

Allegory of Earth. For all that the subject of this drawing by François Boucher (French, 1703–70) is similar to that of the Anshutz painting, these happy children provide a dramatic contrast. They too are busy gardening, but their principal task here is merely to express an allegorical theme. They seem to personify the Rococo spirit that inspired Marie-Antoinette to play at farming in her palace garden, an activity that enraged the French people.

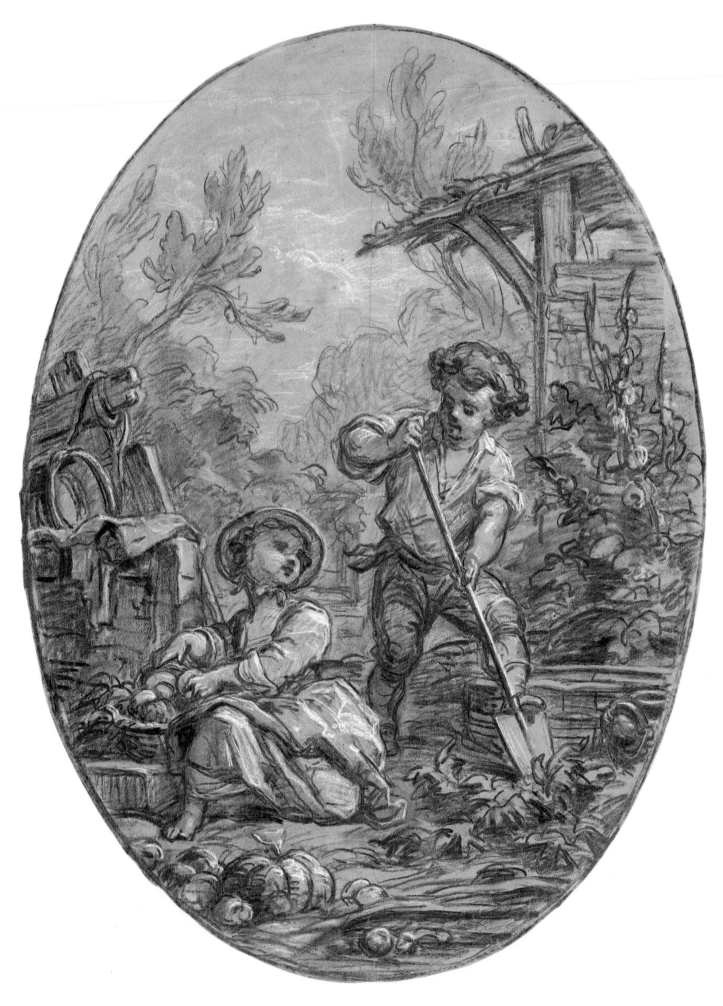

81

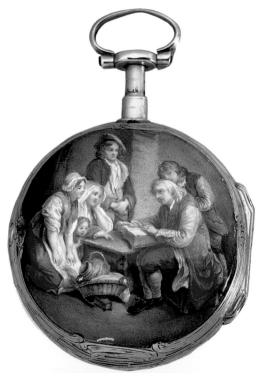

The Bible Reader. This French watchcase of 1755–60 reproduces in enamel a painting by Jean-Baptiste Greuze (French, 1725–1805), whose moralizing genre works were very popular in the 18th century. In this domestic scene, a father is reading the Scriptures to his children, who are attending closely, as all good children are supposed to do. Children, like flowers, were suitable subjects for watchcases, signifying the brief passage of our time on earth.

Woman Pushing a Perambulator with White Parasol. Another pleasant family activity is taking the children to the park on a sunny afternoon, a scene frequently recorded by Maurice Prendergast (American, 1859–1924), who made regular sketching excursions to parks and beaches. This is a fine example of his exceptional work in watercolor, a spontaneous, luminous medium ideally suited to this subject.

Jungle Tales. As every mother knows, reading to children is a family activity that all can enjoy, especially when the reading matter is as entertaining as Rudyard Kipling's *Jungle Book*, published in 1894, the year before James J. Shannon (American, 1862–1923) made this delightful painting. Mrs. Shannon and their daughter, Kitty (in profile), often modeled for the artist, who painted many portraits of children with great warmth and affection.

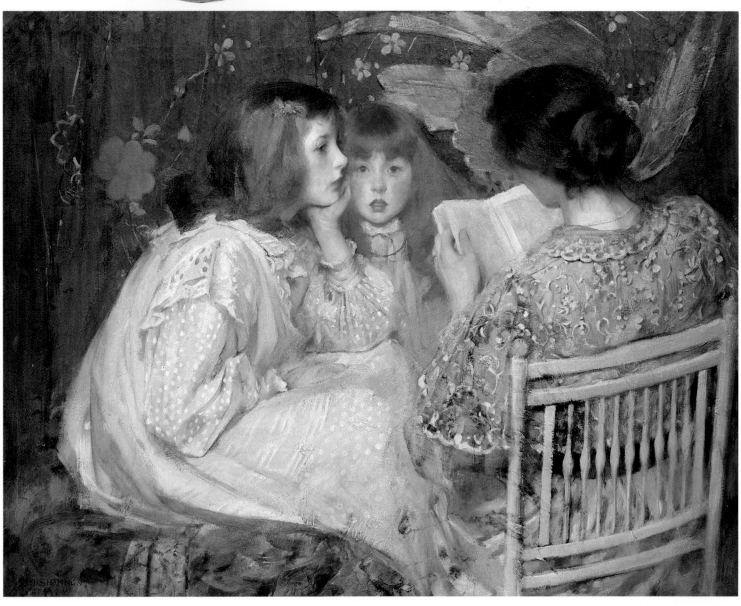

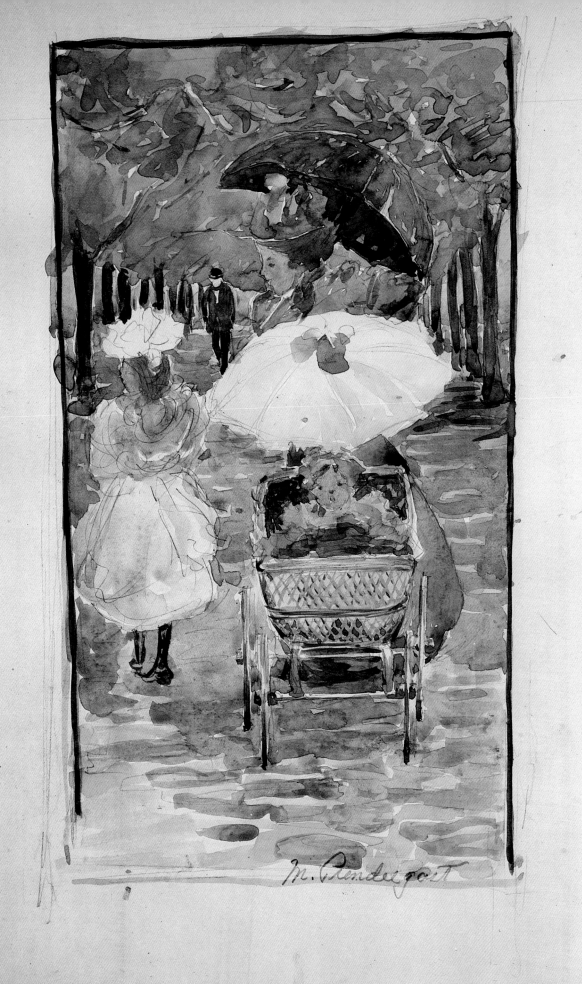

M. Prendergast

School Scene. The Chinese have always taken great pleasure in their children, dressing them in bright colors and calling them precious flowers. This 18th-century painting on silk shows that Chinese artists can find amusement even in watching children misbehave. The school courtyard pictured here is in an uproar, for discipline has given way to chaos as the pupils cavort around their sleeping teacher. Instead of showing proper regard for his wisdom and status, these imps are scandalously naughty; one of them has gone so far as to lift off his hat, and another balances a stool on his feet while lying on a table.

Layla and Majnun at School. This richly painted school scene comes from a 16th-century Persian manuscript containing the poems of Nizami and illustrates an episode in the popular love story about the children of two Arab chieftains who meet at school. The old, bearded teacher, who holds a stick in his hand to encourage good performance, is instructing one attentive pupil, and others seem to be concentrating on their manuscripts, but the schoolroom is not very orderly. Two boys play in the courtyard while another pulls a friend's ear, and pen boxes and inkpots are scattered about.

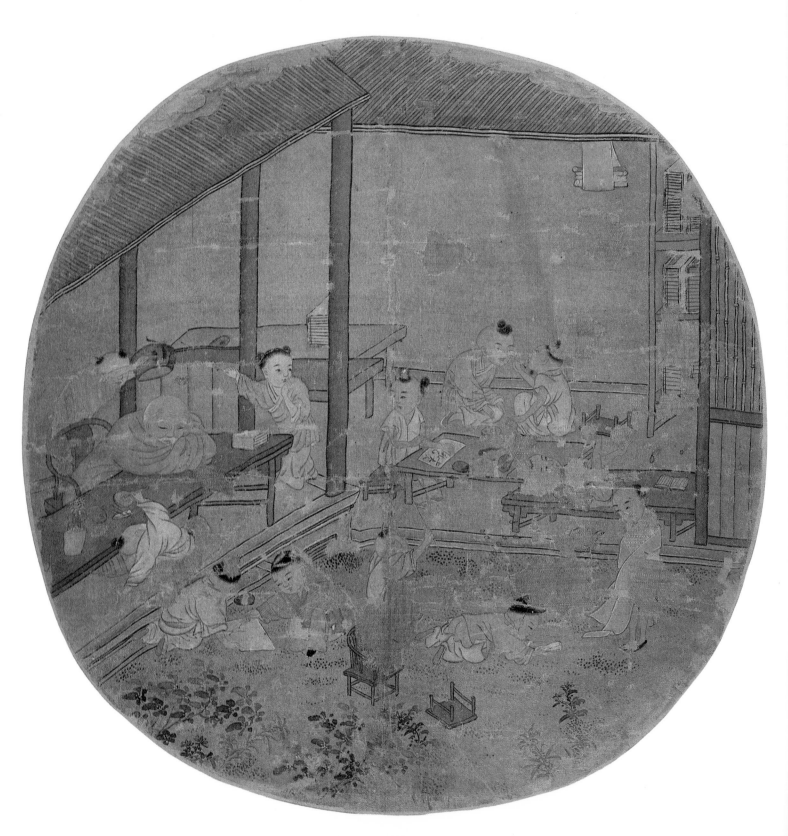

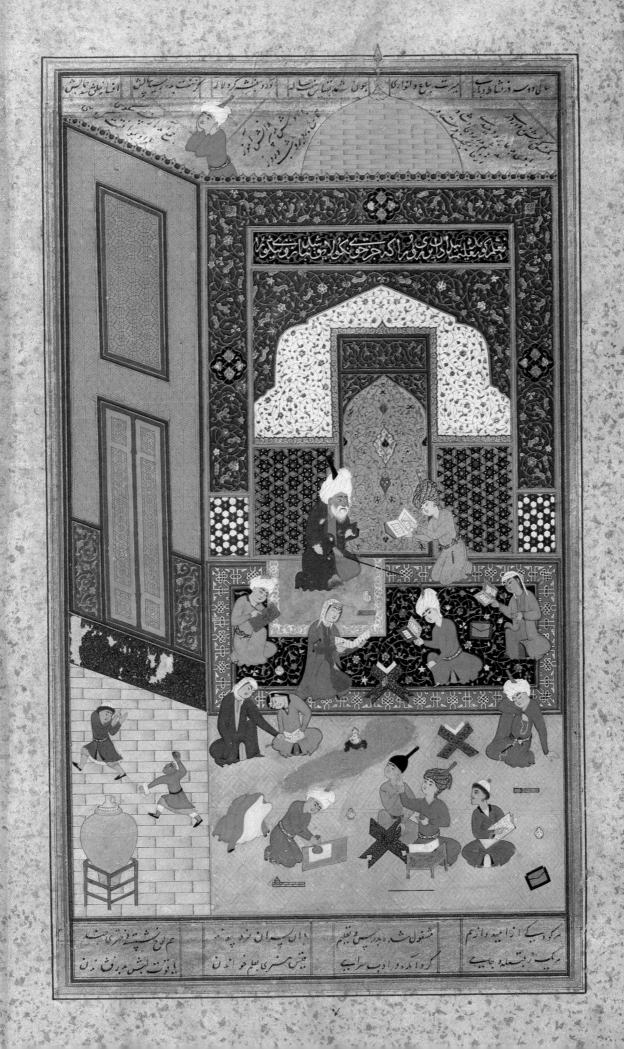

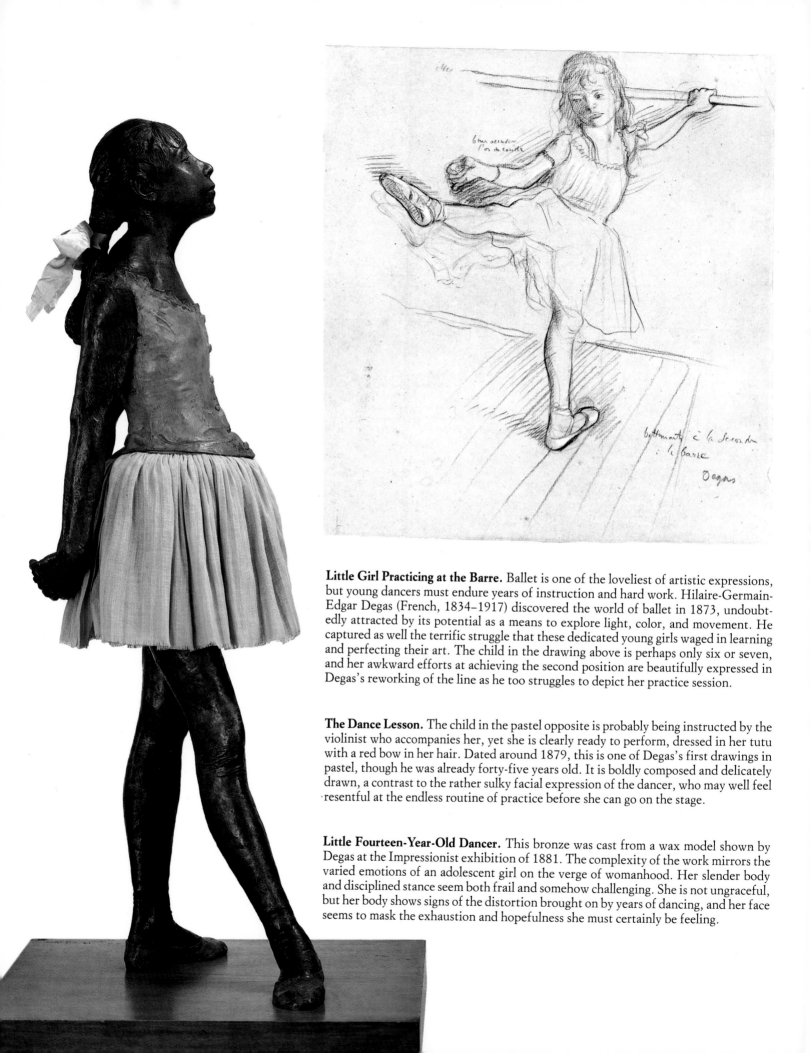

Little Girl Practicing at the Barre. Ballet is one of the loveliest of artistic expressions, but young dancers must endure years of instruction and hard work. Hilaire-Germain-Edgar Degas (French, 1834–1917) discovered the world of ballet in 1873, undoubtedly attracted by its potential as a means to explore light, color, and movement. He captured as well the terrific struggle that these dedicated young girls waged in learning and perfecting their art. The child in the drawing above is perhaps only six or seven, and her awkward efforts at achieving the second position are beautifully expressed in Degas's reworking of the line as he too struggles to depict her practice session.

The Dance Lesson. The child in the pastel opposite is probably being instructed by the violinist who accompanies her, yet she is clearly ready to perform, dressed in her tutu with a red bow in her hair. Dated around 1879, this is one of Degas's first drawings in pastel, though he was already forty-five years old. It is boldly composed and delicately drawn, a contrast to the rather sulky facial expression of the dancer, who may well feel resentful at the endless routine of practice before she can go on the stage.

Little Fourteen-Year-Old Dancer. This bronze was cast from a wax model shown by Degas at the Impressionist exhibition of 1881. The complexity of the work mirrors the varied emotions of an adolescent girl on the verge of womanhood. Her slender body and disciplined stance seem both frail and somehow challenging. She is not ungraceful, but her body shows signs of the distortion brought on by years of dancing, and her face seems to mask the exhaustion and hopefulness she must certainly be feeling.

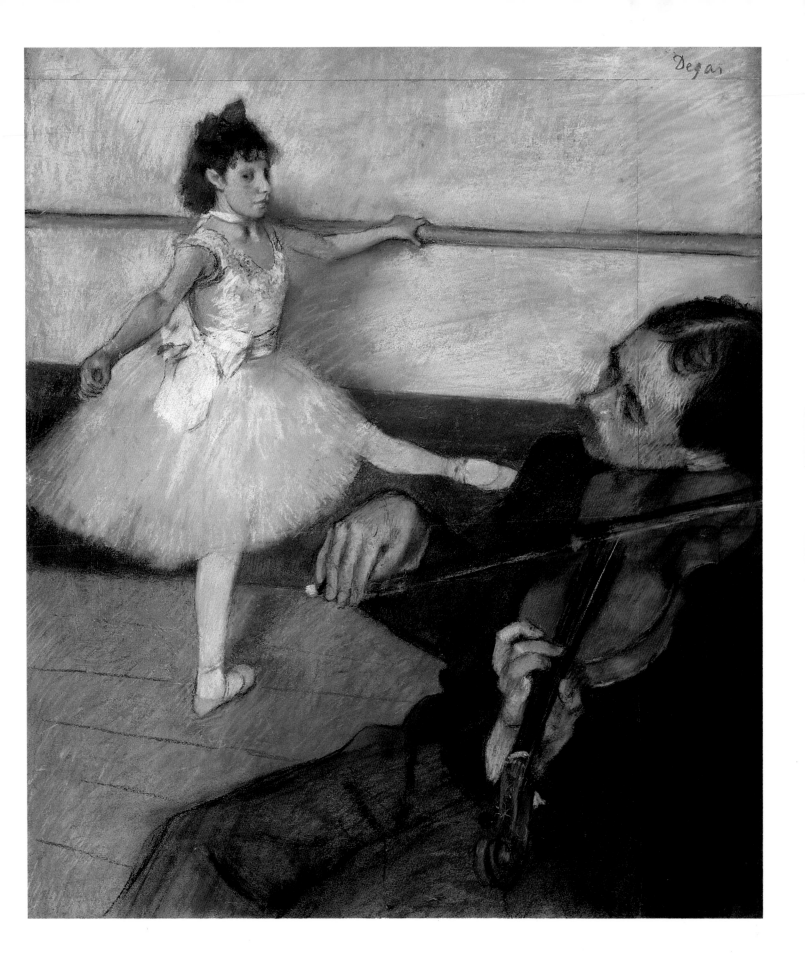

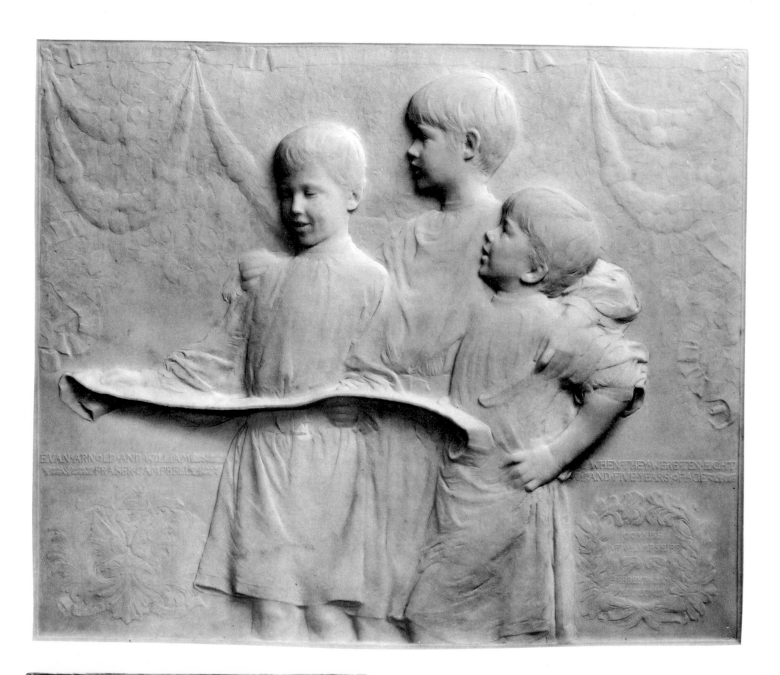

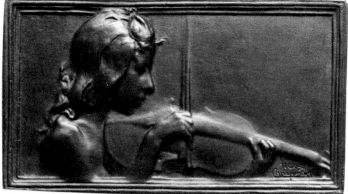

Singing Boys. This handsome relief portrait of Evan, Arnold, and William Frazer-Campbell, carved in 1894 by Herbert Adams (American, 1858–1945), is a fine example of his style. The composition is taken from Luca Della Robbia's singing angels in Florence, but we can also see the influence of Saint-Gaudens in the combination of high and low relief.

The Violin. The young violinist at left was one of a series of musical children modeled by the most lyrical of late 19th-century French medalists, Alexandre Charpentier (French, 1856–1909). The relief is uniformly low, with a fine painterly quality, and the composition—neatly split in half by the vertical bow—is innovative and modern. Charpentier's plaquettes were avidly collected, though they may have been designed originally as inserts for pieces of furniture.

Two Young Girls at the Piano. In this lovely domestic scene painted in 1892 by Pierre-Auguste Renoir (French, 1841–1919), the artist has used music and flowers to enhance the fresh, ephemeral nature of youthful beauty. These two young girls, probably the daughters of Renoir's painter friend Henri Lerolle, are charmingly painted with soft contours and harmonious colors, which make them radiant and sensuous without being either provocative or sentimental.

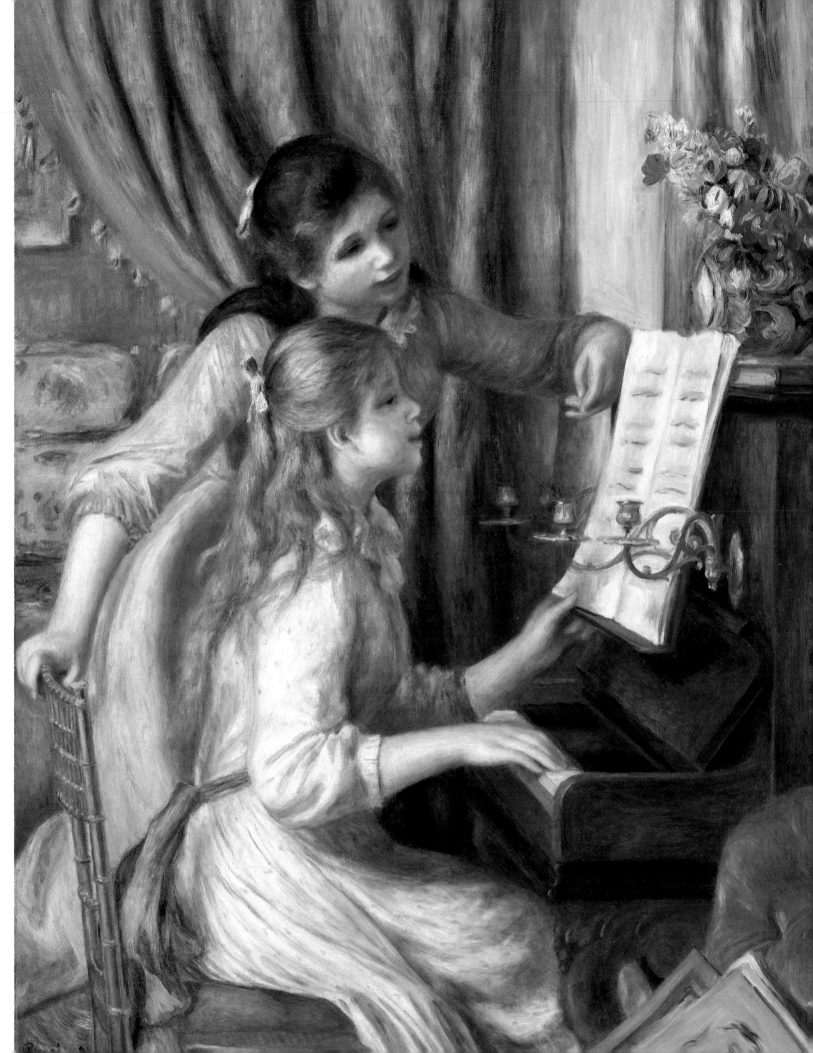

Portrait of a Boy. Little is known of this boy except that he must have enjoyed playing battledore and shuttlecock, a decorous 18th-century version of badminton. He may also have had a pet dog, although the artist, William Williams (American, 1727–91), was not above using a symbolic stage prop to enhance the composition of his rather theatrical portraits.

Little Boy with Cart. Children in ancient Greece played with a variety of toys and are frequently pictured with balls, hoops, and tops, as well as pet animals. This child of the 5th century B.C. pulls a toy cart, perhaps a miniature chariot. The *oinochoe*, or wine jug, on which he appears is a small-sized version of a special shape used in the Diony-sian festival called the Anthesteria, held in autumn to celebrate the new wine. During the second day of the festival, wine was ceremoniously poured into drinking vessels, and even children could partake (the Greeks diluted wine with water, remember). They were prominent participants in this festival, an occasion for gift-giving.

Boy Juggling Shells. Children in the Far East also play with a wide assortment of toys, but this youngster shows both skill and ingenuity by putting snail shells into service as juggling balls. This charming scene must have seemed an ideal subject for the master Katsushika Hokusai (Japanese, 1760–1849), who was famed for his bold, fluent brushwork and joyous view of the world.

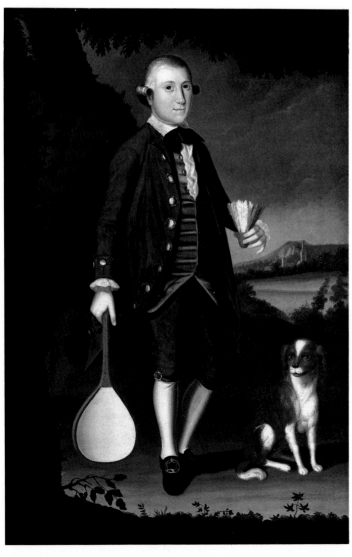

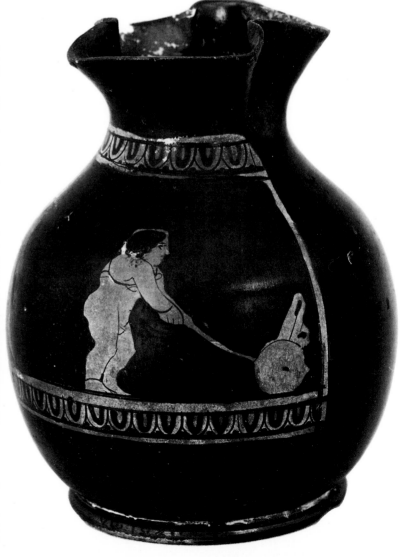

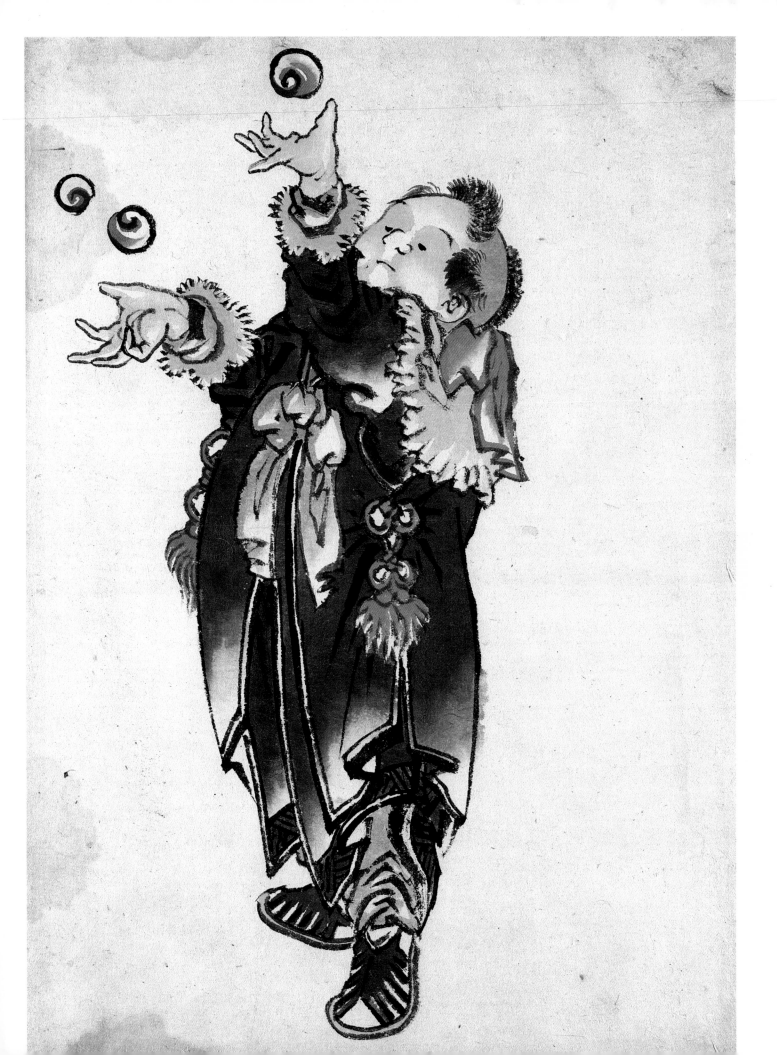

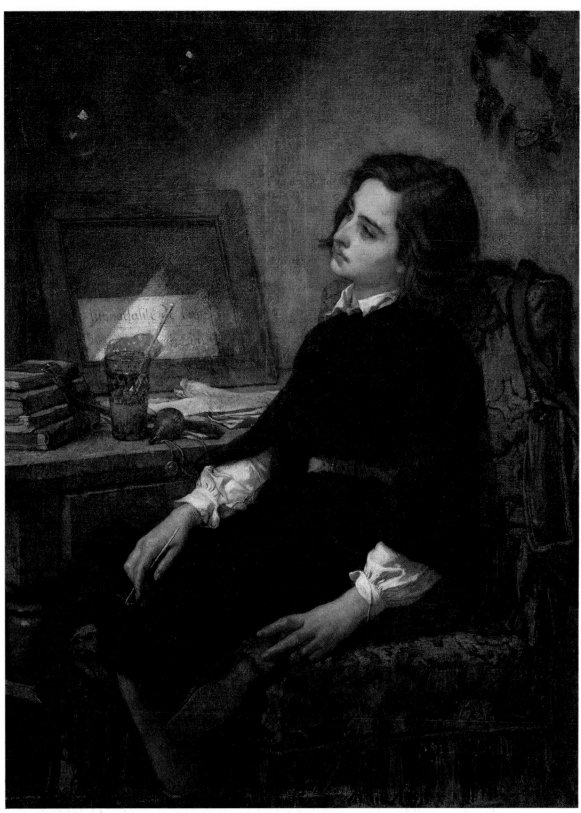

Soap Bubbles. Since ancient times, children blowing soap bubbles have symbolized the transience of human life, and Thomas Couture (French, 1815–79) made several versions of this theme, perhaps inspired by the work of Chardin (opposite). He has virtually loaded this simple scene with allegorical meaning; the inscription "immortalité de l'un" appears in the mirror (vanity), and the evils of idleness are expressed in the listless figure of the aristocratic schoolboy who whiles away his time while masonry crumbles around him and his books lie unread.

Blowing Bubbles. Jean-Baptiste-Siméon Chardin (French, 1699–1779) was in turn inspired by similar scenes in 17th-century Dutch painting. The subject—the ephemeral nature of life—is the same as in the Couture, but Chardin's painting is far simpler, and perhaps even more meaningful. The two boys concentrate intently on the bubble, which is about to burst, but the straightforward composition, the solid forms, and the fact that they are clearly members of the solid middle class give an eternal quality to this record of a brief moment in time.

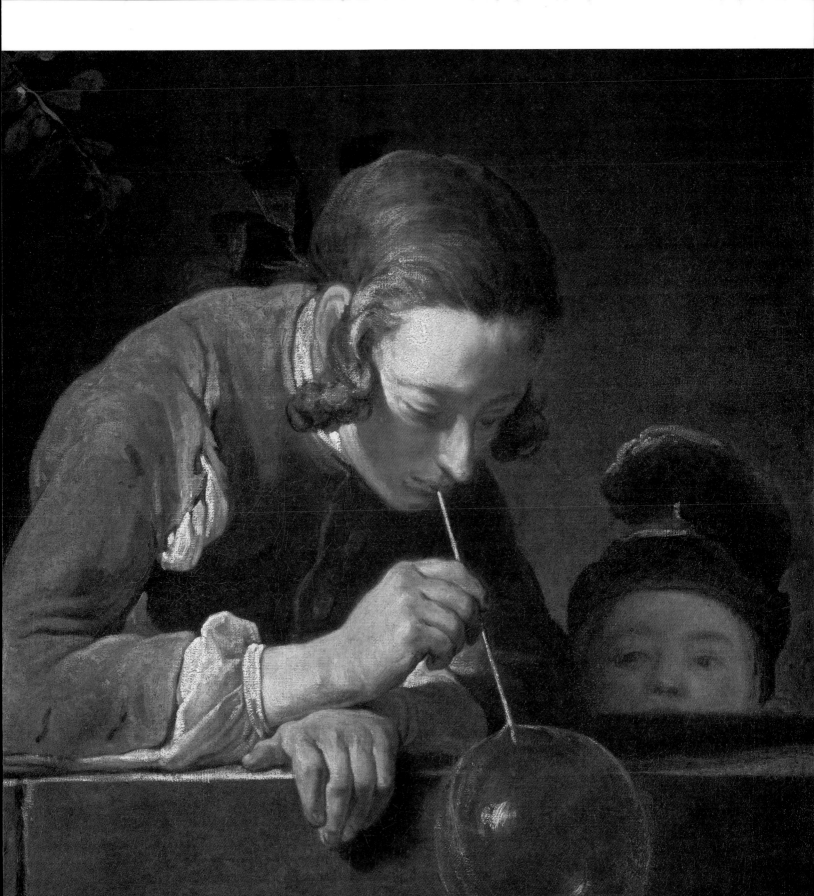

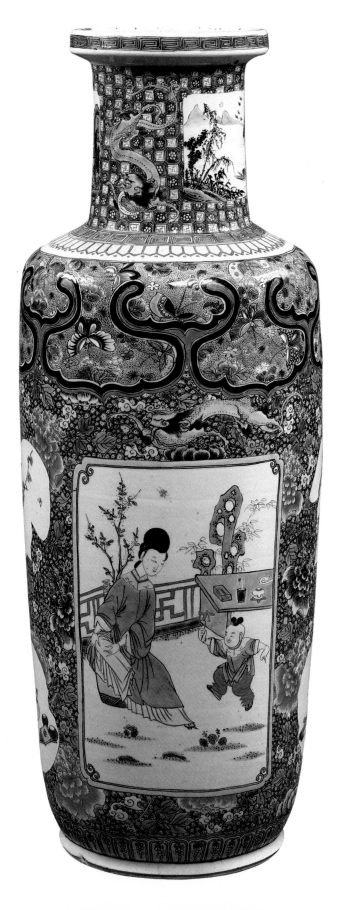

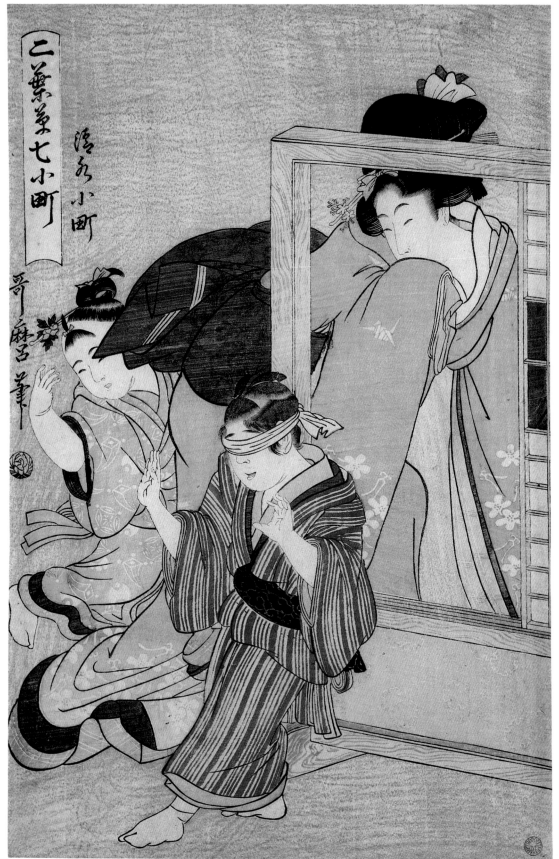

La Rue (detail). In this poster advertising the printing shop of Charles Verneau, Alexandre-Théophile Steinlen (French, 1859–1924) chose to depict one of his favorite subjects, the teeming humanity of the streets of Paris. Steinlen was an important printmaker, who, like Toulouse-Lautrec, helped make color lithography a legitimate art form. He reflected popular tastes and was extremely prolific, illustrating thousands of journals and over 100 books. He was especially fond of cats and children and included them in his work whenever he could.

Vase. This handsome porcelain vessel was probably made during the reign of the K'ang-hsi emperor in China (1662–1722) and, like many Chinese works of art, features the activities of children. This delightful child, who is jumping for pure joy under the watchful eyes of his adoring mother, wears brightly colored clothing, just as Chinese children do today.

A Woman Watches Two Children Playing Blindman's Buff. In this lively woodblock print, Kitagawa Utamaro (Japanese, 1753–1806) again shows a mother taking enormous pleasure in the playful antics of her children. The origins of blindman's buff are unknown, but it seems to have been as popular in Japan as in the Western world. The prints of Utamaro and other Japanese artists had a strong influence on 19th-century French art, as we can see in the Steinlen poster, most obviously in the hairstyles of the two mothers.

Knickknack Peddler. Like the school scene on page 84, this charming painting was originally a fan, which was an important format for traditional Chinese painting. This work is attributed to Li Sung (active about 1210–30), whose fame rested on these meticulously detailed genre scenes. The peddler is carrying a huge array of objects, including household utensils and tools, but it is obviously the toys that are of greatest interest here, at least to the four children who cling excitedly to their nurse. In the unlikely event that his captive audience becomes distracted, the smiling salesman will certainly be able to win them back by twirling the flag in his cap or activating the trained magpies that perch on his wares.

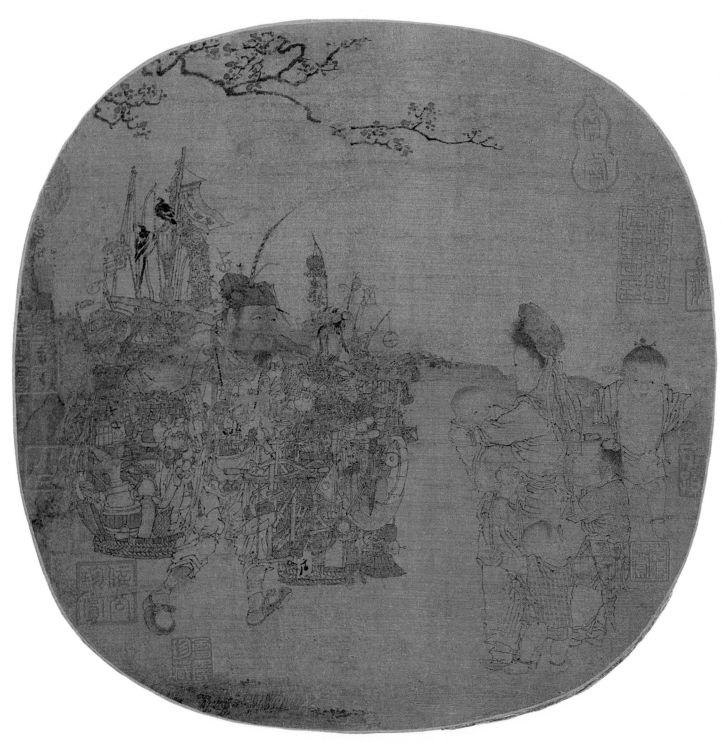

Children with Toy Seller on the Quai du Louvre.
These 19th-century French children are no less entranced by the prospect of new toys than their 13th-century Chinese counterparts. Here they gather around a toy seller who has spread his offerings on a Paris sidewalk, recalling the Christmas Eve act in *La Bohème* in which Parpignol appears with similar treats for the children. The artist, Jean Beraud (French, 1849–1936), painted many portraits but after 1875 concentrated on genre, leaving a picturesque record of French life, which he often sketched on the spot from a specially outfitted carriage.

OVERLEAF: **Snap the Whip.** During the 1870s, Winslow Homer (American, 1836–1910) worked as an illustrator for *Harper's Weekly* and other journals in New York City, but he frequently visited the Catskill area since he was not much interested in scenes of urban life. Ever attuned to popular interests and fully aware that images of children were in great demand, Homer made a number of marvelous paintings of children at play at this time. Among them is this study for the final version, which is in the Butler Institute of American Art. It is unsentimental yet optimistic, a joyful, vibrant image of rural America. Although Homer was a bachelor, children are often featured in his work; one of his earliest drawings was a portrait of his twelve-year-old brother, Charles, which he entitled *Adolescence*.

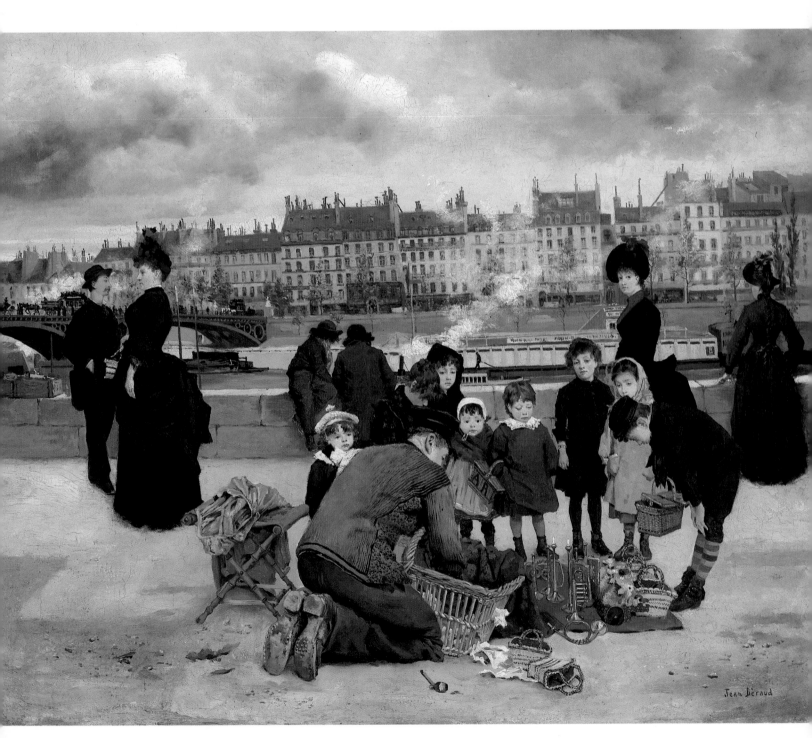

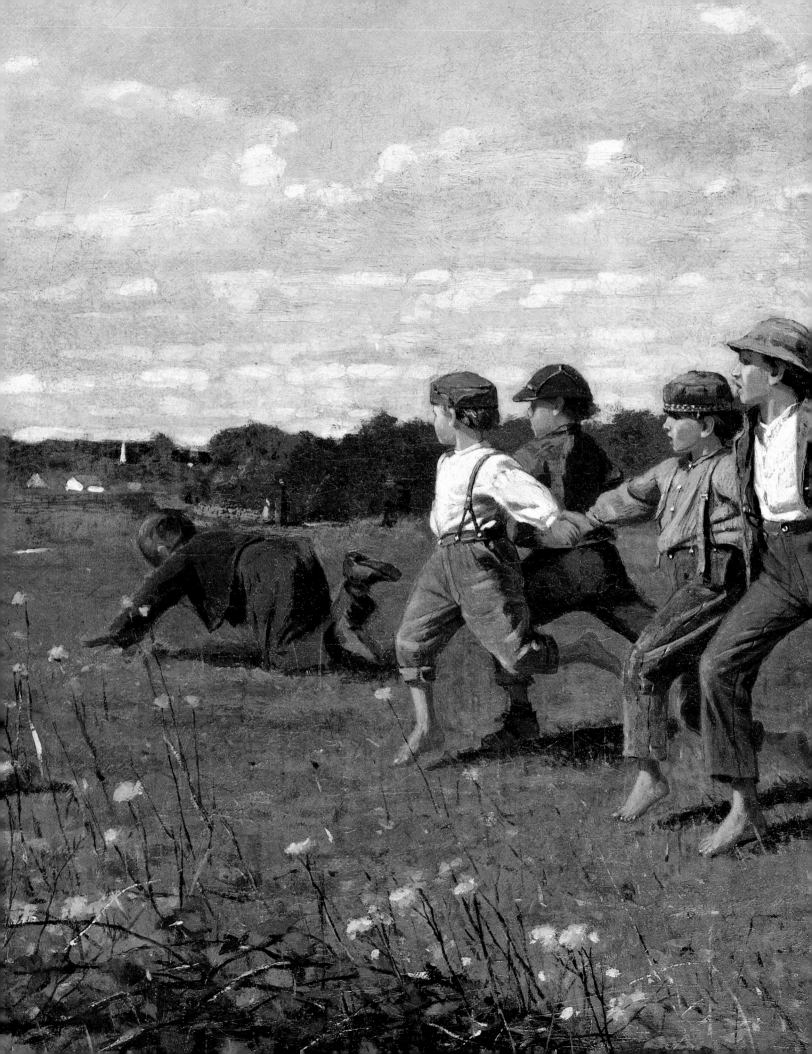

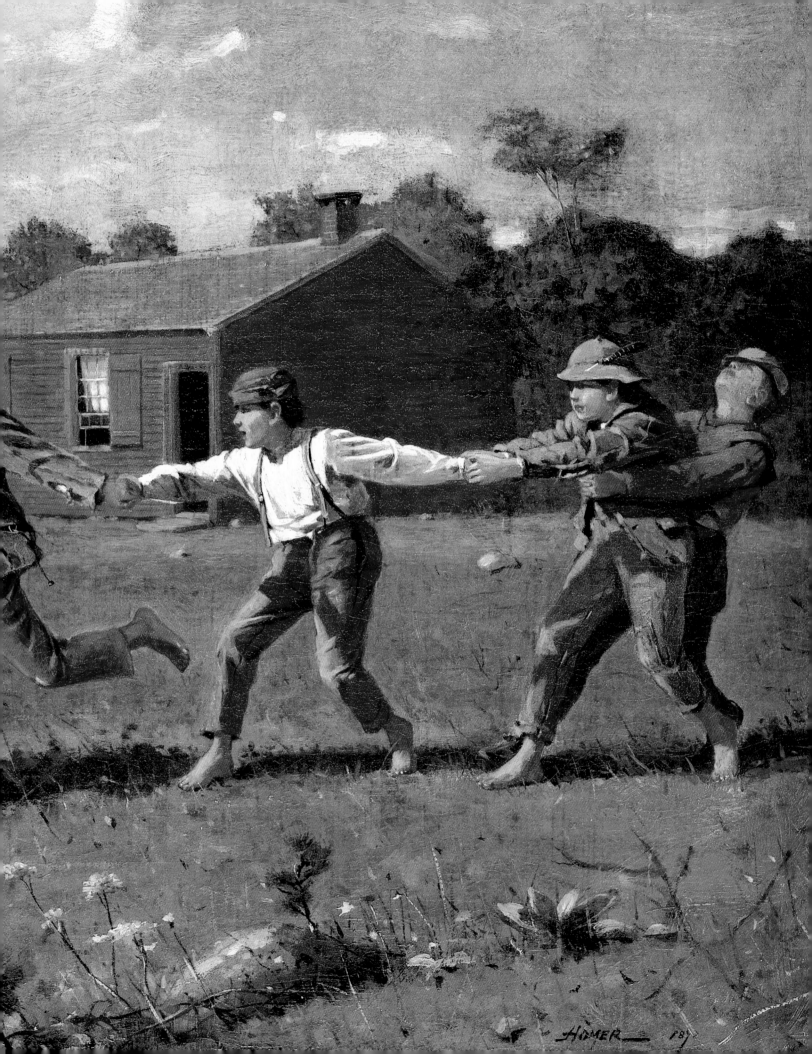

A Day in a Child's Life. Few artists have so delighted in children as Kate Greenaway (British, 1846–1901), who wrote and illustrated many books for them, including this charming volume, published in 1881. Sprinkled thoughout the text are children playing at all sorts of games, but the most exuberant of all shows them running one after another, probably enjoying a Victorian version of tag.

Fanfan Playing with Punchinello and Friends. This etching seems to be an 18th-century equivalent of a snapshot, for it is a view of two-year-old Alexandre-Evariste Fragonard, nicknamed Fanfan, playing with his dogs and his doll. Fanfan was the son of Jean-Honoré Fragonard (French, 1732–1806), who doted on his children; the etching was made with the assistance of his sister-in-law Marguerite Gérard, who joined the Fragonard household when she was herself a child.

Studies of Children. We know little about this lovely drawing, except that it was produced by an Italian artist in the 16th or 17th century. Perhaps it is a study for a painting featuring putti or cherubim, but clearly the artist had a keen eye and appreciation for the playful nature of real children.

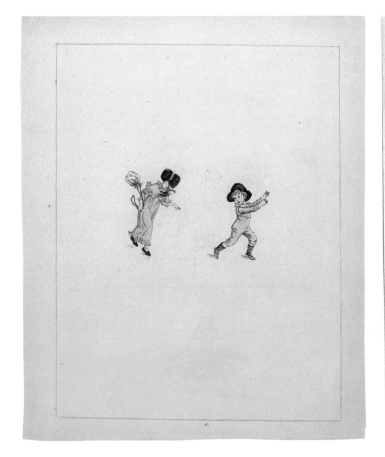

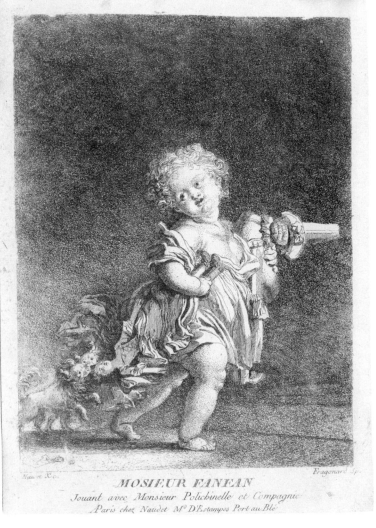

MOSIEUR FANFAN
Jouant avec Monsieur Polichinelle et Compagnie
Paris chez Naudet M.ᵈ D'Estampes Port au Blé

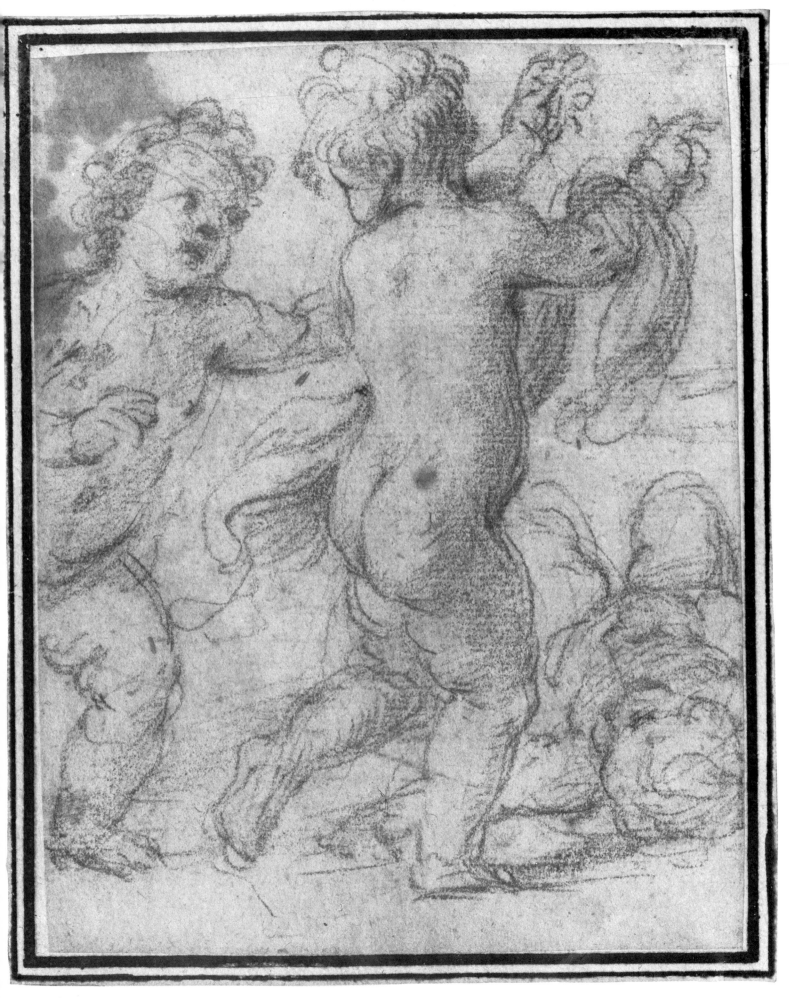

Child at Play. This very young child is spinning a top as he decorates a handsome porcelain dish (opposite) produced about 1770 by the Meissen factory near Dresden. Since its establishment in 1710, Meissen had been producing some of the finest porcelain in Europe, and after about 1750, children were an increasingly popular theme. This particular tot actually spun his top in the 17th century for an artist named Jacques Stella, whose niece, Claudine Bouzonnet Stella, made a series of engravings entitled *Les Jeux et Plaisirs de l'Enfance.*

Ecuelle. Although the children fishing on the side of this attractive porcelain soup bowl are definitely Chinese, the object itself is purely French. It was produced at Chantilly, about 1730, at a factory founded by the prince de Condé, who was an enthusiastic collector of Chinese and Japanese porcelain. The image may have been inspired by an Oriental source, but the whimsical style of the decoration—including the snail on the lid—is typical of European chinoiserie, which was very popular in France during the 18th century.

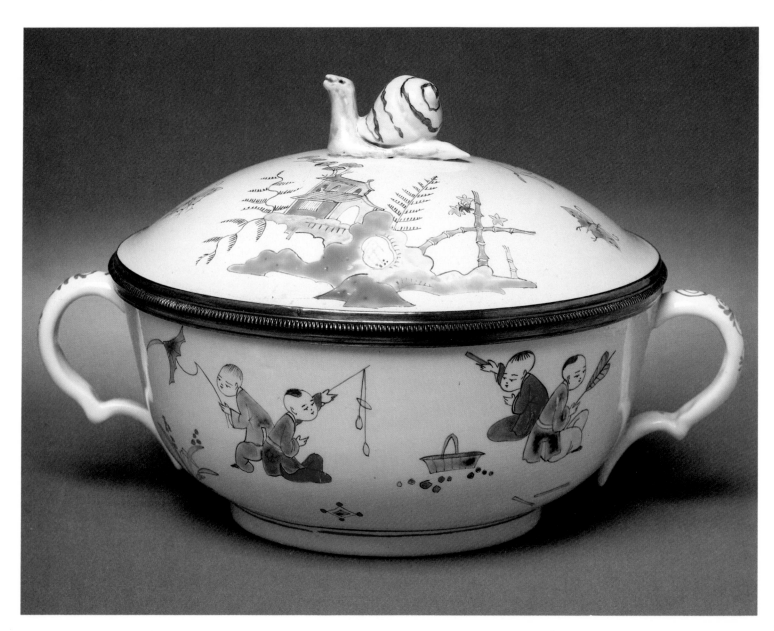

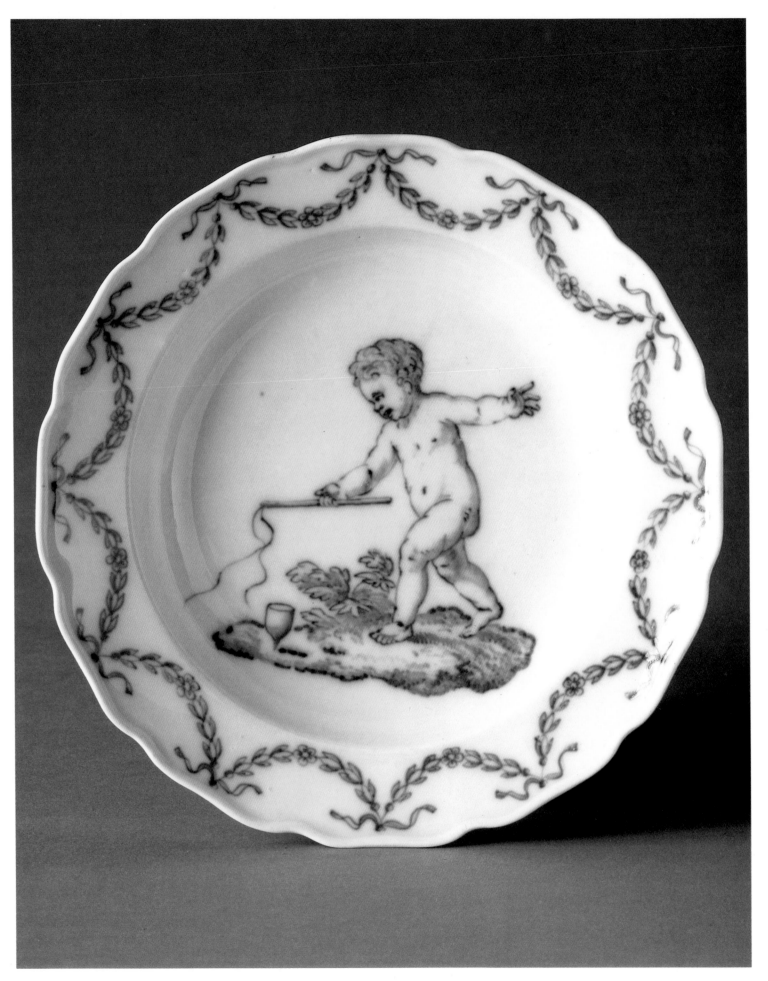

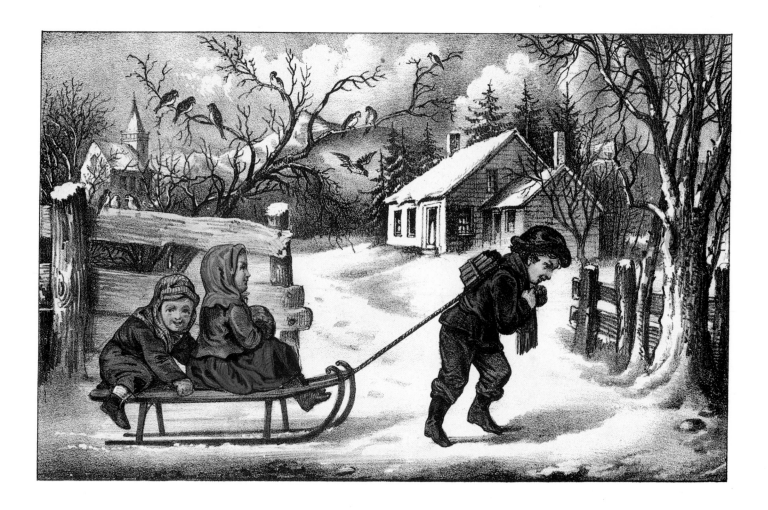

A Ride to School. The lithography firm operated by Nathaniel Currier and James Merritt Ives produced nearly 7500 prints, which enable us today to observe nearly every aspect of mid-19th-century America. These colored prints based on paintings made by a number of different artists were incredibly popular, and winter scenes involving children were favorite subjects. This small print, measuring only 5 x 8 inches, probably sold for 15¢. Currier & Ives also catered to young customers by producing school cards, undoubtedly teaching moral lessons rather than celebrating the joys of childhood.

Postcard. In Austria at the turn of the 20th century, a design movement known as the Wiener Werkstätte produced lithographs and postcards based on the work of many talented artists. (See the following pages for more examples.) Like the firm of Currier & Ives, this was a commercial venture, an international company that even had a retail store in New York City, and, as any printer interested in sales would do, inserted children frequently in the scenes, many of which featured holidays.

The Snow Ball. This lively winter scene was designed by Suzuki Harunobu (Japanese, 1725–70), who portrayed women of all social levels, many of them engaged in activities with children. The snowball in this woodblock print is embossed to give a three-dimensional effect. Above it are pink plum blossoms already in bloom, showing the promise of spring.

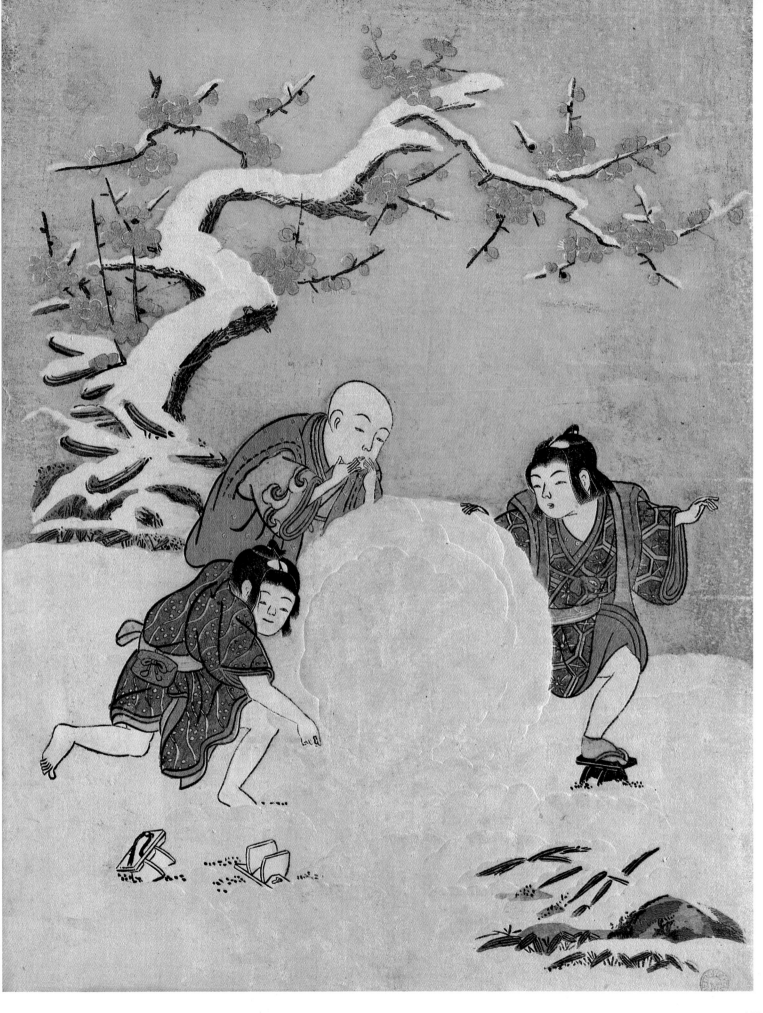

List of Illustrations

PAGE 19. *Woman Holding a Child*
Dinos Painter (Greek, 5th century B.C.)
Red-figured terracotta bell krater (fragment); 2½ x 2⁵/₁₆ in.
Fletcher Fund, 1924, 24.97.39

PAGES 20–21. *First Steps*
Vincent van Gogh (Dutch, 1853–90)
Oil on canvas; 28½ x 35⁷/₈ in.
Gift of George N. and Helen M. Richard, 1964, 64.165.2

PAGE 22. *The Lacemaker*
Nicolaes Maes (Dutch, 1634–93)
Oil on canvas; 17³/₄ x 20³/₄ in.
Bequest of Michael Friedsam, 1931, The Friedsam Collection,
 32.100.5

PAGE 23. *Young Mother Sewing*
Mary Cassatt (American, 1845–1926)
Oil on canvas; 36³/₈ x 29 in.
Bequest of Mrs. H. O. Havemeyer, 1929, H. O. Havemeyer
 Collection, 29.100.48

PAGE 24. *The Coiffure*
Pablo Picasso (Spanish, 1881–1973)
Oil on canvas; 68⁷/₈ x 39¼ in.
Wolfe Fund, Catharine Lorillard Wolfe Collection, 1951. Acquired
 from The Museum of Modern Art, Anonymous Gift, 1953,
 53.140.3

PAGE 25. *Yamauba Combing Her Hair and Kintoki*
Kitagawa Utamaro (Japanese, 1753–1806)
Woodblock print; 14⁵/₈ x 10 in.
Gift of Estate of Samuel Isham, 1914, JP 979

PAGE 26. *The Artist Sketching a Young Girl*
Hubert Robert (French, 1733–1808)
Red chalk on paper; 10 x 13⁵/₁₆ in.
Bequest of Walter C. Baker, 1971, 1972.118.230

PAGE 27. *Head of a Young Girl, Studies of Her Right and Left Hands
 and of Her Right Foot*
Charles de La Fosse (French, 1636–1716)
Red, black, white, and yellow chalk; 14⁷/₁₆ x 10⁷/₁₆ in.
Harry G. Sperling Fund, 1980, 1980.321

The Proportions of an Infant, woodcut illustration from
 De Symmetria Partium Humanorum Corporum (Nuremberg, 1534;
 first edition 1528)
Albrecht Dürer (German, 1471–1528)
Illustrated book; 12 x 7³/₄ in.
Gift of Mortimer L. Schiff, 1918, 18.57.4

PAGE 28. *Spring: Margot Standing in a Garden*
Mary Cassatt (American, 1845–1926)
Oil on canvas; 26³/₄ x 22³/₄ in.
Bequest of Ruth Alms Barnard, 1981, 1982.119.2

Portrait of a Child
Paulus Moreelse (Dutch, 1571–1638)
Oil on wood, oval; 23 x 19⁵/₈ in.
Bequest of Alexandrine Sinsheimer, 1958, 59.23.17

PAGE 29. *Margot Bérard (1872–1956)*
Pierre-Auguste Renoir (French, 1841–1919)
Oil on canvas; 16¹/₈ x 12³/₄ in.
Bequest of Stephen C. Clark, 1960, 61.101.15

PAGE 30. *Little Girl Holding Grapes*
Artist unidentified (American, 19th century)
Oil on canvas; 35³/₄ x 28⁷/₈ in.
Gift of Edgar William and Bernice Chrysler Garbisch, 1973,
 1973.323.6

PAGE 31. *Her World*
Philip Evergood (American, 1901–73)
Oil on canvas; 48 x 35⁵/₈ in.
Arthur Hoppock Hearn Fund, 1950, 50.29

PAGE 32. *Florence Leyland*
James McNeill Whistler (American, 1834–1903)
Etching; 3³/₈ x 5⁷/₁₆ in.
Harris Brisbane Dick Fund, 1917, 17.3.68

PAGE 33. *Marion Lenbach, Daughter of the Artist*
Franz von Lenbach (German, 1836–1904)
Oil on canvas; 58⁷/₈ x 41½ in.
Bequest of Collis P. Huntington, 1900, 25.110.46

PAGE 34. *The Wood Gatherers*
Thomas Gainsborough (British, 1727–88)
Oil on canvas; 58¹/₈ x 47³/₈ in.
Bequest of Mary Stillman Harkness, 1950, 50.145.17

Brother and Sister
Auguste Rodin (French, 1840–1917)
Bronze group; 15 in. high
Rogers Fund, 1908, 08.265

PAGE 35. *The Calmady Children (Emily, 1818–1906, and Laura Anne,
 1820–94)*
Sir Thomas Lawrence (British, 1769–1830)
Oil on canvas; 30⁷/₈ x 30¹/₈ in.
Bequest of Collis P. Huntington, 1900, 25.110.1

PAGE 36. *The Two Sisters*
Jean-Honoré Fragonard (French, 1732–1806)
Oil on canvas; 28¹/₄ x 22 in.
Gift of Julia A. Berwind, 1953, 53.61.5

PAGE 37. *The Two Sisters*
Jean-Claude Richard, Abbé de Saint-Non (French, 1727–91)
Pastel on paper, mounted on canvas; 31⁵/₈ x 25 in.
Gift of Daniel Wildenstein, 1977, 1977.383

PAGE 38. *Portrait of a Boy*
Egyptian (Roman period, 2nd century A.D.)
Encaustic on wood panel from mummy of boy; 14¹⁵/₁₆ x 7½ in.
Gift of Edward S. Harkness, 1918, 18.9.2

PAGE 39. *Joseph Barra, after F. Garnerey*
Pierre-Michel Alix (French, 1762–1817)
Color etching and aquatint; 10 x 7³/₄ in.
Rogers Fund, 1961, 61.653.34

PAGE 40. *Midshipman Augustus Brine*
John Singleton Copley (American, 1738–1815)
Oil on canvas; 50 x 40 in.
Bequest of Richard D. Brixey, 1943, 43.86.4

José Costa y Bonells, Called Pepito (d. 1870)
Francisco Goya (Spanish, 1746–1828)
Oil on canvas; 41³/₈ x 33¹/₄ in.
Gift of Countess Bismarck, 1961, 61.259

PAGE 41. *Portrait of a Child*
Camille Corot (French, 1796–1875)
Oil on wood; 12⁵/₈ x 9¹/₄ in.
Bequest of Mrs. H. O. Havemeyer, 1929, H. O. Havemeyer
 Collection, 29.100.564

PAGE 42. *Boy with a Sword*
Edouard Manet (French, 1832–83)
Oil on canvas; 51⁵/₈ x 36³/₄ in.
Gift of Erwin Davis, 1889, 89.21.2

PAGE 43. *Portrait Bust of Sabine Houdon*
Jean-Antoine Houdon (French, 1741–1828)
White marble on gray marble base; 17¹/₂ in. high
Bequest of Mary Stillman Harkness, 1950, 50.145.66

Portrait of Titus Van Ryn
Rembrandt van Rijn (Dutch, 1606–69)
Etching; 3⁷/₈ x 2⁷/₈ in.
Harris Brisbane Dick Fund, 1917, 17.3.1411

PAGE 44. *Boy with Baseball*
George Luks (American, 1867–1933)
Oil on canvas; 30 x 25 in.
The Edward Joseph Gallagher III Memorial Collection,
 Gift of Edward J. Gallagher, Jr., 1954, 54.10.2

PAGE 45. *Roland*
William Merritt Chase (American, 1849–1916)
Oil on canvas; 20³/₈ x 16¹/₄ in.
Bequest of Emma T. Gary, 1934, 37.20.1

PAGE 46. *Francesco Sassetti (1421–90) and His Son Teodoro*
Domenico Ghirlandaio (Italian, ca. 1448–94)
Tempera on wood; 29¹/₂ x 20¹/₂ in.
The Jules Bache Collection, 1949, 49.7.7

Medal Commemorating the Baptism of the King of Rome
Bertrand Andrieu (French, 1761–1822)
Bronze; 2 in. diameter
Rogers Fund, 1977, 1977.254.3

PAGE 47. *The Emperor Shah Jahan and His Son Shuja,* leaf from the
Shah Jahan Album
Attributed to Nanha, Mughal period (Indian, ca. 1625–30)
Ink, colors and gold on paper; 4⁷/₈ x 7³/₄ in.
Purchase, Rogers Fund and The Kevorkian Foundation Gift, 1955,
 55.121.10.36

PAGE 48. *Portrait Bust of a Child*
Artist unknown (Roman, first half of the 1st century A.D.)
Bronze; 11¹/₂ in. high
Funds from various donors, 1966, 66.11.5

PAGE 49. *Federigo Gonzaga*
Francesco Francia (Italian, ca. 1450–1517/18)
Tempera on wood; 18⁷/₈ x 14 in.
Bequest of Benjamin Altman, 1913, 14.40.638

PAGE 50. *Louis XV (1710–74) as a Child*
Hyacinthe Rigaud (French, 1659–1743)
Oil on canvas; 77 x 55¹/₂ in.
Purchase, Bequest of Mary Wetmore Shively in memory of her
 husband, Henry L. Shively, M.D., 1960, 60.6

PAGE 51. *Edward VI (1537–53), King of England, When Duke
 of Cornwall*
Hans Holbein the Younger (German, 1497/98–1543)
Tempera and oil on wood; 12³/₄ in. diameter
The Jules Bache Collection, 1949, 49.31

PAGE 52. *Portrait of a Young Princess (Probably Margaret of Austria,
 1480–1530)*
Master of Moulins (French, active last quarter 15th century)
Tempera on wood; 13¹/₂ x 9¹/₂ in.
Robert Lehman Collection, 1975, 1975.1.130

PAGE 53. *Infanta María Teresa of Spain (1638–83)*
Diego Velázquez (Spanish, 1599–1660)
Oil on canvas; 19 x 14¹/₂ in.
Robert Lehman Collection, 1975, 1975.1.147

PAGE 54. *Lady Smith (Charlotte Delaval) and Her Children*
Sir Joshua Reynolds (British, 1723–92)
Oil on canvas; 55³/₈ x 44¹/₈ in.
Bequest of Collis P. Huntington, 1900, 25.110.10

PAGE 55. *The Sackville Children*
John Hoppner (British, 1758–1810)
Oil on canvas; 60 x 49 in.
Bequest of Thomas W. Lamont, 1948, 53.59.3

PAGE 56. *Henry Frederick (1594–1612), Prince of Wales, and Sir John
 Harington (1592–1614)*
Robert Peake the Elder (British, active by 1576, d. 1626)
Oil on canvas; 79¹/₂ x 58 in.
Purchase, Joseph Pulitzer Bequest, 1944, 44.27

PAGE 57. *Studies of a Seated Youth in Armor*
Vittore Carpaccio (Italian, 1460/65–ca. 1526)
Point of brush and gray wash, heightened with white, on blue paper;
7⁷/₁₆ x 7¹/₁₆ in.
The Elisha Whittelsey Collection, The Elisha Whittelsey Fund,
1954, 54.119

Child's Armor
Italian (?), ca. 1570
Steel; 55 in. high
Rogers Fund, 1904, 04.3.266

PAGE 58. *Welcoming the New Year* (detail)
Artist unknown (Chinese, Yüan dynasty, 1279–1368)
Silk embroidery and plant fiber on silk gauze, 85 x 24³/₁₆ in.
Purchase, The Dillon Fund Gift, 1981, 1981.410

*Starting for the Hunt (Michiel, 1638–53, and Cornelis Pompe van
Meerdervoort, 1639–80, with Their Tutor and Coachman)*
Aelbert Cuyp (Dutch, 1620–91)
Oil on canvas; 43¹/₄ x 61¹/₂ in.
Bequest of Michael Friedsam, 1931, The Friedsam Collection,
32.100.20

PAGE 59. *The Drummond Children*
Sir Henry Raeburn (British, 1756–1823)
Oil on canvas; 94¹/₄ x 60¹/₄ in.
Bequest of Mary Stillman Harkness, 1950, 50.145.31

PAGE 60. *The Children of Jacob H. Schiff*
Augustus Saint-Gaudens (American, 1848–1907)
Marble bas-relief; 69¹/₂ x 51 in.
Gift of Jacob H. Schiff, 1905, 05.15.3

Temple Boy
Cypriot (3rd century B.C.)
Stone; 12³/₈ in. high
Cesnola Collection of Antiquities from Cyprus, Purchased by
subscription, 1874–76, 74.51.2762

PAGE 61. *Daniel Crommelin Verplanck*
John Singleton Copley (American, 1738–1815)
Oil on canvas; 49¹/₂ x 40 in.
Gift of Bayard Verplanck, 1949, 49.12

PAGE 62. *Boy on a Rooster*
Epiktetos (Greek, ca. 520–510 B.C.)
Terracotta, 7³/₈ in. diameter
Purchase, Classical Purchase Fund, Schimmel Foundation, Inc. and
Christos G. Bastis Gifts, 1981, 1981.11.10

PAGE 63. *Children Playing with Birds*
François Ladatte (Italian, 1706–87)
Lead; 36¹/₂ in. high
Purchase, Josephine Bay Paul and C. Michael Paul Foundation, Inc.
Gift, and Charles Ulrick and Josephine Bay Foundation, Inc., Gift,
1970, 1970.80.1

PAGE 64. *Boy and Duck*
Frederick W. MacMonnies (American 1863–1937)
Bronze statue; 46 in. high
Rogers Fund, 1922, 22.61

Girl Holding Two Pigeons
Greek (5th century B.C.)
Marble grave relief; 31¹/₂ in. high
Fletcher Fund, 1927, 27.45

PAGE 65. *Frederick de Vries*
Hendrik Goltzius (Dutch, 1558–1617)
Engraving, 14⁵/₁₆ x 10⁷/₃₂ in.
Harris Brisbane Dick Fund, 1926, 26.72.101

PAGE 66. *Edward and Sarah Rutter*
Joshua Johnston (American, active 1796–1824)
Oil on canvas; 36 x 32 in.
Gift of Edgar William and Bernice Chrysler Garbisch, 1965,
65.254.3

PAGE 67. *Allegory of Air: Two Children with a Bird*
François Boucher (French, 1703–70)
Black chalk, heightened with white chalk, on brown paper;
30 x 22³/₁₆ in.
Louis V. Bell Fund, 1964, 64.281.2

Don Manuel Osorio Manrique de Zuñiga
Francisco Goya (Spanish, 1746–1828)
Oil on canvas; 50 x 40 in.
The Jules Bache Collection, 1949, 49.7.41

PAGE 68. *The Holy Kinship*
Lucas Cranach the Elder (German, 1472–1553)
Woodcut, 9 x 12²³/₃₂ in.
Rogers Fund, 1921, 21.35.2

PAGE 69. *The Hatch Family*
Eastman Johnson (American, 1824–1906)
Oil on canvas; 48 x 73³/₈ in.
Gift of Frederic H. Hatch, 1926, 26.97

PAGE 70. *Priest Presenting Man and Boy*
Egyptian (Late Dynasty 18, ca. 1379–1350 B.C.)
Painted limestone; 7⁷/₈ in. high
Rogers Fund, 1911, 11.150.21

PAGE 71. *Family Scene*
Pierre Bonnard (French, 1867–1947)
Color lithograph; 12¼ x 6¹⁵/₁₆ in.
Rogers Fund, 1922, 22.82.1–3

PAGES 72–73. *Madame Charpentier and Her Children*
Pierre-Auguste Renoir (French, 1841–1919)
Oil on canvas; 60½ x 74⅞ in.
Wolfe Fund, Catharine Lorillard Wolfe Collection, 1907, 07.122

PAGE 74. *The Monet Family in Their Garden*
Edouard Manet (French, 1832–83)
Oil on canvas; 24 x 39¼ in.
Bequest of Joan Whitney Payson, 1975, 1976.201.14

PAGE 75. *Rubens, His Wife, Helena Fourment, and Their Son Peter Paul*
Peter Paul Rubens (Flemish, 1577–1640)
Oil on wood; 80⅜ x 62⅝ in.
Gift of Mr. and Mrs. Charles Wrightsman, 1981, 1981.238

PAGES 76–77. *Mrs. Noah Smith and Her Children*
Ralph Earl (American, 1751–1801)
Oil on canvas; 64 x 85¾ in.
Gift of Edgar William and Bernice Chrysler Garbisch, 1964, 64.309.1

PAGE 78. *The Vintage*
Early Christian (3rd–4th century)
Marble sarcophagus fragment; 22⅝ x 15³/₁₆ in.
Fletcher Fund, 1924, 24.97.12

PAGE 79. *Thanksgiving Turkey*
Anna Mary Robertson Moses (Grandma Moses; American, 1860–1961)
Oil on wood; 15⅛ x 19⅛ in.
Bequest of Mary Stillman Harkness, 1950, 50.145.375

PAGE 80. *The Way They Live*
Thomas Anshutz (American, 1851–1912)
Oil on canvas; 24 x 17 in.
Morris K. Jesup Fund, 1940, 40.40

PAGE 81. *Allegory of Earth: Two Children Gardening*
François Boucher (French, 1703–70)
Black chalk, heightened with white chalk on brown paper; 30 x 22⅛ in.
Louis V. Bell Fund, 1964, 64.281.1

PAGE 82. *Jungle Tales*
James J. Shannon (American, 1862–1923)
Oil on canvas; 34¼ x 44¾ in.
Arthur Hoppock Hearn Fund, 1913, 13.143.1

The Bible Reader
Pierre Michaud (French, 18th century)
Gold and enamel watchcase; 1⅞ in. diameter
Gift of J. Pierpont Morgan, 1917, 17.190.1591

PAGE 83. *Woman with White Parasol Pushing a Perambulator,* page from *Large Boston Public Garden Sketchbook*
Maurice Prendergast (American, 1859–1924)
Watercolor; 14½ x 9 in.
Robert Lehman Collection, 1975, 1975.1.952

PAGE 84. *School Scene*
Artist unknown (Chinese, 18th century)
Fan mounted as an album leaf, colors on silk; 10⅞ x 10¾ in.
Fletcher Fund, 1947, 47.18.39

PAGE 85. *Layla and Majnun at School,* leaf from a manuscript of the *Khamseh* (Quintet) of Nizami
Artist unknown (Persian, Safavid Period, 16th century), style of Shaykh Kadeh
Ink, colors, and gold on paper; 4¾ x 7½ in.
Gift of Alexander Smith Cochran, 1913, 13.228.7, folio 129 recto

PAGE 86. *Little Fourteen-Year-Old Dancer*
Hilaire-Germain-Edgar Degas (French, 1834–1917)
Bronze, tulle skirt, and satin hair ribbon; 39 in. high
Bequest of Mrs. H. O. Havemeyer, 1929, H. O. Havemeyer Collection, 29.100.370

Little Girl Practicing at the Barre
Hilaire-Germain-Edgar Degas (French, 1834–1917)
Charcoal, heightened with white chalk, on pink paper; 12⅛ x 11½ in.
Bequest of Mrs. H. O. Havemeyer, 1929, H. O. Havemeyer Collection, 29.100.943

PAGE 87. *The Dance Lesson*
Hilaire-Germain-Edgar Degas (French, 1834–1917)
Pastel on paper; 25⁷/₁₆ x 22³/₁₆ in.
Anonymous gift, H. O. Havemeyer Collection, 1971, 1971.185

PAGE 88. *Singing Boys*
Herbert Adams (American, 1858–1945)
Marble relief; 36¼ x 44½ in.
Bequest of Charles W. Gould, 1931, 32.62.2

The Violin
Alexandre Charpentier (French, 1856–1909)
Bronze plaquette; 3½ x 5⅞ in.
Gift of Victor D. Brenner, 1903, 03.7.18

PAGE 89. *Two Young Girls at the Piano*
Pierre-Auguste Renoir (French, 1841–1919)
Oil on canvas; 44 x 34 in.
Robert Lehman Collection, 1975, 1975.1.201

PAGE 90. *Portrait of a Boy, probably of the Crossfield Family*
William Williams (American, 1727–91)
Oil on canvas; 52¼ x 35¾ in.
Victor Wilbour Memorial Fund, 1965, 65.34

Little Boy with Cart
Greek (5th century B.C.)
Red-figured terracotta *oinochoe*; 3⅝ in. high
Rogers Fund, 1906, 06.1021.202

PAGE 91. *Boy Juggling Shells*
Katsushika Hokusai (Japanese, 1760–1849)
Album leaf, ink and color on paper; 13⁵/₁₆ x 9½ in.
Charles Stewart Smith Collection, Gift of Mrs. Charles Stewart
 Smith, Charles Stewart Smith, Jr. and Howard Caswell Smith, in
 memory of Charles Stewart Smith, 1914, 14.76.59 (4)

PAGE 92. *Soap Bubbles*
Thomas Couture (French, 1815–79)
Oil on canvas; 51½ x 38⅝ in.
Bequest of Catharine Lorillard Wolfe, 1887, Catharine Lorillard
 Wolfe Collection, 87.15.22

PAGE 93. *Boy Blowing Bubbles*
Jean-Baptiste-Siméon Chardin (French, 1699–1779)
Oil on canvas; 24 x 24⅞ in.
Wentworth Fund, 1949, 49.24

PAGE 94. *La Rue* (detail)
Alexandre-Théophile Steinlen (French, 1859–1924)
Color lithograph; 80⁷/₃₂ x 39¹³/₃₂ in.
Harris Brisbane Dick Fund, 1932, 32.88.18

Vase
Artist unknown (Chinese, Ching dynasty, late 17th–early
 18th century)
Porcelain painted in the *famille verte* palette of overglaze enamels
 and gilt; 19 in. high
Bequest of John D. Rockefeller, Jr., 1960, 61.200.33

PAGE 95. *A Woman Watches Two Children Playing Blindman's Buff*
Kitagawa Utamaro (Japanese, 1753–1806)
Woodblock print; 14½ x 9½ in.
Gift of Estate of Samuel Isham, 1914, JP 986

PAGE 96. *Knickknack Peddler*
Attributed to Li Sung (Chinese, active ca. 1210–30)
Fan mounted as an album leaf, ink and slight color on silk;
 10⅜ x 10½ in.
Purchase, Gift of J. Pierpont Morgan, by exchange, 1973,
 1973.121.10

PAGE 97. *Children with Toy Seller on the Quai du Louvre*
Jean Beraud (French, 1849–1936)
Oil on canvas; 25¾ x 32⅛ in.
Gift of Raymonde Paul, in memory of her brother, C. Michael Paul,
 1982, 1982.179.8

PAGES 98–99. *Snap the Whip*
Winslow Homer (American, 1836–1910)
Oil on canvas; 12 x 20 in.
Gift of Christian A. Zabriskie, 1950, 50.41

PAGE 100. Illustration from *A Day in a Child's Life*
Hand-colored wood engraving after a drawing by Kate Greenaway
 (British, 1846–1901)
Illustrated book; 9⅝ x 8¼ in.
Rogers Fund, 1921, 21.36.91

Fanfan Playing with Punchinello and Friends
Jean-Honoré Fragonard (French, 1732–1806) and Marguerite
 Gérard (French, 1761–1837)
Etching; 10⅛ x 7⅜ in.
Purchase, Roland L. Redmond Gift, Louis V. Bell, and Rogers
 Funds, 1972, 1972.539.1

PAGE 101. *Studies of Children*
Anonymous artist (Italian, 17th century)
Red chalk; 5⅛ x 4 in.
Gift of Cornelius Vanderbilt, 1880, 80.3.329

PAGE 102. Ecuelle with chinoiserie decoration and silver-mounted
 cover
French, Chantilly, ca. 1730
Soft-paste porcelain; 4⁵/₁₆ in. high
Bequest of R. Thornton Wilson in memory of his wife, Florence
 Ellsworth Wilson, 1977, 1977.216.59ab

PAGE 103. *Child at Play*
German, Meissen, ca. 1770, decorator's mark "L," after an
 engraving by Claudine Bouzonnet Stella
Hard-paste porcelain soup plate, underglaze blue decoration;
 9¼ in. diameter
The Charles E. Sampson Memorial Fund, 1981, 1981.47.2

PAGE 104. *A Ride to School*
Currier & Ives (American, active 1835–1907)
Color lithograph; 5 x 8 in.
Bequest of Adele S. Colgate, 1962, 63.550.356

Postcard
Designer of Wiener Werkstatte (Austrian, founded 1905)
Color lithograph; 5½ x 3½ in.
Museum accession

PAGE 105. *The Snow Ball*
Suzuki Harunobu (Japanese, 1725–70)
Woodblock print; 11 x 8⁵/₁₆ in.
Rogers Fund, 1921, JP 1223

PAGES 106–111. Postcards
Designers of Wiener Werkstatte (Austrian, founded 1905)
Color lithograph; 5½ x 3½ in.
Museum accession

PAGE 112. Pillow
Tz'u Chou ware (Chinese, Late Northern Sung-Chin dynasty,
 12th–13th century)
Stoneware painted in black on white slip; 11¼ in. long
Harris Brisbane Dick Fund, 1960, 60.73.2

Pillow. This young equestrian straddles a mount familiar to parents throughout the world, although his hobbyhorse is definitely Chinese, for its hindquarters are constructed of bamboo. The pillow itself is a ceramic stoneware piece, useful as a neckrest for a woman wearing an elaborate headdress, and especially cool in summertime. This pillow dates from the 12th or 13th century and may have been made for a mother who wanted her child close to her even in sleep.

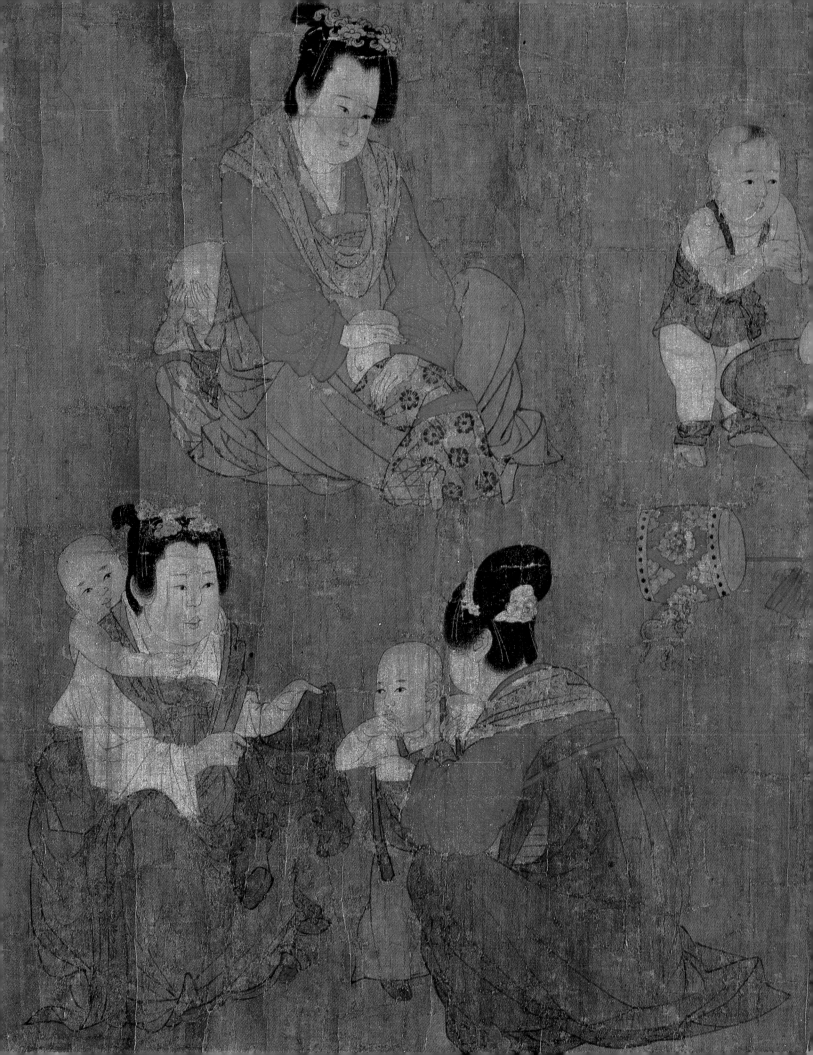